The
Stained Glass
Garden

Projects & Patterns

George W. Shannon
and Pat Torlen

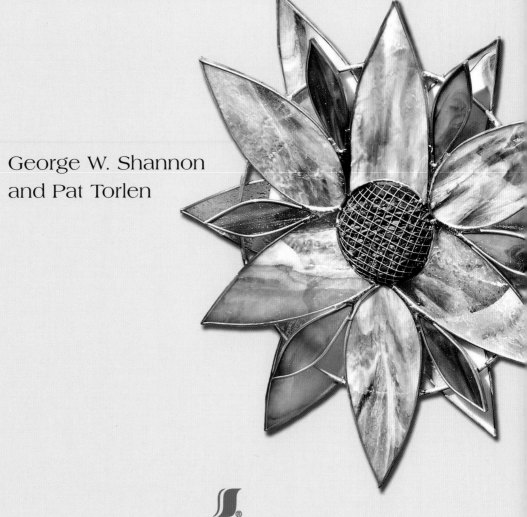

Sterling Publishing Co., Inc. New York
A Sterling/Tamos Book

A Sterling/Tamos Book
© 2006 George W. Shannon & Pat Torlen
Patterns/designs © G. W. Shannon & P. Torlen

Sterling Publishing Co., Inc.
387 Park Avenue South, New York, NY 10016-8810

Tamos Books Inc.
300 Wales Avenue, Winnipeg, MB Canada R2M 2S9

10 9 8 7 6 5 4

Distributed in Canada by Sterling Publishing
c/o Canadian Manda Group, 165 Dufferin Street,
Toronto, Ontario, Canada M6K 3H6
Distributed in Great Britain by Chrysalis Books Group
PLC The Chrysalis Building, Bramley Road, London
W10 6SP, England
Distributed in Australia by Capricorn Link (Australia) Pty.
Ltd. P.O. Box 704, Windsor, NSW 2756, Australia

Design A. Crawford
Photography Jerry Grajewski, grajewski·fotograph·inc.,

Printed in China

National Library of Canada Cataloging in Publication Data
Shannon, George (George Wylie), 1961-
 The stained glass garden: projects & patterns / George
W. Shannon and Pat Torlen
 "A Sterling/Tamos book".
 Includes index.
 ISBN 13: 978-1-895569-57-5
 ISBN 10: 1-895569-57-5
 1. Glass painting and staining. 2. Glass painting and
staining --Patterns 3. Glass Craft 4. Garden ornaments
and furniture I. Torlen, Pat, 1960- II.Title.
TT298.S53 2004 786.5'028'2 C2004-907211-0

Library of Congress Cataloging-in-Publication Data
Shannon, George, 1961-
The stained glass garden / George W. Shannon and
 Pat Torlen.
 p. cm.
"A Sterling/Tamos book"
ISBN 1-895569-57-5
 1. Glass craft. 2. Glass painting and staining. I.
 Torlen, Pat, 1960- II. Title.
TT298.S39 2006
748.5—dc22 2005056331

Tamos Books Inc. acknowledges the financial support of
the Government of Canada through the Book Publishing
Development Program (BPIDP) for our publishing activities.

Dedication For Edna Shannon

Acknowledgments

Special thanks to: Len Dushnicky, Michelle Gaber, Susan Green, and
Wendy Meyer for their creative input and assistance in constructing the
projects in this book, Zyna and Alex Boyes for permitting us to
photograph projects in their sunlit English-style garden and for
serving tea and toast on the patio, and Arlene and Richard
Osen for the use of their beautiful country property for a
photography location at a moment's notice.

About The Authors

George W. Shannon's and Pat Torlen's fascination with
glass began as a hobby and mutual interest. The hobby
quickly evolved into a dual career change with the 1992
opening of their business, On The Edge Glass Studio in
Winnipeg, Canada. Pat and George design and fabricate
commissioned works for commercial and residential clientele utilizing
traditional and contemporary stained glass techniques, sandblasting,
kiln work, and mosaic construction. In 1999, they were commissioned
to create a sand carved and airbrushed glass wall for Air Canada's
Maple Leaf lounge at the Winnipeg International Airport. The Trinity
Series of communion chalices and vessels they created for the Parish
of St. Timothy received a 1999-2000 Modern Liturgy Visual Arts Award.
In the past year, On The Edge Glass Studio designed and produced two
large commissioned works for clients in the United States. Stained
glass doors and windows were created for the private dining room at
Beaver Run Ski Resort in Breckinridge, Colorado. Several sand carved
door panels and a sand carved and airbrushed glass wall, complete
with passage door and kiln-formed waterfall, were created for the great
room of an exclusive Florida home overlooking the Gulf of Mexico.

George and Pat find teaching rewarding and inspirational. Many new
and wonderful designs and techniques come to fruition because of the
challenges put forth by their students and the efforts made to provide
instruction that is informative and fun for students and instructors.
Through the years, both artists participated in intensive workshops and
classes given by internationally renowned glass artists such as Irene
Frolic, Marc Gibeau, Mitchell Gaudet, Paul Marioni, Virginia Gabaldo,
Richard Millard, Rachel Mesrahi, Tim O'Neill, and Dan Fenton. George
has attended Pilchuck Glass School in Stanwood, Washington and Pat
was a coordinator and participant in a glass casting course taught at
the University of Manitoba.

Another creative endeavor shared by Pat and George is their love of
gardening. They designed the stained glass projects featured in this
book to enhance and reflect the natural beauty found within a garden
and its inhabitants. George and Pat are the authors of four other books
published by Sterling/Tamos: *Stained Glass Projects & Patterns;
Stained Glass Mosaics Projects & Patterns; Decorative Glass:
Sandblasting, Copper Foil & Leaded Stained Glass Projects &
Patterns* (released in soft cover as *The New Stained Glass:
Techniques, Projects, Patterns & Designs*); and *Marvelous Mosaics
With Unusual Materials.* Pat and George are currently working on
two more glass crafting project and pattern books. Their upcoming
books will feature new mosaic projects and a collection of stained
glass lamps and large panels for windows, doors, and room dividers.
For more information about books already in print and their upcoming
new titles, visit **www.ontheedgeglass.com**

Contents

The projects in this book are not recommended for children under the age of 12 years. Children ages 12 to 16 should have adult supervision when working on projects described in this book.

All projects in this book are original designs by On The Edge Glass Studio.

Introduction

Stained glass artisans and gardening enthusiasts have much in common and often share mutual interests. Visible similarities are an eye for color and attention to details that are accompanied by an inherent love of working hands-on to carry out a project. Using raw materials provided by Mother Nature, gardeners and glass artists explore and stretch the boundaries of form and function and rely on the skills they have mastered to fashion imaginative creations to be shared and enjoyed with others.

In this book we have combined the skills and artistry of our twin passions to design stained glass compositions that are inspired by Nature's beauty. Stained glass and gardening are pursuits that require that we dig deep to come up with original concepts to distinguish ourselves from the rest of the field. Working with our hands and witnessing the growth and expansion of our initial ideas until they reach fruition is always an exciting, though sometimes frustrating, process but the final outcome always comes with a sense of accomplishment.

The purpose of *The Stained Glass Garden: Projects and Patterns* is to guide the reader through the necessary steps to acquire the skills required for crafting with stained glass. The projects shown throughout the book are designed to appeal to hobbyists of all skill levels and to introduce the methods we utilize in fabricating these garden-inspired object d'arts. Enjoy learning the craft of stained glass while creating pieces that will add color and light to enhance your home and garden for years to come.

About Glass

Glass is one of the most versatile substances known to man and is the earliest man-made (synthetic) material. A basic formula, composed primarily of silica sand mixed with smaller amounts of soda ash and lime, is needed to create glass and has not changed much over the past 3500 years. These raw materials are inexpensive, recyclable, and available in abundant quantities around the world allowing for the development of the vast array of glass products that play a vital role in our everyday lives. The raw materials of glass are mixed together to form batch. Molten glass is produced when the batch is heated in a furnace to temperatures ranging from 2600° F to 2900° F. Considered by some to be a super-cooled liquid, glass looks like a solid when in its rigid state but does not have the internal crystalline structure of solids. In its molten state, glass is malleable and flows like a liquid. The liquefied mass is manipulated into the requisite form or shape and is then gradually cooled in a lehr, a large temperature-controlled oven. This process, called annealing, is a period of controlled cooling to release unwanted internal stress within the glass.

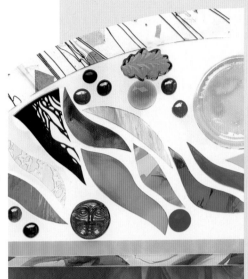

Clear, flat glass used for windows is now predominately produced using the float process. A continuous flow of molten glass is drawn from the melting furnace into another one containing a bath of molten tin. Because the bed of molten tin is perfectly smooth and level, the ribbon of glass becomes flat and uniform in thickness as it "floats" over the tin. The glass is carefully cooled until it reaches a solid state and can be guided from the still-molten tin bath to an annealing oven without damaging the glass surface. The older flat glass methods required the cooled glass be ground and polished but with the float process this is not necessary. It produces glass that is uniformly even and has a brilliant fire-polished surface on both sides.

The varying colors in stained glass are achieved when metal oxides are added to the batch. Lead oxides are introduced to add brilliancy and clarity. Cobalt and chromium produce shades of blue while adding manganese to cobalt blue results in purple. Red, orange, and yellow contain selenium and cadmium. Copper can be found in sheets of black, green, or red glass. Gold oxides produce the beautiful and expensive gold-pinks. Temperature and iron content in the batch also play a factor in the shades and colors achieved.

Sheets of stained glass are produced using one of three methods: hand-blown, machine rolled, or hand cast. Glassblowers pick molten glass up out of the furnace on the end of a blowpipe and a cylindrical shape is blown. It is then rotated in a mold to even the surface and create the striations unique to antique glass. The ends are cut off and the cylinder is cut lengthwise, allowing it to flatten and form a sheet of glass.

Machine-rolled glass is known for its consistency in color and thickness. Molten glass is continuously fed through sets of metal rollers and onto a slow-moving conveyer-type line. As the glass passes through the rollers, patterns and textures can be embossed on the surface before the ribbon of glass reaches the annealing lehr.

Hand cast glass is produced one sheet at a time. Molten glass is ladled onto a metal table and rolled by hand to the desired thickness. Interesting sheets of glass can be produced by mixing in swirls of different colors, thin glass rods, and shards of colored glass before the sheet of glass is transferred to the lehr and allowed to gradually cool.

Types of Art Glass

Sheets of stained glass are commonly referred to as art glass and are predominately produced in Europe, Asia, and the United States. Glass is available in countless and unique color and texture combinations.

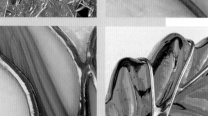

Full Antique Glass manufactured using the centuries-old glassblowing technique is referred to as antique glass and is characterized by rich coloring, translucency, and surface striations. Variations in color and uniformity as well as trapped air pockets and bubbles make this handmade glass distinguishable from all other types.

Semi-Antique Machine-made, semi-antique glass is translucent, of a single color, consistent thickness, and has surface striations reminiscent of full antique glass.

Architectural Glass Glass that is smooth on one side and textured on the other and is 4mm to 6mm thick, is often referred to as architectural glass. Usually clear, some patterns are available in bronze or amber. Because of its thickness, this glass is sometimes substituted for clear float glass in windows, doors, room dividers, sidelights, etc.

Cathedral Translucent and usually of a single color, cathedral glass is reminiscent of the glass traditionally used in making church windows. It can be machine-rolled or mouth-blown.

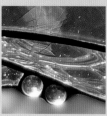

Craquel During the initial stages of manufacturing full antique glass, the hot glass is dipped in cool water. The sudden temperature change causes the exterior layer of the glass to "crack" forming a unique alligator-like pattern on the surface.

Flashed A form of antique glass that has a thin layer of a second color on top of the base color. Designs and tremendous detail can be created by sandblasting or acid etching away parts of the top layer to expose portions of the base layer.

Fractures and Streamers Also referred to as "confetti" glass, this hand cast glass is created by adding shards of colored glass and thin glass rods to a clear or opal base sheet. Louis Comfort Tiffany's studio used it to represent muted or distant foliage in window panels and the famous Tiffany lamps.

Glue Chip Animal hide glue is applied to cathedral glass that has been sandblasted on one side. The sheet is then placed in a warming oven. A frost-like pattern is produced as the glue dries and tears away flakes of glass from the sheet's surface.

Iridescent A shimmering rainbow-like finish can be created on cathedral or opalescent glass by coating the surface with an ultra-thin layer of metallic salts during the manufacturing process.

Mirror Sheets of clear float glass and colored art glass can be coated with a reflective silver backing to create mirror.

Opalescent Distinguished by its milky, luminescent appearance, it is often referred to as opal glass. Opalescent glass is usually composed of a combination of two or more tones or colors. Often used in stained glass lamp shades, it transmits light while obscuring the hardware within.

Opaque Glass that is dense and transmits little light is called opaque glass. It can be a single color or a combination of two or more colors swirled together. Opaque glass is best seen in reflected light and is a popular material for making mosaics.

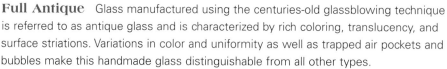

Ring Mottled A hand cast opalescent glass with a hazy surface covering small circular patterns within the glass is referred to as "ring mottled". It is ideal for use in Tiffany-style lamp shades, nature-theme window panels, and stained glass mosaics.

Seedy This cathedral glass with a smooth surface has small air bubbles dispersed throughout.

Streaky These have swirls of two or more colors mixed but not blended together.

Textured Ripple, hammered, granite, crystal ice, herringbone, ribbed, fibroid, moss, catspaw, muffle, and cube are just a few of the textures made by art glass manufacturers.

Bevels A piece of glass is cut to the shape required and an angled border of approximately $\frac{1}{2}$ in wide is ground and polished on the topside edges of the piece. Light refracts and sends rainbows of color throughout a room when it strikes the beveled edges. Individual beveled pieces or clusters can be purchased in a wide variety of shapes and sizes.

Jewels These gem-like pieces of pressed glass are usually faceted and come in a selection of shapes and colors. They can be used as accents in windows, lamps, or to highlight any stained glass project.

Glass Nuggets Irregular in shape and size, these small pieces of glass are sometimes called globs and are used in much the same manner as glass jewels.

Glass Shapes Leaves, stars, hearts, and moonfaces are examples of the glass shapes that are used in several projects in this book.

Rondels Circular pieces of glass made by spinning molten glass on the end of a glassblower's punty rod. They are translucent and are available in various sizes and colors.

Stained Glass Construction

This book presents two distinct construction methods for completing stained glass projects for the home and garden. The *copper foil* technique is a development attributed to the studios of Louis Comfort Tiffany at the turn of the 20th century and allows the stained glass artisan to craft intricate and detailed works in glass. Beautiful window and door panels as well as Tiffany-inspired lamp shades and jewel boxes can be made utilizing this procedure. The *3D Lead Came* method involves wrapping individual glass pieces with U-shaped strips of lead and then assembling the pieces to create glass projects that are more sculptural in form. Illuminating candelabras and rotating glass sprinklers are fashioned this way.

To build the projects demonstrated throughout the following pages requires materials and tools found in the home workshop and a few tools and supplies specifically designed for crafting stained glass. Check the internet and your telephone directory yellow pages for listings of retail outlets that cater to stained glass artisans and establishments offering mail order and on-line shopping services. If you know someone who has worked with stained glass ask for recommendations. A wide selection of tools and materials is available so finding tools that best suits your needs or the right materials to complete any stained glass project should not be difficult.

Materials

■ **Copper foil** is the base upon which the metal support structure is created to join together the pieces of glass in a stained glass project assembled using the copper foil method attributed to Louis Comfort Tiffany. An adhesive-backed copper foil tape is wrapped around each piece of glass once it has been cut and ground to fit the pattern. Molten solder is then applied with a soldering iron along the foiled seam that is created when the individual foiled pieces are placed side by side on the pattern. The rounded solder seams hold the pieces of stained glass in place. Copper foil is available in rolls, approximately 36 yds long, and in a variety of widths. The most common foil widths used are $^3/_{16}$ in, $^7/_{32}$ in and $^1/_4$ in, depending on the thickness of the glass used. Copper foil with a silver or black backing can be used when the glass is translucent and a view of the copper underside is not desirable. Copper foil is also available in 12 in by 12 in sheets that may be cut and soldered to produce decorative overlays applied to glass surfaces.

■ **Solder** is an alloy composed primarily of tin and lead that will fuse to copper foil and lead came when flux and heat are applied (approximately 600° to 800° F). Labels list the amount of tin present in a spool of solder first, followed by the lead content. For easy handling, solder is produced in one-pound spools of solid wire, approximately $^1/_8$ in thick. The most commonly used solders for stained glass construction are

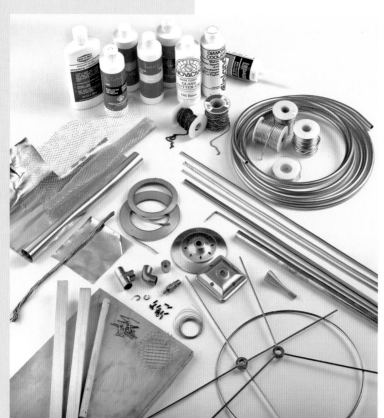

60/40 combination of 60% tin and 40% lead. It melts quickly and is easy to work with when trying to achieve a rounded solder joint or seam. Once it cools, the surface has a shiny finish.

50/50 equal parts of tin and lead. This solder melts at a higher temperature and takes longer to solidify. It is often used as a base coat on the seams of 3-dimensional projects, such as patio and candle lanterns, to help prevent the final bead of solder from dripping through seams before it solidifies.

Lead free consists primarily of tin and is recommended for construction of stained glass jewelry and any project where lead content is a concern. Its melting point is higher than the other 2 solders making it more difficult to work with.

■ **Came** Extruded lengths of channeled metal used to hold pieces of stained glass together are called "came". H-shaped lengths of lead have been used since the tenth century and act as the internal support structure or skeleton that secures in position the many adjoining glass pieces of a traditional leaded stained glass window. U-shaped cames can be used to finish the outside perimeter of both lead came and copper foil projects and is used to assemble many of the 3-dimensional projects presented in this book. Came is obtainable in 6 ft lengths and in many sizes and styles. It is also manufactured in zinc, brass, and copper.

■ **Copper Pipe, Steel Rods, and Brass Rings** from local hardware or plumbing supply stores make up the bases and support structures for many of the featured projects. Sprinklers, garden stakes, obelisks, torchieres, and more are all made functional for use in the garden with these everyday materials.

Vase Caps are usually made of spun brass and should have several small vent holes. A vase cap is soldered over the top opening of patio lantern shades and candle lanterns to hold the individual panels together and to provide a way to hang the shade or lantern. Vent holes allow the heat given off by a light bulb or candle to escape. For the torchiere and candelabra projects, a vase cap is used as part of the base support structure and the vent holes prevent the accumulation of rain or moisture.

Spiders A small brass ring with 3 or 4 spoke-like arms radiating outward is called a spider. It lends support to the candle lantern and acts as a base for the votive cup that holds the candle inside the lantern. Traditionally, a spider is used in conjunction with a vase cap to give additional support to a large stained glass lamp shade and as a means to suspend it from a ceiling fixture or on a lamp base.

Tinned Copper Wire 14- to 20-gauge copper wire is available with or without a slight coating of tin. Tinned copper wire is used to make hanging loops, for additional support, and as a decorative element added to many of the projects in this book. Copper wire can be tinned by applying flux and coating the wire with a thin layer of solder.

Flux Regardless of the method of construction, before a stained glass project can be soldered together, the copper foil or the lead came must be clean and free of oxidation to ensure an even solder joint or seam. The application of flux aids in the fusion of the solder to the copper foil and the lead came. Solder will not stick to the foil or the came if flux is not applied. Flux solutions are available in a variety of forms – liquid, paste, gel, or cream. A water-soluble safety flux formulated for stained glass construction is recommended. Fluxes containing zinc chloride and hydrochloric acids may cause skin and respiratory irritations in some individuals and should be avoided.

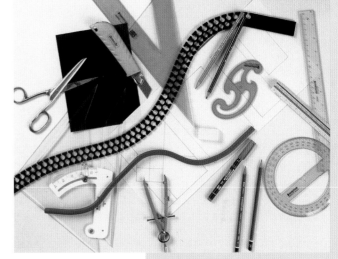

Lubricant is required to keep the glass cutter wheel clean and well oiled. Use odorless, water soluble lightweight machine oil (sewing machine oil) or an oil formulated specifically for glass cutters.

Patina is a solution of water, copper sulfates, and mineral acids that is applied to solder seams to change the surface color to a copper or black finish. Patina is commonly used on copper foil projects.

Neutralizing Solution is a mixture of water, sodium bicarbonate, and a sudsing agent that is used to wash away all traces of excess flux and patina, and to neutralize the acids and minerals found in these compounds.

Finishing Wax is a compound applied to the cames and solder seams of finished stained glass projects. Once the wax is dry and buffed with a soft cloth, the project is left with a shiny protective coating that is water-repellent. Specially formulated stained glass finishing compounds or a quality car wax can be used.

Fine-link Chain is used to suspend small stained glass window panels, candleholders, and hanging planters.

Plywood, Wood Trim, and Nails A ³/₄ in plywood project board, several pieces of straight wood trim, and some nails may be required to assemble some projects or to create a jig. A project board should be at least 2 in larger (on each side) than the finished project.

Equipment

Permanent Waterproof Fine-tipped Marker is used for darkening lines when drawing project patterns and for outlining pattern shapes on glass to aid in the cutting and grinding stages. Silver, gold, and white markers work well on dark and opaque glasses.

■ **Drawing Equipment** consists of small square, pencil, eraser, cork-backed ruler or straightedge, grid paper, tracing paper, carbon paper, marking pen, compass, scissors, light cardstock. Drawing materials and tools assist in making pattern copies, in drawing and scoring straight lines, verifying angles and proper alignment, and for making templates.

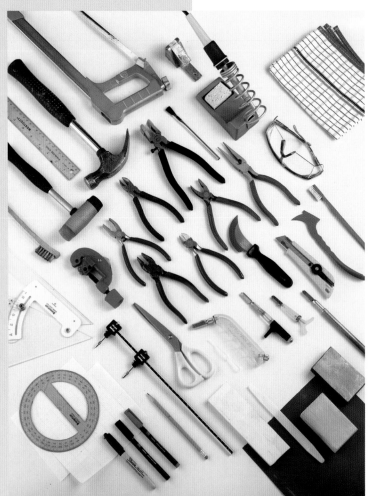

■ **Glass Cutter** accurately scores and breaks individual pieces of glass to fit the project pattern. Common types are dry wheel and oil-fed. An inexpensive steel wheel cutter has a larger steel cutting wheel, which requires lubricating for each score, and is usually disposed of after each project. It is a good choice when first starting out in stained glass. In comparison, more expensive self-lubricating cutters have smaller carbide steel cutting wheels and a reservoir for oil. They last for many years. The smaller size wheel can better follow the contours and uneven surfaces of art glass. Popular models have either a traditional pencil-shaped barrel or one of several different handle grips. The pistol grip handle is advantageous for people with limited hand strength and for reducing hand fatigue.

■ **Breaking, Grozing, and Combination Pliers** are used for breaking glass along the score line. Breaking pliers have flat smooth jaws that are well suited for gripping and breaking off scored pieces of glass. Grozing pliers have narrow, flat, serrated jaws to nibble away at unwanted bits along the edge of the glass so the piece will fit the pattern. Versatile combination pliers combine the uses of breaking and grozing pliers. The top jaw is flat and the bottom jaw is concave – both are serrated.

■ **Running Pliers**, metal or plastic, apply equal pressure on both sides of score line forcing it to "run" or break along its length and are used mainly for breaking score lines that are long and straight or gently curved, or with practice, more difficult score lines. Metal running pliers are preferred and have a concave jaw (positioned on topside of the glass) and a convex jaw (placed on underside of the glass). They can carry a "run" over a longer distance. Plastic running pliers have 3 teeth – 2 on the top jaw and one on the lower jaw. These pliers are limited in how narrow a piece of glass they can break since all 3 teeth need to be in contact with the glass. The plastic handles may have a fair amount of flex which reduces the length of the "run". Some running pliers have a central guide mark on the top jaw to help align pliers on top of the glass correctly, or use a permanent marker to draw a guide mark on the top jaw.

■ **Utility Knife** is used to trim and cut designs in copper foil, cut out paper patterns, etc.

■ **Carborundum Stone** is a small rectangular block composed of a hard carbon compound and silicon, and is used to file sharp edges off pieces of glass. The stone must be kept wet when smoothing the rough edges of the glass to help keep minute glass particles from becoming airborne.

■ **Diamond Pads** are handheld foam pads with one side coated with a diamond particle coating that when dampened is used to polish away rough glass edges.

■ **Wet/Dry Sandpaper** is a waterproof paper with a silicon carbide coating that can be used to blunt the sharpness of cut glass edges. It must be wet when used on glass.

■ **Glass Grinder** Complex and detailed shapes, and more sophisticated and creative designs in stained glass are now possible with the aid of a glass grinder and its diamond coated bit. Rough and uneven edges of cut pieces of glass can be smoothed and ground to fit a pattern more accurately. Excess glass on tight inside curves can be ground away, reducing the risk of cracking a piece during the breaking or grozing process. A ground edge on a glass piece also aids in the adhesion of copper foil to the glass. A reservoir containing water traps the dust produced when grinding and helps prevent hazardous airborne glass particles. A face shield and back splash are recommended to contain any larger glass chips or overspray of water that may occur during the grinding process.

■ **Lead Came Cutters and Lead Knives** are important when cutting lead came to achieve a clean, even cut that does not crush the channels of the came. This can be achieved by using lead came cutters or a traditional lead knife. Lead came cutters, often referred to as knippers or lead dykes, are fashioned like a pair of pliers but have a set of sharp, pointed jaws that are ground flat on one side and are designed specifically for cutting and mitering lead came. A lead knife has a sharp, curved blade. The came is cut by rocking the curved edge of the blade in a back and forth motion on the face of the came and exerting a firm yet gentle pressure.

■ **Lead Vise** attached to the surface of a worktable, is used to clamp one end of the came while the lead is being pulled from the other end with a pair of pliers. Lengths of lead came must be straightened to remove kinks and to make the came more rigid.

■ **Lathekin or Fid** is used to open up and widen the channels of any type of metal came to accommodate the width of a glass piece. This versatile hand tool can also be used to burnish copper foil wrapped around the edges of glass pieces.

■ **Horseshoe Nails** are used to hold lead came and pieces of stained glass in position while constructing a stained glass panel. Also referred to as glazier's nails, these flat-sided nails are less likely to leave an unsightly impression in the came or to chip a glass edge than conventional rounded nails.

■ **Soldering Iron, Sponge, and Stand** A soldering iron melts the tin-lead alloy solder required to attach the pieces of a copper foiled project together or to solder a metal came joint. The iron must have a chisel-shaped tip to ensure a smooth and even solder seam and should be between 80 and 150 watts (a 100-watt iron is the most commonly used by hobbyists). For ease of soldering, the iron must be able to maintain a constant and even temperature (600° to 900° F). Many models have a built-in temperature control or can be regulated by a small control unit. Tips are available in a variety of widths and can be changed to accommodate the type of soldering being done. A stand is required to hold the soldering iron while it is hot and a moistened sponge made of natural fibers is necessary to clean the tip during the soldering process.

■ **Wire cutters (snips or side cutters)** have a pair of sharp, pointed jaws to cut wire, chain, and zinc or brass came. They are not suitable for cutting softer metals such as lead came.

■ **Hacksaw** can cut rigid zinc cames and copper pipes.

■ **Brushes** (small paint or craft) are used to apply flux, wire brushes scrape oxidation from the surface of lead came, and old toothbrushes can apply patina applications and clean finished projects.

■ **Polishing Cloths** buff the surface of finished project. Use clean, dry cloths (cotton or linen recommended).

■ **Woodworking Tools** may be required to make jigs, install completed panels, etc. Where applicable, a list of required tools, materials, and instructions is given.

The Work Area

Choose a comfortable working space with enough room to spread out the project. A working area requires

- Large, sturdy table or workbench at comfortable working height (around waist level) with a smooth, level work surface (preferably plywood).
- Overhead lighting (natural light if possible).
- Electrical outlet with grounded circuit for soldering iron and glass grinder.
- Easy-to-clean hard surface floor.
- Rack or wooden bin with dividers to store glass sheets in an upright position to prevent scratching the glass surface. Store smaller pieces in a cardboard box.
- Good ventilation (window, fan) when soldering and working with patinas.
- Supply of newspaper to cover work surface for easy cleaning.
- Bench brush and dust pan to clear work surface of glass chips and other debris. To avoid the risk of cuts to other family members, do not throw glass chips and shards into household garbage bins or bags. Keep a separate, sturdy box in which to discard glass scraps.

- Access to water for cleaning projects as well as rinsing away debris when using glass grinder or carborundum stone.
- Storage box for lengths of lead came to prevent oxidation and unnecessary twisting of the cames. Always keep lead products out of children's reach. If the box cannot be closed, cover with newspaper to reduce oxidation. Ask your local stained glass shop for an empty came box or devise a storage rack that the lead came can be draped over.

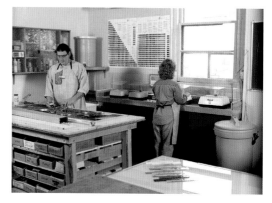

- Sealable storage box for lead came scraps. Take full scrap box to a recycling depot that handles heavy metals. Do not throw lead into a regular garbage bin.
- Light table for tracing patterns onto hard-to-see-through glass.

Building A Light Table

Using a light box as an aid can make tracing patterns onto glass surfaces easier. Simply place the pattern on the light table and position the art glass on top of the pattern. Trace the outline of the required pattern piece.

Build a light table by following these steps:
- Make a plywood box with a fluorescent fixture secured inside. Drill a hole in one end for the electrical cord. Attach handles to move light box easily around work area.
- Use $1/4$ in (6mm) clear float glass for the top. Sandblast the underside of the glass to diffuse the light from the bulbs. Most shops selling float glass offer sandblasting services.
- Apply white paint to the inside surface of the plywood box for better light reflection.

Note

When tracing patterns onto smaller pieces of glass, the following method can be used in place of a light table: tape the pattern onto an outside facing window, place the glass on top of the pattern, and trace the pattern onto the glass. This method is not recommended for large pieces of glass.

Safety Practices and Equipment

While working with stained glass, there are four items that should always be present and used when appropriate: safety glasses or goggles, work apron, rubber or latex gloves, and dust mask or respirator. Following these common sense rules will ensure a safe and healthy work environment.

- Always wear safety glasses or goggles when cutting glass, soldering, or using chemicals. This will lessen the risk of eye injury caused by small glass fragments that may become airborne during cutting and grinding, and from splatters of flux, patina, and solder.
- Do not eat, drink, or smoke while working with stained glass. Keep hands away from mouth and face while working. Wash hands, arms, and face thoroughly with soap and water at the end of a work session.
- Wear rubber or latex gloves when handling patinas and other harsh chemicals. Cover all cuts and scrapes with an adhesive plaster when working with lead, solder, or chemicals. Lead cannot usually be absorbed through the skin but can enter through open sores and cuts. Fluxes and patinas can be very irritating to broken skin.
- Protect your clothing by wearing a full-length work apron at every stage of the process. This will also help prevent the spread of glass fragments and lead from entering your living space. Wash work clothes and aprons separately from other clothing.
- Wear closed shoes to prevent glass fragments and molten solder from coming in contact with your feet.
- It is advisable to wear a dust mask or respirator when engaged in soldering stained glass projects over an extended time period.
- Clear your work surface often with a bench brush. Clean your work area and floor surface with a damp mop or wet sponge to prevent glass and minute lead particles from becoming airborne. Avoid sweeping and vacuuming whenever possible.
- Carry glass in a vertical position with one hand supporting the sheet from below and the other hand steadying the sheet from the side. Wear protective gloves when moving larger sheets.

Soldering Safety

Lead fumes are produced in such minute quantities at the temperatures required for stained glass soldering that there is little danger of lead contamination through inhalation. However, there can be some mist produced as the flux is burned off during soldering.

- Apply only the amount of flux needed to solder the seam you are working on. Excessive flux will give off unnecessary fumes and may cause the solder to splatter and spit, creating pits in your solder seam and possibly burning your hands.
- Though the mist produced by safety flux is generally considered harmless, it is a good idea to work in a well-ventilated area with a small fan positioned so that the mist is pulled away from you. If ventilation is a concern, wear a respirator with filters designed to screen out mists and vapors.
- Avoid fluxes containing zinc chloride and hydrochloric acids.
- Always rest a hot soldering iron in a metal soldering iron stand. Never rest it on a work surface or leave a plugged-in iron unattended.

Note For pertinent information on the appropriate respirators and filters, visit your local safety supply store. Young children should not work with stained glass unless supervised by an experienced adult. Pregnant women are advised to check with their physician.

Lead Safety

Working with lead is not hazardous if it is handled with care and treated with respect. When working with stained glass, the greatest risk of over-exposure to lead comes from ingesting it orally. This can happen if food, drink, or cigarettes are placed on a lead-tainted surface or handled with hands that have come in contact with lead.

- Keep hands away from mouth and face, particularly when soldering or leading stained glass projects.
- Always wash hands, arms, and face thoroughly with soap and water after working on a project.
- When possible, wear rubber or latex gloves when leading and discard after the project is finished.
- Always cover cuts and scrapes with an adhesive bandage.
- Do not leave lead scraps lying about. Store scraps in a separate box or container and take the unwanted lead to a recycling depot when the box is full.
- Scrub work surfaces with soap and water and wipe with paper towels that can be discarded immediately.
- Always keep lead out of the reach of small children and inform older ones of the safety rules.

Basic Techniques

Glass Selection

The combination of color, texture, and light plays a major role in determining how successful the outcome of a stained glass piece will be. Many artisans find selecting the glass for a project to be one of the most exciting and challenging aspects of the craft. Novices often find it an overwhelming task when presented with the innumerable choices available so don't hesitate to ask another stained glass enthusiast or an instructor for suggestions. Take your time, enjoy the process, and keep the following guidelines in mind

- When crafting small projects keep color selections to a minimum by focusing on 2 or 3 colors. Additional colors and textures can be introduced when constructing larger pieces. If a wider range of glass is required, try using varying shades of one of the dominant colors or add in some clear textured glasses.
- Observe glass selections in lighting conditions similar to those where the finished project will be displayed. For pieces that will not be lit from behind or required to transmit light, choose glasses that are lighter in color and attractive in reflective light. Colorful opaque glasses and iridescent surface coatings add sparkle and interest to stained glass pieces situated amongst the verdant foliage of the garden.
- View glass choices side by side to see how the colors affect each other. Bold colors are softened when surrounded by lighter colors and clear textured glasses while darker shades can be used as accents to highlight paler opaque pieces.
- Consider the function of your stained glass project. Is it purely a decorative piece or does it have a particular purpose? Privacy may be the principle objective for a bathroom window or true-to-life color and organic-looking glass may be the focus of a stained glass panel depicting a scene from nature. A soft romantic glow on beautiful summer evenings may be the purpose for a candleholder in the garden but the right selection of vibrant and colorful glasses can make it come alive in the sunlight.

Making Copies of the Patterns

Make 2 or 3 pattern copies for each stained glass project to be constructed. Most patterns can be altered if a specific size or shape is desired. Before starting your project verify that all pattern copies are the same by comparing each copy to the original pattern for accuracy. When drawing stained glass patterns the design lines represent the space required between each glass piece to accommodate the support structure created by the solder seams. The thickness of the design lines should be $1/32$ in for copper foil projects. Use a permanent marker with the appropriate size nib to draw the pattern lines. Some projects use precut bevels and jewels. Verify that they fit the pattern before cutting the other glass pieces required.

Photocopying This is the easiest method for duplicating copies. Verify each copy with the original pattern for accuracy, especially for 3-dimensional projects. Many photocopiers can also enlarge or reduce patterns.

Tracing Lay tracing vellum over the pattern and trace the lines of the design. Multiple copies can be made using carbon sheets. Lay a sheet of paper on the work surface and place a carbon face down overtop. For each copy required, add another layer of paper and carbon. Place the project pattern on top and fasten in place, using push pins or tape. Trace the outline of the pattern, pressing firmly so that the image is transferred through to each layer of paper.

■ **Grid Method** Use a grid to enlarge, reduce, or change the dimensions of a design. On paper, draw a new grid work with the size of the squares adjusted to fit the new grid. Copy the design from the original grid onto the modified one, square by square.

■ **Blueprinting** By tracing the project pattern onto drawing vellum, exact copies can be made by a blueprinting firm. Blueprints are exact and do not distort the pattern in any way. If a pattern requiring bevels or jewels of a specific size and/or shape is reduced or enlarged, verify that these pieces fit the pattern before starting the project. Alter the pattern if necessary.

■ **Overhead and Opaque Projectors** Used to enlarge pattern designs, but patterns may be distorted and require adjustments. Use this method as a guideline only. When enlarging patterns with pieces that must be a certain size, the pattern will have to be altered accordingly.

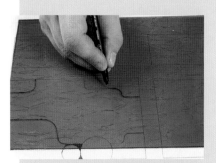

Place translucent glass on pattern & trace piece to be cut

Note For sizing reference, patterns in this book that are not full size are placed on grid work, 1 square = 1 inch.

Transferring the Pattern onto Glass

For accurate glass cutting it is advisable to draw the outline of the piece to be cut directly onto the glass with a permanent waterproof fine-tipped marker. Try to position the pattern piece on the glass sheet to avoid excessive waste when cutting. Take into account the grain or texture of the glass piece you are cutting and how it will flow with the other glass pieces around it. Leave approximately 1/4 in around the piece so the breaking pliers will have some material to grasp when breaking the score line.

For many **translucent and light-colored opalescent glasses**, transfer the pattern by placing the sheet of glass directly on pattern copy and trace the design lines with a marker. A light box will help illuminate the pattern from below, but it is not essential.

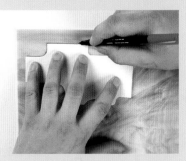

Cut out individual pattern pieces, trace onto opaque glass

Note
When cutting out a piece from the pattern copy or making a cardboard template, be sure to cut along the inside edge of the pattern lines so that the glass piece does not become larger than the pattern once it has been traced and cut.

For **opaque glass**, transfer the pattern onto the glass using one of three methods.

1 Cut out the required pattern piece from an extra pattern copy. Make sure all traces of the design line have been cut away. When using stained glass pattern shears use the appropriate pair for the type of project (copper foil or leaded glass). Place the pattern piece on the glass and trace around the perimeter with the marker.

2 Use cardstock or lightweight cardboard to make templates of the pieces to be cut (see tracing method, p14). Trace around template perimeter onto glass with the marker. This method is preferable when making several projects using the same pattern.

3 Place a carbon sheet face down on the glass with the pattern on top. Press firmly on the lines with a pen to transfer the pattern onto glass. Go over carbon lines with the marker.

How to Cut Glass

Cutting a piece of glass is the result of two separate actions – scoring and breaking. Once the requisite shape has been traced onto the glass with a permanent marker, the glass is scored by running the wheel of a glass cutter along the traced line. By applying even pressure on either side of the score line the piece is broken away from the main sheet of glass. Cutting glass properly is a skill that can be attained with a little effort and the repetition of practicing the flow of the cutting motion and the amount of pressure to exert. Draw cutting patterns A, B, C, and D (p19) onto 3mm float glass (windowpane glass) and practice the techniques of scoring and breaking before starting your first project.

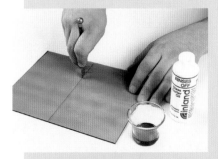

Disposable cutter held in traditional manner. Cutter rests between index & middle fingers with ball of thumb placed to push cutter along. Disposable cutters wear quickly & cutting wheel needs to be lubricated before each score

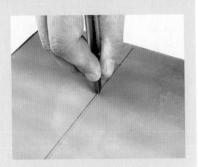

Oil-fed pencil style cutter is held like a pencil

Pistol grip cutter held in palm of hand with thumb resting on barrel & index finger guiding cutter head

To break glass, grasp glass on each side of scored line & roll wrists up & outward

Use running pliers for breaking straight lines or straight curves

Basic Rules of Glass Cutting

1 Wear safety glasses and a work apron. Stand in an upright position in front of the worktable.

2 Work on a clean, level, nonskid work surface covered with newspaper.

3 Place the glass smooth side up with the pattern piece traced on the surface with a permanent marker. Make sure the surface of the glass is clean and free of any debris.

4 Lubricate the wheel of the glass cutter before each score if the cutter is not self-oiling. Use oil designed specifically for glass cutters or lightweight sewing machine oil.

5 Hold the cutter in your writing hand and perpendicular to the glass, not tilted to the left or the right. How you hold the cutter in your hand will depend on what type is used and what grip is the most comfortable. Steady the glass sheet with your other hand and on the opposite side of the line you wish to score.

6 Run the cutter away from your body and along the inside of the pattern lines, using a fluid motion and exerting constant, even pressure as you score the glass. The pressure should be coming mainly from the shoulder, not the hand. Start the score line at one edge of the glass and follow through to another edge of the sheet. Do not stop or lift the cutter from the glass surface before the score is completed. Try not to run the cutter off the edge of the glass sheet as it can chip the glass and may damage the cutter wheel. You will be able to hear the cutter score the glass and the score line will be visible to the naked eye. If small, white slivers are present along the score line then too much pressure has been applied.

7 Never go over a score line a second time. To do so will damage the cutter wheel and will increase the likelihood of an unsuccessful break.

8 Grasp the glass with a hand on each side of the score line, thumbs parallel to the score, knuckles touching. Roll wrists up and outward, breaking the glass along the scored line. Because of the nature of their shape, some pieces will require that you make a series of scores and breaks.

9 Maintain your glass cutter. Keep the cutter wheel oiled and covered when not in use. Periodically, check that the reservoir of the self-oiling cutter contains a sufficient amount of oil. Wipe away any small glass fragments that may have collected on the cutter wheel.

Additional Methods for Breaking Glass Along a Score Line

Score lines can also be broken by employing one or a combination of several different methods.

- **Using Running Pliers** Running pliers are used for breaking straight lines and slight curves and are also useful for starting a break at either end of a score line. Metal running pliers are preferable. The slightly concave jaw must be placed on the topside of the glass and the convex jaw on the underside. If you use plastic running pliers, position the jaw with the 2 outside "teeth" or ridges on the topside of the glass.

1 Position the running pliers so that the score line is centered and the glass is partially inside the jaws, approximately ¹/₂ in to ³/₄ in.

2 Gently squeeze the handles and the score will "run" (travel), causing the glass to break into 2 pieces. If the run does not go the full length of the score line, repeat the procedure at the other end of the score line. The two runs should meet, causing the score line to break completely.

- **Using Breaking Pliers or Combination Pliers** Breaking pliers have 2 identical flat, smooth jaws that can be placed on either side of the glass. Combination pliers have a flat top jaw and a curved bottom jaw – both are serrated.

1 Position the pliers perpendicular to the score line and as close as possible without touching it. Start at either end of the score line (not the middle).

2 Use an out-and-downward pulling motion on the pliers to break the glass.

3 When using 2 sets of pliers to break apart 2 smaller pieces of glass, place the pliers on the glass on either side of the score line and opposite to each other. Hold one set of pliers steady and use an out-and-downward pulling motion with the other set to separate the glass piece.

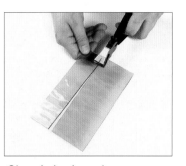

Glass is broken along straight score line

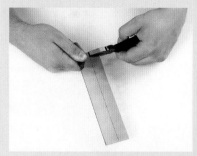

Position jaws of breaking pliers or combination pliers perpendicular to score line

• **Breaking a Score Line by Tapping Underneath**
Occasionally you may be unable to break a score line using your hands or a set of pliers. As a last resort, try the tapping method if all others are unsuccessful in breaking out stubborn pieces. Tapping may cause small chips and fractures along the score line and, if not done carefully, may result in the score running in a different direction than the one intended.

1 Hold the glass close to the surface of the worktable. Using the ball at the end of the cutter, gently strike the glass from the underside, directly underneath the score line. Once the score begins to run, continue tapping ahead of the run until it reaches the other end of the score line.

2 With your hands or a pair of pliers, separate the scored piece from main sheet of glass.

Scoring a Straight Line

To score straight lines, the most consistent method is to use a cork-backed metal ruler/straightedge with a thick, rounded edge as a guide for the glass cutter.

1 Mark the line to be cut and position the straightedge parallel and approximately $1/8$ in from the line (the exact distance is determined by the space between the cutter wheel and the outside edge of the cutter head).

2 Align the head of the glass cutter with the straightedge and verify that the wheel is positioned upon the marked line.

3 Holding the straightedge firmly on glass surface, make the score line by either pulling the cutter toward the body or by pushing it away. Maintain even pressure throughout.

4 Break the score line, using the method you feel most comfortable with (pp16 & 17).

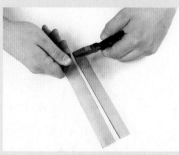

Use out-and-downward motion to break glass along score line

Cutting Large Sheets of Glass

Glass is usually priced by the square foot and can often be purchased in small sheets. For some projects, larger quantities or pieces may be required. Cut larger sheets of glass into more manageable segments. See photos on p18.

1 Check the pattern to determine how large a piece of glass will be required. Score the sheet of glass, using a straightedge as a guide for the glass cutter.

2 Align the score line with the edge of the worktable.

3 Grasp the glass firmly with both hands, raise end of the sheet, approximately one inch from table surface. The opposite end of the sheet must still be in contact with the table.

4 With a swift, downward motion, snap off the end of the piece.

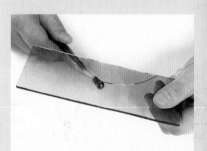

Tap ahead of the "run" until score line is broken out

Cutting Squares and Rectangles

Glass is almost impossible to score and break at a 90° angle. A series of straight scores and breaks is recommended when cutting square and rectangular pieces.

1 Trace pattern A (p19) onto the glass, aligning one of the sides of the pattern with the edge of the glass.

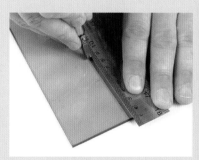

Use straightedge to guide cutter when scoring straight lines

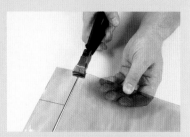

Cutting squares & rectangles requires several straight score lines & breaks

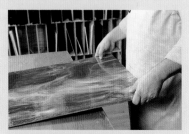

Align score line with edge of worktable

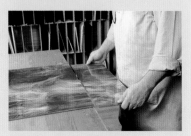

Snap off end of glass with swift, downward motion

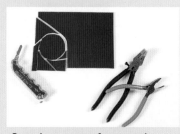

Cut piece away from main sheet of glass before scoring & breaking the glass in a pinwheel fashion

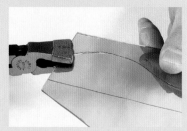

Start "run" at one end of score line.

2 Score along opposite side of pattern piece and proceed to break score line, using the method you prefer (pp16 & 17).

3 Score and break any remaining cut required to achieve the shape of the pattern piece.

Cutting Inside Curves

Inside curves are the most difficult cuts to score and break out successfully. Attempt the most difficult cut first before cutting and breaking the piece away from the main sheet of glass.

1 Trace pattern piece B (p19) onto the glass. Position the outer edges of the curve so they align with the edge of the glass.

2 Score inside curve of pattern piece but do not break it out.

3 Make several smaller concave score lines (scallops) between the initial score line and the outside edge of the glass.

4 Using breaker or combination pliers, start removing the scallops, one at a time, beginning with the one closest to the edge of the glass. Use a pulling action with the pliers rather than a downward motion. Remember to position the jaws of the pliers at either end of the score line and not in the middle.

5 Break away scallops until initial score line is reached. Score and break away pattern piece from the larger glass sheet.

Cutting Circles, Ovals, and Outside Curves

1 Trace pattern C (p19) onto glass, leaving $1/2$ in between outside edge and pattern outline.

2 Make an initial score line that will separate the pattern piece from the sheet of glass. The score line will go from the outside edge of the glass and upon reaching the circle will follow the perimeter of it for a short distance and then head off on a tangent to an opposing edge of the glass (see line 1). Break away this piece.

3 The second score line will follow around the circle for a short distance (approximately $1/6$ th of the perimeter) and then leave on a tangent to the outside edge (see line 2).

4 Repeat step 3, scoring and breaking the glass in a pinwheel fashion, until the circle shape has been formed (see lines 3, 4, 5, and 6).

5 Small jagged edges can be ground off with a glass grinder, nibbled away with combination pliers, or filed off with a carborundum stone (see pp20-21).

6 This method for cutting circular pieces can be adapted to cut outside curves and ovals.

Scoring and Breaking S-Shaped Curves

1 Trace pattern D (p19) onto glass, placing one side against edge of glass.

2 Score the most difficult cut first (S-shape).

3 Align the running pliers with the score line. Squeeze only hard enough to start the run. Repeat the procedure at the opposite end of the score line. If both runs meet, use your hands to separate the resulting 2 pieces. If the runs do not meet, gently tap along the score line on the underside of the glass.

4 Score and break out remaining cuts.

Glass squares & rectangles broken apart

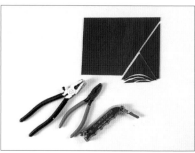

Cutting a piece with inside curves requires a series of cuts

Pattern A – square/rectangles

Pattern B – inside curves

Pattern D – s-shaped curve

Pattern C – circle

Pattern C – oval

Pattern C – half circle

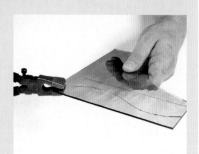

Then start "run" at opposite end of line

Separate into 2 pieces & score & break out remaining cuts

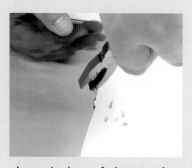

Jagged edges of glass can be smoothed by grozing

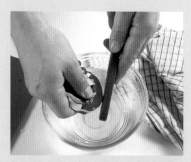

Keep glass piece, wet/dry sandpaper or carborundum stone wet while smoothing edges

Using a Diamond Band Saw

With its specially designed diamond-coated stainless steel blade that will cut glass, ceramic tile, and similar hard materials, the band saw has added new dimensions to the crafting of stained glass. It can cut intricate pattern shapes resulting in smooth edges, eliminating the need for grinding away rough edges. Several models are now available to the stained glass craftsperson. Read the manufacturer's instructions carefully and follow all safety precautions. A band saw must have a water reservoir to cool the blade and prevent glass dust from becoming airborne. Always plug a band saw into a grounded electrical outlet to avoid shocks.

1 Trace the pattern shape onto the glass surface with a metallic paint marker or a thin-line paint marker. Allow the marker to dry thoroughly before cutting so water won't wash away the pattern outline. Another method is to make a copy of the pattern piece from a clear overhead transparency sheet and secure it to the glass with double-sided tape.
2 Verify that the band saw reservoir contains water and keep a moistened sponge positioned adjacent to the diamond-coated blade at all times.
3 Cut the pattern shape following the instructions provided by the manufacturer.
4 Rinse each piece under clear running water to remove glass grit and dust.
5 Place the glass shape on the pattern to verify an accurate fit. If the piece is slightly too large use a glass grinder to achieve the correct size and shape (p21).

Smoothing Jagged Edges of Glass

Glass grinders are used by many hobbyists and artisans to smooth away jagged edges and shape glass pieces to fit the pattern more accurately. In some cases, nibbling at uneven edges with pliers or using a carborundum stone, wet/dry sandpaper, or a diamond pad is all that is required to smooth a sharp edge. If these methods are not suitable, altering the pattern to accommodate the shape is another option.

Grozing

The jagged edge of glass along a broken out score line can be smoothed by grozing. Grasp the piece of glass firmly in one hand, place the combination pliers perpendicular to the edge of the glass, and drag the serrated jaws along the jagged edge in an up-and-down motion.

Using a Carborundum Stone or Wet/Dry Sandpaper

A carborundum stone is a thin rectangular block composed of a hard carbon compound and silicon. Wet/dry sandpaper is a waterproof paper with a silicon carbide coating. Both are available at hardware stores or home and garden centers. They are used in the same manner though the carborundum stone will last much longer and is capable of removing more glass from the edge. The wet/dry sandpaper leaves a more finished edge to the glass.

1 Moisten carborundum stone or wet/dry sandpaper and glass piece with water. Stone or sandpaper must always be wet so minute glass particles and dust don't become airborne.
2 Rub the stone or the sandpaper in a file-like motion along the edge of the glass that requires smoothing. Continue the motion until the desired edge is acquired, making sure that the glass and the paper or stone are moist at all times.
3 Rinse glass and carborundum stone or wet/dry sandpaper under running water.

Using a Glass Grinder

Most stained glass projects constructed using the copper foil method rely on accurate cutting and grinding to properly fit glass pieces together. Although some projects may not require that each glass piece be exact and have perfectly smooth edges, a glass grinder is recommended

for accuracy and efficiency. To spend less time grinding try to cut glass pieces as close to the correct size and shape as possible.

1. Have a face shield attached to the grinder and position a back splash along the back and sides of the grinder to contain any airborne glass chips and water overspray.
2. Keep water in the reservoir and have a moistened sponge positioned adjacent to the diamond-coated bit at all times.
3. Cut each glass piece on the inside of the pattern line to fit the pattern with a minimum of grinding and to allow space for lead came or the application of copper foil between each piece. If the glass pieces fit within and do not overlap the pattern lines, make one quick swipe against the grinding bit on each edge of the glass to dull any sharpness. Only light pressure is required when pushing the glass against the bit.
4. If traces of the marked line are still visible on the piece, grind the edge to ensure an accurate fit within the pattern lines.
5. Check each piece against the pattern. If any part of the piece overlaps and there is not adequate spacing between the pattern pieces, mark the area with a permanent waterproof marker and grind away the excess. Check the glass piece to the pattern and repeat grinding until the piece fits.
6. Repeat steps 3 to 5 for each glass piece. For projects constructed using copper foil construction technique, leave a narrow space between pieces to accommodate the foil. Pieces that have a large gap between the line and the adjacent piece should be re-cut.
7. Rinse each piece under clear running water when grinding is complete and dry with a soft cloth. Care should be taken so that the pattern copy does not become wet and distort its shape and configurations.
8. Wipe the surface of the grinder often with a wet sponge to prevent small glass chips from scratching the underside of the pieces being ground. Do not run bare hands across the grid surface. Glass slivers can be painful and difficult to remove.
9. Ensure proper performance of the glass grinder by thoroughly cleaning and rinsing the water reservoir at the end of each work session.

Glass grinders can be used to shape difficult-to-cut glass piece

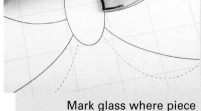

Mark glass where piece overlaps pattern lines

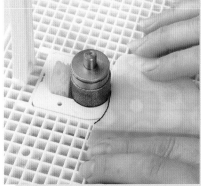

Grind along marked line until excess glass is removed

 Note
Always wear safety glasses and a work apron while grinding. Glass grinders should be plugged into a grounded electrical outlet.

 Helpful Hint
Keep smaller patterns dry during the grinding stage by placing them inside vinyl sheet protectors or covering them with a clear adhesive-backed vinyl.

Cutting Zinc Came

Applying U-channel metal came to the perimeter of an autonomous (free-hanging) stained glass panel gives the piece a neat, finished look while providing additional strength and support. U-channel came comes in an assortment of widths and profiles, and is usually available in 6 ft lengths. Zinc, brass, and copper cames are quite rigid, do not require stretching, and are stronger and harder to cut and manipulate than softer, malleable lead cames.

- The type and size of the project being assembled will determine which came is used. U-channel zinc came is a popular choice as it is a strong, rigid material that is lightweight and similar in appearance to untreated solder seams and lead came.
- Cut a piece of U-channel zinc came for each side of the panel that requires finishing. The length of each came piece should be slightly longer than the corresponding panel edge to accommodate any airspace inside the came and for mitering the ends.

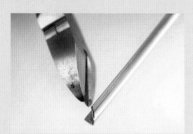

Mitering came at 45° angle

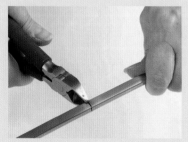

Align wire cutters on mark

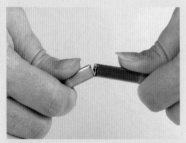

Snip leaf on both sides of the came. Bend back & forth until the spine snaps

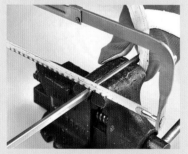

Clamp metal came in vise & cut with a hacksaw at the prescribed mark

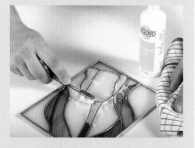

- For square and rectangular panels, miter each end of came pieces at an inward 45° angle so that a 90° angle is formed when an end and a side piece are brought together. Entire panel will be visible when hung, so mitering the came will produce neat corners and finished appearances.
- Once marked to the angle and length required, employ one of the following methods to cut rigid metal cames:

Wire cutters Use to cut smaller cames or to trim angled cuts at the ends of wider lengths. With the side cutters, snip both leafs of the came at the required angle. Gently bend the came back and forth until the spine snaps and the came is separated into two pieces.

Hacksaw Clamp one end of the came (with the spine facing towards the ceiling) in a vise that has been secured to the end of the work surface. The longest length of came protruding from the vise should be supported or resting on the work surface to prevent kinking or warping the came. Align the hacksaw, fitted with a fine-toothed, metal-cutting blade, along the spine and at the angle marked. Grasp the end of the came being cut away with your free hand. Cut the required piece of came away from the main length by carefully sawing through the zinc came. If a vise is not available to hold the came steady, use a miter box or have someone assist you. Use wire cutters if additional trimming is required.

- Use a small metal file to remove burrs and smooth edges after cutting a length of zinc came.

Cleaning the Project

Once the project has been soldered together, clean thoroughly to remove any flux residue. Flux solutions can be corrosive and cause solder seams to oxidize and tarnish if not removed from the project immediately after soldering. To clean:

- Apply a small amount of neutralizing solution to your project. Neutralizing solutions counteract the effects of flux as they clean. Use a commercial formula or make your own by adding sodium bicarbonate to liquid dish detergent.
- Moisten the neutralizing solution with water and gently scrub the project surface with a soft cloth or an old toothbrush.
- Rinse under warm, running water. Do not let the project soak in water.
- Dry with a soft, lint-free cloth.

Finishing the Project

Solder seams on copper foil projects can be left shiny and silver or lightly rubbed with steel wool for a subtler, pewter look. Applying a black or copper patina will alter the surface color of the solder seams and 3D lead came projects will have a dull pewter color with silver solder joints. The joints will oxidize over time and will achieve the same color as the lead came. Black patina will change the lead came to an antique black finish but many copper patina solutions are not as successful. Patina is usually applied after soldering is complete and the project has been thoroughly cleaned. Regardless of the finish, protect solder seams and lead came from oxidization and tarnish, with a thin coating of finishing wax.

Applying Patina

- Work in a well-ventilated area when applying patina and cover work surfaces with several layers of newspaper. Always wear safety glasses and a work apron.
- If the project sits overnight or you have decided at a later date to apply patina, remove any oxidization

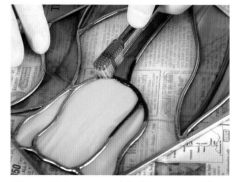

Turn solder seams black or copper by applying appropriate patina

by rubbing fine steel wool (000) across the metal surface. By rubbing across, not lengthwise, any cooling lines in the solder seam or joint will become less visible and give the appearance of a smoother seam.

- Use a soft cloth to brush off any traces of steel wool onto the newspaper. Discard the top layer of newspaper.
- Pour a small amount of patina into a smaller container. This will prevent the risk of contamination to the unused patina in the original container. Apply the patina to the solder seams or lead came with an old toothbrush, cotton swabs, or soft disposable cloth and rub gently until you achieve an even finish. Try not to get patina on the glass. Due to metal oxides present in stained glass, some glasses may incur a slight, rainbow-like hazing where the patina contacts glass surfaces.
- Clean the project thoroughly with warm, running water and a neutralizing solution. Dry with a soft cloth.
- Dispose of newspaper, any leftover patina that was poured into the smaller container and any cotton swabs or cloths used to apply the patina. If a toothbrush was used, rinse it in clean, soapy water.

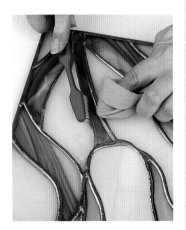

Applying Finishing Compound or Wax

Protect lead came and solder seams and help prevent oxidization by applying stained glass finishing compound or a quality car wax.

- Place a small amount of the liquid wax on a soft cloth and apply a thin layer over the solder seams or lead came. Avoid getting wax on heavily textured glass because it may be difficult to remove.
- Allow the wax to dry to a hazy, powdery consistency. Buff with a dry, lint-free cloth until the metal is shiny and excess wax has been removed from the project surface.
- Use an old toothbrush or a soft bristled brush to remove excess wax along lead came edges, solder seams, and textured glass surfaces.

Maintaining the Finished Project

All stained glass garden projects featured in this book are designed for display in the garden or home. Store your projects indoors during periods of extreme weather. Inclement weather conditions, such as freezing and thawing, snow, hail, and high winds, have the potential to break or crack glass pieces. Normal rainfall and warmer temperatures should not affect your project.

Before placing a treasured glass piece back in the garden, check for any damage and repair if necessary. Give the project a thorough cleaning with ammonia-free commercial window cleaner and a soft, dry cloth. If metal surfaces have been treated with patina, they can be touched up if the patina is worn or scraped off. Tarnished solder seams and lead cames can be waxed and polished again to provide a protective buffer against the elements.

Note

If you did not complete soldering and will not be returning to it that day, it is advisable to wipe away any flux present on the project surface. Use a damp cloth and a small amount of neutralizing solution to remove as much of the flux as possible.

Helpful Hints
- Some patinas may be applied immediately after soldering, without removing the flux residue first. Check the bottle for instructions before starting.
- Because the black or copper color is the result of a chemical reaction with the metal surface of the solder seam or lead came, the patina may be removed if you are not happy with the outcome by rubbing with fine steel wool (000).
- An even, shiny finish can sometimes be difficult to achieve when using copper patina. Copper patina may react to or be neutralized by minerals present in the local water supply. Use distilled water to clean and rinse projects when copper patina is used. Apply a liberal coating of finishing wax and buff the seams vigorously to attain that shiny, copper look.

Copper Foil Construction

Materials

2 copies of pattern
Newspaper
Wood board and trim
Masking tape
Glass for project
Glass cutter oil
Copper foil
Safety flux
60/40 solder
Neutralizing solution
Patina
Wax or finishing compound

Tools

Apron
Safety glasses
Utility knife or scissors
Permanent waterproof fine-
tipped marker
Cork-backed straightedge
Glass cutter
Running pliers
Breaking/combination pliers
Glass grinder
Lathekin or fid
Hammer and nails
Soldering iron and stand
Natural fiber sponge
Cotton swabs
Rubber or latex gloves
Fine steel wool (000)
Toothbrush
Polishing cloths

Assemble stained glass projects constructed with the copper foil technique in the following:
- Draw the pattern to the correct scale and make 2 or 3 accurate copies.
- Cut the pieces of art glass and grind to fit the pattern.
- Wrap the edges of each glass piece with copper foil.
- Arrange glass pieces on pattern, creating a copper foil seam between adjacent pieces.
- Apply molten solder to the copper foil seam, forming a supportive structure that joins the glass pieces together and holds them in place.
- Finish the project by applying patina, cleansing with neutralizing solution, and polishing with protective wax compound.

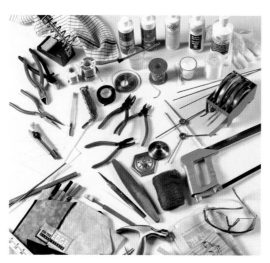
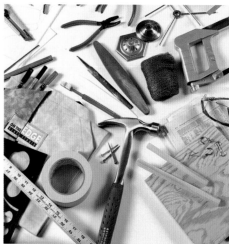

Materials and Tools
The basic materials and tools required for constructing a stained glass project using the *Copper Foil Construction* technique are listed in the side bar at left. Additional listings will be given for those projects with specific requirements.

How-To Techniques
Getting Started
Refer to **Basic Techniques** (pp14 to 21) for specific information given for preparing the pattern and making copies, cutting the glass pieces, and smoothing or grinding glass edges to fit the pieces to the pattern. Two important points to remember when making stained glass projects using the copper foil construction method are the following:
- The pattern lines should be $1/32$ in wide to allow enough space between each glass piece for the application of the copper foil. Use a permanent waterproof fine-tipped marker to trace over the pattern lines.
- Cut each glass piece along the **inside** of the pattern line. Less grinding will be necessary to fit the pieces to the pattern and room will be left between each piece to accommodate the copper foil.

Making a Jig

Keeping a project's shape true to the pattern outline can sometimes present a challenge. By making a jig, glass pieces can be accurately fitted together during the grinding and soldering stages. Jigs are especially helpful when constructing 3-dimensional projects composed of multiple panels that need to be the same size and shape. Assembly will be easier if each panel is accurately fitted together and your project will have a more professional look. To make a jig

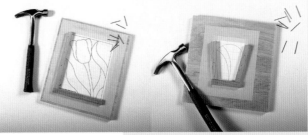

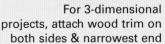

1 Use masking tape to secure a copy of the pattern to a wood board that is at least 2 in wider (on each side) than the pattern. Do not tape over the pattern outline.

2 Align a length of wood trim along one edge of the pattern and nail into place. The trim should just cover the pattern line.

3 Attach wood trim to 2 or more sides of the pattern. When assembling a 3-dimensional project such as a patio lantern, trim is usually nailed along both sides and narrowest end of each panel in the project. The widest end is left open for easy removal from the jig.

For panels, attach wood trim along one side & one end of pattern

For 3-dimensional projects, attach wood trim on both sides & narrowest end

Applying Copper Foil

The copper foil construction method entails wrapping the edges of glass pieces with a thin, adhesive-backed copper foil tape. Copper foil is usually available in 36 yard rolls and in various widths – $1/8$ in to $1/2$ in. The widths most commonly used are $3/16$ in, $7/32$ in, and $1/4$ in. Copper foil can also be obtained in 12 in by 12 in sheets and is used for the overlay technique demonstrated in **SUMMER BREEZE** Candle Lantern (p61). For most projects in this section, $7/32$ in copper foil is required. When a piece of glass varies in thickness along edge to be foiled, use a wider copper foil and trim it evenly with a utility knife.

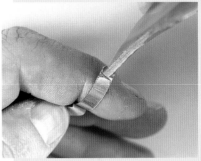

Start foil on a corner of glass piece that will be positioned towards center of panel

1 Rinse each glass piece under running water and dry thoroughly to remove cutter oil or powdery residue from grinding. Clean edges will help secure copper foil to glass pieces.

2 Choose the backing and width of foil best suited for the project. When glass is translucent and the underside of the copper foil will be visible, use a copper foil with the appropriate color of adhesive. Use regular foil (copper-backed) if seams are to be treated with copper patina, black-backed foil for black seams, and silver-backed foil for seams that are to be left silver. If you are not yet certain what color the seams of your finished project will be, use black-backed copper foil. It will have the appearance of a shadow and is quite unnoticeable regardless of the color of the seams.

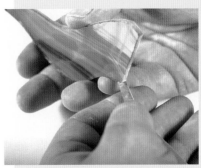

Glass should be centered on foil with equal amounts of foil showing on either side

3 Position the roll of copper foil in front of you and have glass pieces to be wrapped close at hand. Peel 2 in to 3 in of the paper backing away from the end of the copper foil and lightly grasp the backing between your thumb and index finger. Drape exposed foil over the remaining fingers with adhesive-covered side facing upward.

4 Hold glass piece in your writing hand, perpendicular to work surface. Foiling should be started at a corner of the glass piece that will be positioned towards the center of the project. Center the edge of the glass on the foil, leaving an equal amount of foil showing on either side of the piece. Fold edges of foil over and press firmly to the glass.

5 Continue wrapping the copper foil around the remaining glass edges. Press the foil onto the piece by sliding the middle and ring fingers of your opposite hand along the bottom edge of the glass. Let the foil slide through the thumb and index finger, automatically peeling the backing away from the foil. You should have a clear view of both sides of the

Rotate each piece as each edge is wrapped until entire piece is foiled

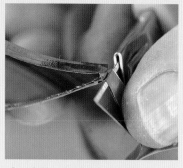

Cut foil with utility knife, overlapping starting edge ¼ in

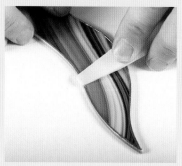

Crimp & burnish edge of foil onto glass surface

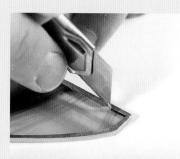

Trim excess & overlapping foil edges with utility knife

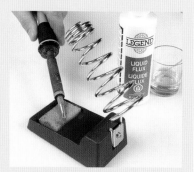

Frequently wipe iron tip on water-moistened sponge to remove flux residue & cool iron tip

glass as the foil is being applied. Rotate the piece as each edge is wrapped with foil, making sure to keep it centered. Wrap the entire glass piece.

6 Cut the foil with a utility knife or scissors, overlapping starting edge approximately ¼ in. **Crimp** (fold and press) the edge of the foil onto the glass surface, using a lathekin or fid. Take care to crimp foil neatly at the corners of the glass piece so that it is not bulky. Neatly crimped foil will ensure that glass pieces fit accurately on the pattern and will make soldering easier and more attractive.

7 **Burnish** (press and rub) the foil firmly to the edges and the surface along the perimeter of the glass piece. This will ensure proper adhesion to the glass when the heated soldering iron is applied to the copper foil seam during the soldering stage.

8 Trim excess and overlapping foil edges with a utility knife. Apply only enough pressure to cut the copper foil, as you do not want to score the glass surface with the knife blade.

 Helpful Hints

- An assortment of household objects can be used to burnish copper foil to the glass surface. Popsicle sticks, orange peelers, pens and pencils, and shorter lengths of wood dowel, are just a few of the many items that can be put into service.
- Copper foil may tear when foiling a tight inside curve. To prevent tearing, don't crimp the foil over the glass edge. Instead, slowly burnish the foil with the lathekin while pressing it over the edge and onto the glass surface. The friction created while burnishing the foil will cause it to soften slightly, become more pliable, and reduce the risk of tearing the copper foil.

Soldering the Project

Use a 100 watt soldering iron with a built-in temperature control and a chisel-style tip to solder copper foil projects. Solder in a well-ventilated area and on a level work surface covered with newspaper and remember to wear safety glasses and a work apron. Always rest the soldering iron in a metal stand, never on the work surface. Review **Safety Practices and Equipment** (p13) before starting.

1 Plug the soldering iron in. Moisten a natural fiber sponge with water and place in the holder on the soldering iron stand. Clean the iron tip at regular intervals by wiping the tip on the moistened sponge, removing flux residue.

2 Assemble the copper foiled pieces on the project pattern while the soldering iron is heating up. Whenever possible, use a jig for assembling your project accurately.

3 To solder, you will require a spool of 60/40 solder and a safety flux. Pour a small amount of the flux in a separate container and replace the cap on the flux bottle to prevent spills.

4 **Tack solder** the glass pieces together. Use a cotton swab or a small brush to dab flux onto the copper foil at a point where at least 2 pieces meet. Unwind several inches of the solder wire from the spool. Grasp the soldering iron handle like a hammer, in your writing hand. Holding the hot iron tip close to the fluxed copper foil, melt a small amount of solder onto the tip. Place the iron tip on the copper foil and hold only long enough for the solder to melt onto the foil, **tacking** (joining) the pieces together.

5 Flux and tack solder all the pieces together, making sure to tack wherever 2 or more pieces join. Tack each piece in several spots so it will not move out of position when the entire seam is being soldered. At regular intervals, wipe the tip of the soldering iron on the moistened sponge to remove flux residue.

6 **Tinning** Once all the pieces have been tacked together, exposed copper foil must be coated with a thin, flat layer of solder. First apply flux along entire length of a foiled seam. Holding soldering iron in your writing hand, place the flat side of iron tip on fluxed copper foil and grasping spool of solder in the other hand, place the end of the solder on tip. As solder melts, pull the tip along the seam, leaving a thin coating of solder over foil. **Tin** each foiled seam and fill in any gaps between the stained glass pieces with solder. This initial layer of solder makes soldering a finishing bead on the seam much easier.

7 **Bead soldering** gives seams a rounded and even finish and provides the necessary support structure to keep glass pieces in place. Reapply flux along one seam. Place the narrower side of the iron tip onto one end of seam (the flat side of the tip will now be in a vertical position), keeping tip in contact with seam at all times. Holding the solder to the tip, slowly draw the iron along the length of seam allowing solder to build up only enough to create a slightly raised, half-round seam. When solder begins to build up more than necessary, pull the strand of solder away from iron tip. Draw tip along the seam until molten solder levels out more evenly. It will take a bit of practice to determine how quickly to move the iron and how much solder to apply. Because glass can crack if it is heated too much, don't go over a solder seam too many times. If you are not happy with the appearance of a seam, allow area to cool while you solder another seam. Return to the seam once it has cooled, apply flux, and reheat the seam with the iron tip. Only apply more solder if seam appears to be too flat. Flux and bead solder remaining seams.

8 Allow the solder seams to cool for a few minutes before turning the project over. Tin and bead solder each seam on the reverse side, as described in the steps above.

9 Finish outside edges of a project that will not have a lead or zinc came border by fluxing and tinning all exposed copper foil on both sides. Holding project in a vertical position, bead edge by applying a small amount of solder and then lifting the iron off the foil long enough for it to cool before adding more. Use a touch-and-lift motion rather than drawing the iron along the edge. This will prevent copper foil from becoming too hot and lifting off the edges of the glass. Proceed around outside perimeter of project. Rotate piece as required to keep the edge being beaded level. If not kept level, gravity will cause the solder to flow away from area you are beading. Various methods of finishing the outside edges of projects will be demonstrated throughout the book.

10 Remove all flux residue to eliminate oxidization and tarnishing of solder seams once you have completed soldering (see **Cleaning the Project**, p22).

Some Tips for Soldering

Achieving beautiful solder seams can sometimes seem like an exercise in frustration, but once mastered, soldering is not difficult. Here are the most common problems encountered when soldering and helpful hints to avoid or overcome them.

Solder is not bonding to the copper foil

- Omitting to apply flux to the copper foil is the most common reason why molten solder does not bond. Apply flux and try again.
- The iron tip must be hot enough and in contact with the foiled and fluxed seam. For the solder to flow and adhere to the foil properly, both the solder and the foil must be heated.
- If you have already been soldering on this seam, the flux has probably evaporated. Apply flux and try again.

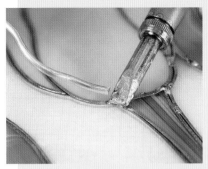

Tack solder pieces together at several locations to prevent pieces from moving out of position while soldering

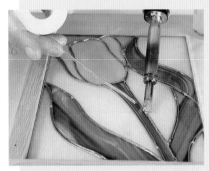

Apply a thin layer of solder (tinning) over all foiled seams before bead soldering

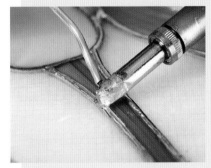

Bead soldering gives seams an even, rounded appearance & provides the support structure for a copper foil project

Note
If you did not complete soldering and are finished for that day, remove as much flux as possible with a damp cloth and a small amount of neutralizing solution.

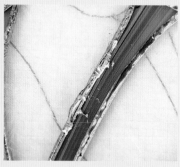

Solder is not bonding to copper foil

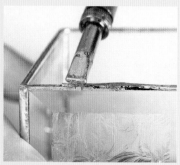

Copper foil is lifting from glass surface while soldering

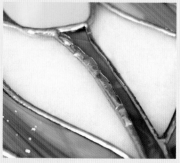

Solder seam has too much solder

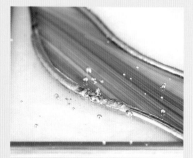

Too much flux will cause solder to bubble & spatter

- Surface of the copper foil will appear dull if a layer of oxidization is present. Remove oxidization by gently rubbing fine steel wool (000) lengthwise along the foil until the seam is shiny again. Apply flux and try soldering again.

Solder melts through the seams

- The soldering tip is too hot, has been held too long in one place, or the seam has been soldered too many times without allowing to cool. Solder in another area of the project until the seam cools and try again.

Melt-through is occurring due to large gaps between glass pieces

- Cut glass pieces accurately to fit the pattern. Large gaps between pieces can be responsible for melt-throughs, especially in 3-dimensional projects.
- Melt-throughs on 3-dimensional projects can often be avoided by tinning seams with 50/50 solder, allowing the seams to cool, and then bead soldering with 60/40 solder. 50/50 solder melts at a higher temperature so melt-throughs will not occur as often if it is used as a base when beading.
- Place masking tape on the underside of a gap to prevent molten solder from falling through before it cools.

Copper foil is lifting from the glass surface during the soldering stage

- Refrain from drawing the soldering iron tip over a seam too many times without letting the seam cool occasionally. Copper foil is very thin and is an excellent heat conductor so applying too much heat to the copper foil can cause it to lift away from the glass surface and towards the heat source – the soldering iron tip. The adhesive may become soft and runny, losing its grip on the glass edge.
- Verify that adhesive backing on the copper foil has not dried out and lost its tackiness before foiling the glass pieces.
- Clean glass pieces thoroughly before applying foil to remove all traces of cutter oil and grinding residue.
- When foiling glass pieces, start and end the foil on an edge that will not be on the perimeter of a project. The position where the foil overlaps should be on an inside seam.
- Burnish the foil tightly to the glass. Rub the foil against the glass surface several times with a lathekin or fid, using a back-and-forth motion.

Solder seams are uneven and have peaks and valleys

- Apply flux and touch up the seam with the soldering iron. Hold the tip on the solder seam long enough to start melting. Lift the tip up and repeat the melt-and-lift motion along the seam, smoothing it out. Add solder, if required.

Solder seams have too much solder

- Remove excess solder by melting the solder with the iron and then quickly dragging the iron tip across the seam, pulling excess molten solder with it. Immediately, remove the excess solder from the iron tip by wiping it on a water-moistened sponge.

Molten solder and flux are bubbling and splattering while soldering the seam

- Use a safety flux formulated for stained glass work and use it sparingly along the foiled seams. You may have applied too much flux. The application of the hot iron tip and molten solder to a foiled seam can cause excessive amounts of liquid flux to boil and sputter before evaporating. Small solder balls are formed and sprayed about as the solder contacts the bubbling flux and may burn exposed skin. The solder seams may appear rough and unsightly.

Small pits are present in the solder seam

- Soldering over a seam repeatedly can overheat the copper foil adhesive causing it to ooze up from between the foil and glass. Traces of adhesive become trapped in the solder, creating small air bubbles in the seam. Let the solder cool slightly and use a cotton swab or paper towel to wipe the adhesive away. Reapply flux and smooth out the solder seam with iron tip.

- Use flux sparingly. Applying too much flux while soldering can also cause a pitted surface on a solder seam.

Solder is not flowing properly, resulting in uneven solder seams

- Apply flux to each foiled seam before attempting to solder. If you have soldered over a seam more than once, the flux may have evaporated. Reapply flux and try again.
- The tip of the iron may be dirty. Clean iron tip regularly on a natural fiber sponge moistened with water, to remove flux residue. If spots are present on the iron tip even after it has been wiped on the sponge, use a tip-tinning compound to re-coat the tip.
- The iron tip may not be hot enough to melt the solder or it may be too hot causing the solder to melt through the seams. Depending on type of soldering iron, the temperature may be adjusted by turning the temperature controller up or down, or by replacing the tip.

Replacing Cracked or Broken Glass Pieces in Copper Foil Projects

Sooner or later, every stained glass craftsperson has to replace a cracked or broken piece of glass. Here's how:

1 Remove the broken piece using method A or B.

Method A

- Apply a hot soldering iron tip to the solder seams surrounding the broken piece. As the solder becomes molten, draw the iron tip across the solder seam, pulling the solder off the seam with the iron tip. Wipe the excess solder off the tip and onto the water-moistened sponge used for cleaning the tip. Repeat until the solder seam is flat. Turn the project over and proceed to do the same to the appropriate solder seams on the reverse side.
- Cut a strip of aluminum from an empty soda can and wrap one end with masking tape. Hold the taped end to prevent burns or cuts from exposed metal edges.
- Apply the hot iron tip to the seam and try to wedge the aluminum strip between the broken piece and the one beside it, separating the solder between the 2 pieces. Once the aluminum strip has been pushed through the seam to the opposite side of the project, pull it along the perimeter of the piece, heating the seams with the iron tip as you go.
- When all the solder seams around the broken piece have been separated, carefully remove the piece from the project. Proceed with caution as the broken piece and surrounding glass will be quite hot.

Method B

- Use a glass cutter to make a number of scores on the broken piece of glass in a crosshatch pattern.
- On the underside of the glass, tap along the score lines with the end of the cutter, being careful not to crack the glass pieces next to it.
- When the scores begin to "run" and break into small pieces, remove the fragments with a pair of pliers.

2 Run the hot iron tip around the edges of the entire opening, smoothing away excess solder and pulling out any foil left behind from the broken piece with a pair of pliers.

3 Place a piece of paper beneath the opening and trace the outline of the empty space. Cut the shape out using scissors or a utility knife, remembering to cut along the inside of the pattern line.

4 Trace (p15) pattern onto a new piece of glass. Cut (pp15-20) and grind (p21) the new glass piece to fit into the opening. Wrap with appropriate copper foil and burnish (p26).

5 Position the replacement piece in the opening and tack solder (p26) into place. Continue by tinning (p27) and then bead soldering (p27) on both sides of the project.

6 Apply patina (pp22 & 23) to match the finish of the rest of the project, if required. Clean the project (p22) and apply a finishing compound or wax (p23).

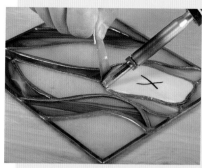

Heat solder seam & wedge aluminum strip between broken glass piece & one beside it

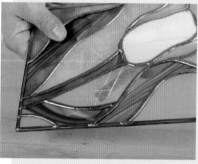

Score broken glass piece in crosshatch pattern & tap along score lines with end of cutter

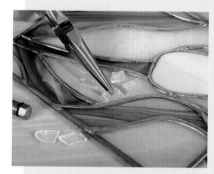

Remove glass fragments with pliers

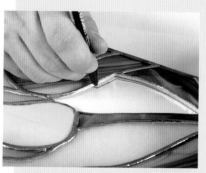

Trace outline of opening onto paper for use as a template

Copper Foil
Projects & Patterns

Spring Tulip
Window Panel

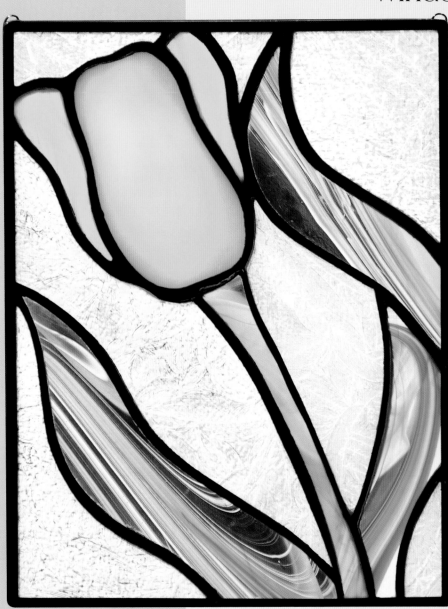

Dimensions 7 in wide X 9 in high
No. Of Pieces 14
Glass Required
 A 5 in X 5 in yellow & white wispy
 B 1 in X 6 in green & white wispy
 C 6 in X 8 in green, white, & clear
 D 7 in X 9 in translucent white glue chip

Letters identify type of glass used on pattern
(p32).The quantity of glass listed is a close
approximation of the amount needed for the
pattern. You may wish to purchase more
glass to allow for matching textures and
grain.

Instructions

1 Make 2 copies (p14) of the pattern on p32. Use one copy as a guide to cut the glass pieces to the required shape and size. Use the second copy to fit and solder the panel together. If opalescent glass is used in this project, make a third copy and cut out the necessary pattern pieces for use as tracing templates.

2 Use the marker to trace (p15) each pattern piece on the glass to be cut.

3 Cut (pp15-20) each piece of glass required, making sure to cut **inside** the marker line. Use the cork-backed straightedge to assist in scoring straight lines (p17).

4 Make a jig (p25) to fit the glass pieces accurately and keep the panel square. Use the small square to verify that the 2 side trim pieces are attached at a 90° angle to one another.

5 As required, grind (p21) each piece of glass to fit the pattern. Leave just enough space between pieces so that the pattern line is visible between each piece ($^1/_{32}$ in width for copper foil projects). Rinse each piece under clean running water to remove any grinding residue and dry with a clean cloth.

6 Choose the width of copper foil appropriate for the thickness of the glass ($^7/_{32}$ in is most common). Wrap each glass piece with copper foil, crimp, and burnish down the edges (pp25 & 26).

7 Center foiled glass pieces within the outlines of the pattern shapes in the jig. Make sure pieces along the perimeter of the panel also align with one another along the outside pattern line.

8 Tack solder (p26) the pieces together

9 Tin (p27) all exposed copper foil on the interior seams. Solder no closer than $^1/_4$ in to the outside edge to allow space to fit the zinc came border pieces onto the perimeter of the panel.

10 Bead solder (p27) the seams of the panel. Achieving a half-round raised seam will strengthen the panel and finish its appearance.

11 Allow the solder seams to cool to room temperature. Carefully turn the panel over and repeat steps 9 and 10. Because a stained glass panel can be viewed from either side, strive for even, rounded seams on both sides.

12 Use wire cutters to cut (pp21 & 22) a length of zinc came for each side of the panel. Use the pattern as a guide for the length required for each side. Cut each end of the 4 zinc came lengths at a 45° angle.

13 Fit the zinc came pieces onto the edges of the panel. If the glass is thicker than the came channel, use the lathekin to widen the channel (see photo on p80).

14 Place the panel in the jig. With a hammer, fasten horseshoe nails along the perimeter of the 2 edges of the panel that are not enclosed by the jig. This will hold the zinc came pieces in place until they are soldered securely to the panel.

15 Solder the zinc cames in place at each point that the came meets a solder seam on the panel and at each of the 4 corners. Repeat on the opposite side of the panel.

16 To make the hanging loops for a small panel, wrap the tinned wire around a small cylindrical object (dowel or pencil) several times to form a coil. Slide the coil off and cut individual loops off the coil, using the wire cutters.

17 Attach a hanging loop to each of the 2 top corners of the panel. Grip an edge of the loop in the jaws of the needlenose pliers and position the loop at the point where 2 pieces of zinc came meet. Apply a dab of flux to the came and the exposed edge of the loop and solder securely in place. The loop should be firmly attached to both the top and the side pieces of zinc came.

Additional Materials & Tools Required

Materials
- Silver-backed copper foil
- 1 length of $^1/_8$ in zinc U-channel came
- 18- to 20-gauge tinned copper wire
- Cup hook screws
- Monofilament line (fishing line)

Tools
- Small square
- Wire cutters
- Horseshoe nails
- Needlenose pliers

Note
Quantities of cames listed are based on a 6 ft length.

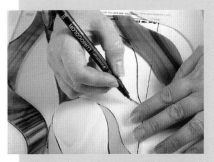

Grind glass pieces to fit pattern. Pattern line should be visible between each piece

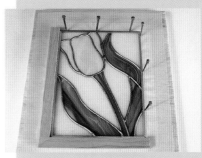

Hold border cames in position with horseshoe nails until soldered

18 Allow the solder joints to cool to room temperature, clean (p22) the panel with neutralizing solution and warm, running water.

19 Apply finishing compound or wax (p23) to the solder seams and the zinc came border.

20 Use heavy monofilament line to hang the panel. Screw the cup hooks into the window frame and hang the panel.

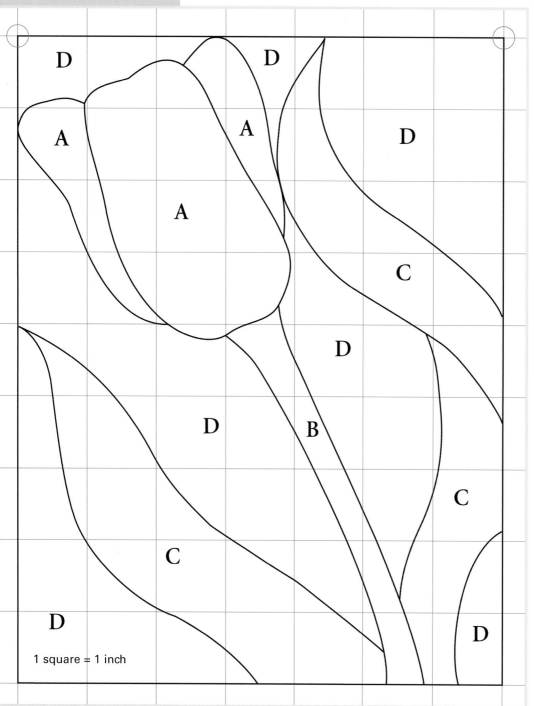

1 square = 1 inch

Coil wire around pencil & cut to make hanging loops

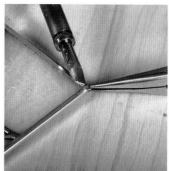

Solder zinc cames in place at each of 4 corners. Solder loops securely to top & side border cames

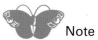 Note

Because exposure to the sun's UV rays can damage the monofilament, check it occasionally and replace as needed.

Sparkling Butterfly
Window Panel

Dimensions	10¹/₄ in wide X 6¹/₂ in high	
No. Of Pieces	16	
Glass Required	A	6 in X 8 in yellow, orange, & white ring mottle with green highlights
	B	4 in X 4 in orange & white wispy
	C	9 in X 4 in clear with green fractures & streamers
	D	1 – 20mm X 45mm orange oval faceted jewel
	E	2 – 24mm clear circular faceted jewels

Letters identify type of glass used on pattern (p35). The quantity of glass listed is a close approximation of the amount needed for the pattern. You may wish to purchase more glass to allow for matching textures and grain.

Materials

- Black-backed copper foil
- 1 length of $1/8$ in zinc U-channel came
- 14-gauge tinned copper wire
- Black patina
- Cup hook screws
- Monofilament line (fishing line)

Tools

- Wire cutters
- Needlenose pliers
- Horseshoe nails or pushpins

 Note

Quantities of cames listed are based on a 6 ft length.

Fit zinc came pieces onto edges of panel

Instructions

This window panel is constructed by using the same basic guidelines given for the SPRING TULIP Window Panel (pp31 & 32).

Assembling the Panel

1. Tape a copy of the pattern to a wood board or level work surface that is several inches larger than the pattern perimeter.

2. Cut (pp15-20), grind (p21) to fit, and foil (pp25 & 26) each piece of glass required for the panel.

3. Assemble the foiled glass pieces on the pattern, verifying the pieces align properly and fit within the pattern outlines. A jig cannot be used to assemble the panel due to its irregular contour. Horseshoe nails or pushpins can be fastened along the perimeter of the pattern to help the glass pieces retain the outline of the panel.

4. Tack, tin, and bead solder (pp26 & 27) both sides of the panel. An allowance must be left for the zinc U-channel came that is to be fitted and soldered to the straight sides of the panel. Do not solder any closer than $1/4$ in from these outside edges.

Finishing the Outside Edges of the Panel

5. Use wire cutters to cut (pp21 & 22) a length of zinc came for the bottom edge and 2 straight sections on the sides of the panel. Use the pattern as a guide for the length required for each piece. Cut both ends of the bottom piece and 1 end of the side pieces of came at a 45° angle. Trim the other end of the side pieces at an angle to correspond with the adjoining solder seams.

6. Fit the zinc came pieces onto the edges of the panel. If the glass is thicker than the came channel, use the lathekin to widen the channel (see photo on p80).

7. Solder the zinc cames in place at each point that the came meets a solder seam and at the 2 corners where the bottom and sides pieces meet. Repeat on the opposite side of the panel.

8. Tin and then solder a finishing bead (p27) along the remaining outside edges of the panel. Because the edges are not straight and level, rotate the panel slowly as you apply small beads of solder in a touch-and-lift motion. Try to keep the area that is being soldered as level as possible so that the molten solder does not roll away. Allow the solder to cool and solidify for a few seconds before adding the next bead of solder.

Attaching the Butterfly Antennae

9. Shape and cut 2 pieces of tinned wire to form the butterfly antennae as indicated on the pattern. Use needlenose pliers to hold the wire antennae as you tack and bead solder them in position to the outside edges.

10. Securely solder hanging loops (pp31 & 32) to the panel at the point the 2 straight side lengths of zinc came meet the underside of the butterfly wings.

11. Clean (p22), apply patina (pp22 & 23) and finishing compound or wax (p23).

12. Use heavy monofilament line to hang the panel. Screw the cup hooks into the window frame and hang the panel.

Note Because exposure to the sun's UV rays can damage the monofilament, check it occasionally and replace as needed.

Helpful Hints

- Place masking tape on the underside of faceted jewels to prevent scratches.
- If faceted jewels are not obtainable in the sizes indicated, adjust the pattern to accommodate the sizes of jewels available or substitute with complementary art glass or glass nuggets.

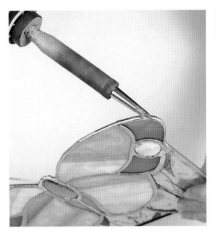

To bead solder irregular edges, rotate panel slowly to keep edge being soldered level

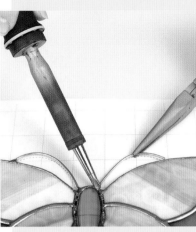

Shape 2 pieces of tinned wire to make butterfly antennae & solder in position

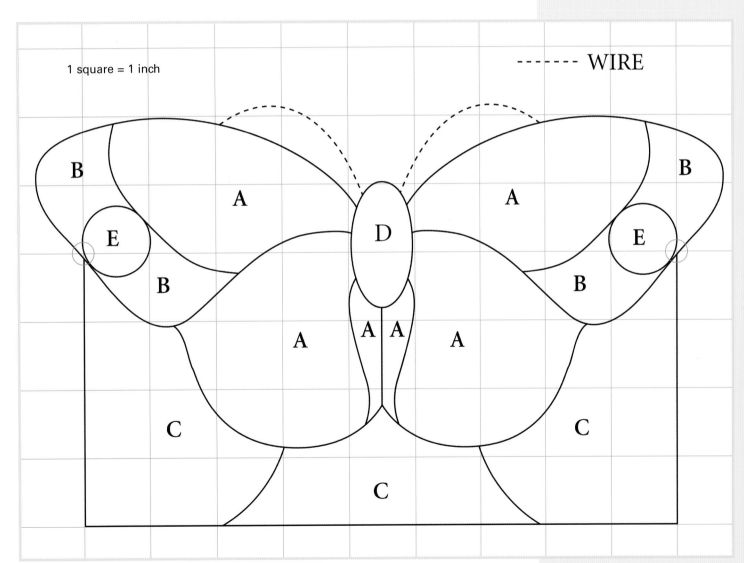

1 square = 1 inch

------ WIRE

Autumn Leaves
Window Panel

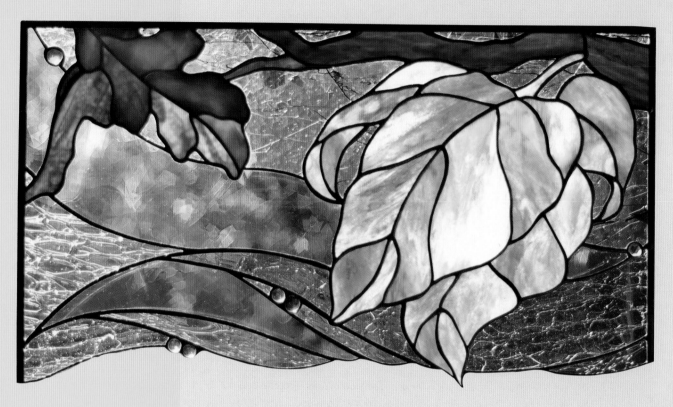

Dimensions	26³/₄ in wide X 14³/₄ in high	
No. Of Pieces	70	
Glass Required	A	15 in X 15 in green, amber, white stipple
	B	9 in X 12 in green, amber, brown, & white ring mottle
	C	6 in X 15 in brown, clear, & white streaky
	D	12 in X 12 in clear with green streamers & green fractures
	E	10 in X 15 in clear semi-antique
	F	10 in X 12 in clear craquel
	G	12 in X 12 in light green craquel
	H	2 iridescent amber glass nuggets (medium)
	J	1 dark green glass nugget (medium)
	K	1 iridescent clear glass nugget (medium)
	L	1 iridescent light green glass nugget (medium)
	M	1 – 15mm clear circular faceted jewel

 Note The letter I is not used in this listing

Letters identify type of glass used on pattern (p38).

The quantity of glass listed is a close approximation of the amount needed for the pattern. You may wish to purchase more glass to allow for matching textures and grain.

Glass pieces D, E, F, K, and M are clear but show background garden foliage in photo.

Instructions

This window panel is constructed using the same basic guidelines given for the SPRING TULIP Window Panel (pp31 & 32).

Assembling the Panel

1 Tape a copy of the pattern to a wood board or level work surface that is several inches larger than the pattern perimeter.

2 Cut (pp15-20), grind (p21) to fit, and foil (pp25 & 26) each piece of glass required for the panel.

3 Make a jig (p25) to fit the glass pieces accurately and keep the panel square. Fasten wood trim along the top and 1 side of the panel pattern. Use the small square to verify that the trim pieces are at a 90° angle to one another.

4 Assemble the foiled glass pieces on the pattern, verifying the pieces align properly and fit within the pattern outlines. Horseshoe nails or pushpins can be fastened along the open side and the irregular contour of the bottom of the panel to help the glass pieces retain the outline of the pattern.

5 Tack, tin, and bead solder (pp26 & 27) the front side of the panel. An allowance must be left for the U-channel zinc came that is to be fitted and soldered to the straight sides of the panel. Do not solder any closer than ¼ in from these outside edges.

Finishing the Outside Edges of the Panel

U-channel zinc came must be attached to the top and sides of the panel before the panel can be turned over and the back side soldered. The zinc came gives the panel additional stability and finishes off the edges of the panel.

6 Use wire cutters or a hacksaw to cut (pp21 & 22) a length of zinc came for the top edge and the 2 sides of the panel. Use the pattern as a guide for the length required for each piece. Cut both ends of the top piece and 1 end of the side pieces of came at a 45° angle. Trim the other end of the side pieces at an angle that corresponds with the pattern outline at the bottom of the panel. Remove any metal burrs from the end of the came pieces with a metal file.

7 Fit the zinc came pieces onto the edges of the panel. If the glass is thicker than the came channel, use the lathekin to widen the channel (see photo on p80).

8 Solder the zinc cames in place at each point the cames meet a solder seam and at the 2 corners where the top and side cames meet. Heat the zinc well with the soldering iron tip to ensure a good bond between the solder and the zinc.

9 Carefully turn the panel over and proceed to tin and bead solder the back of the panel.

10 Tin and then solder a finishing bead (p27) along the irregular bottom edges of the panel. Because the edges are not straight and level, rotate the panel slowly as you apply small beads of solder in a touch-and-lift motion. Keep the area that is being soldered as level as possible so that the molten solder does not roll away. Allow the solder to cool and solidify for a few seconds before adding the next bead of solder. Due to the size of the panel you may wish to ask a friend to help with holding and rotating the panel while you solder the bottom edge.

11 Use 14-gauge tinned copper wire to make hanging loops (pp31 & 32) for the panel. Securely solder the loops (pp31 & 32) to the top 2 corners on the back side of the panel. The loops must be firmly attached to both the top and side pieces of zinc came.

12 Clean (p22), apply patina (pp22 & 23) and finishing compound or wax (p23).

13 Use linked metal chain to hang the panel. Fasten the heavy-duty screw hooks into the window frame and hang the panel.

Additional Materials & Tools Required

Materials
- Black-backed copper foil
- 1 length of ¼ in zinc U-channel came
- 14-gauge tinned copper wire
- Black patina
- Heavy screw hooks
- Linked metal chain

Tools
- Small square
- Wire cutters or hacksaw with a fine-toothed metal cutting blade
- Metal file
- Horseshoe nails or pushpins
- Needlenose pliers

Note

Quantities of cames listed are based on a 6 ft length.

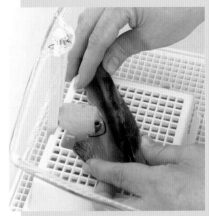

Use a ¼ in grinding bit to grind out tight inside curves

- Use ¼ in drilling/grinding bit to grind out tight inside curves on glass pieces if you are not able to cut the curves by hand.
- Wear leather work gloves while bead soldering the irregular bottom edge of the panel. This will prevent burns should the molten solder roll off the edge of the panel.

Bottom end of zinc side came is cut at an angle that corresponds with the pattern outline at the bottom of the panel

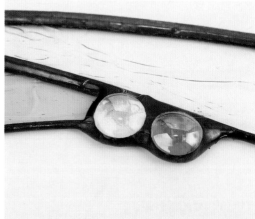

A finishing bead of solder is applied along the irregular bottom edges of the panel

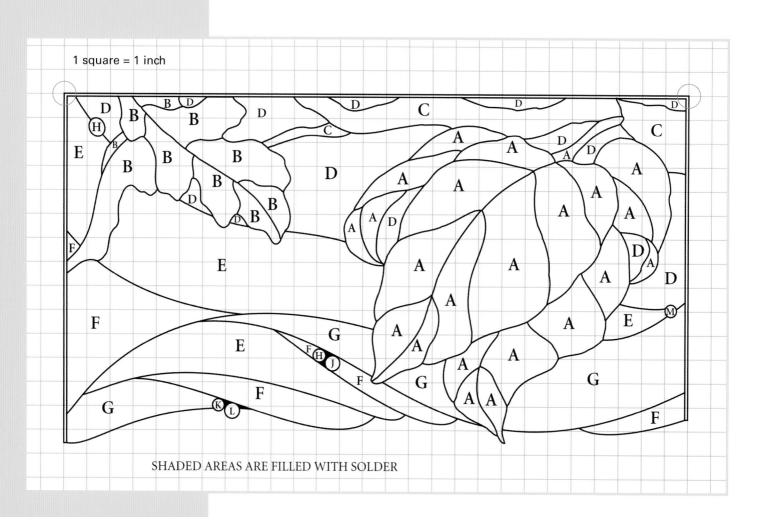

1 square = 1 inch

SHADED AREAS ARE FILLED WITH SOLDER

Butterfly Garden
Window Panel

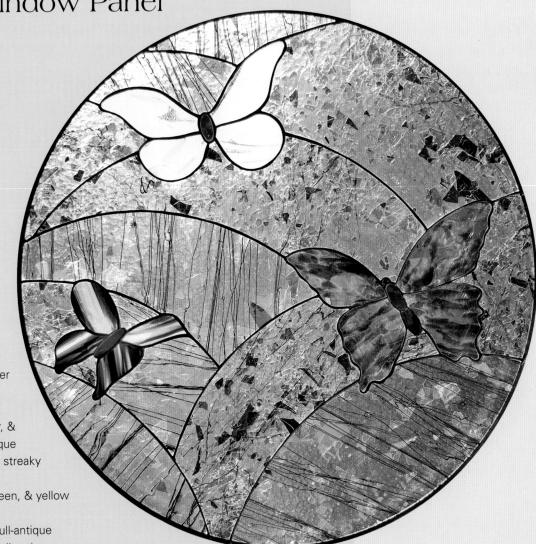

Dimensions 30¼ in diameter
No. Of Pieces 32
Glass Required

A 7 in X 14 in white, clear, &
 orange streaky full-antique

B 9 in X 14 in pink & blue streaky
 full-antique

C 7 in X 9 in red, blue, green, & yellow
 streaky full-antique

D 2 in X 2 in orange red full-antique

E 3 in X 3 in cobalt blue full-antique

F 2 in X 3 in crimson red full-antique

G 8 sq feet clear with pink & green fractures & black streamers **and/or** clear with pink &
 green fractures & green streamers

Letters identify type of glass used on pattern (p41). The quantity of glass listed is a close
approximation of the amount needed for the pattern. You may wish to purchase more glass to
allow for matching textures and grain.

Glass pieces G have a clear base but show background garden foliage in photo.

Materials

- Black-backed copper foil
- 2 lengths of $\frac{1}{4}$ in zinc U-channel came
- 14-gauge tinned copper wire
- Black patina
- Heavy-duty screw hooks
- Linked metal chain

Tools

- Compass
- Metal came bender (optional)
- Wire cutters or hacksaw with a fine-toothed metal cutting blade
- Metal file
- Horseshoe nails or pushpins
- Needlenose pliers

Note

Quantities of cames listed are based on a 6 ft length.

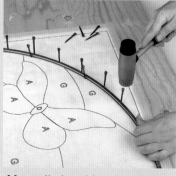

Manually bend border cames into circular shape and hold in place with horseshoe nails

Instructions

This window panel is constructed by using the same basic guidelines given for the SPRING TULIP Window Panel (pp31 & 32).

Assembling the Panel

1 Tape a copy of the pattern to a wood board or level work surface that is several inches larger than the pattern perimeter.
2 Cut (pp15-20), grind (p21) to fit, and foil (pp25 & 26) each piece of glass required for the panel.
3 Assemble the foiled glass pieces on the pattern, verifying the pieces align properly and fit within the pattern outlines. Horseshoe nails or pushpins can be fastened along the perimeter of the pattern to help the glass pieces retain the circular shape of the panel.
4 Tack, tin, and bead solder (pp26 & 27) the panel together. Do not solder any closer than $\frac{1}{4}$ in from the outside edge of the panel. An allowance must be left for the U-channel zinc came that is to be fitted and soldered around the panel perimeter.

Forming U-channel Zinc Came to Fit a Circular Panel

Before turning the panel over and soldering the other side, the U-channel zinc came must be formed and then fitted and soldered to the panel to give support and strength while holding the pieces together. The came must be bent before fitting it onto the circular panel edges. A metal came bender has a set of wheels that the came is fed into. The came is repeatedly turned back and forth between the wheels until the desired size of circle is formed without causing kinks in the metal. Most stained glass studios will bend zinc came upon request, or you can do it manually.

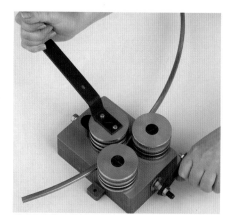

Came is shaped using a metal came bender

- Using a pattern copy as a guide, hammer horseshoe nails securely into a wood project board or work surface around the perimeter of the pattern outline. Position the nails approximately 3 in apart with the flat side of the nail adjacent to the outline.
- Place a length of the zinc came along the outer edges of the nails with the channel facing towards the center of the pattern.
- Begin shaping came by fastening horseshoe nails around outside edge of came. Start in the middle of the came length and work your way around the panel outline on either side. To hold the came in place and to retain the circular shape, hammer in nails opposite to the ones along the inside perimeter. Due to the panel size, form 2 lengths of came.

5 Fit and solder zinc came to the perimeter before turning the panel over. Came ends may not have been curved enough to fit the panel. Trim one end using wire cutters or a hacksaw (pp21 & 22). Remove metal burrs from cut end with a small metal file.
6 Fit the zinc came around the panel, aligning the trimmed end with a solder seam that intersects with an upper edge of the panel.
7 Mark the other end of the zinc came where it intersects with the closest adjacent solder seam and cut the excess away.
8 To complete zinc came border, mark and cut second length of bent came. Cut ends of two cames evenly to ensure they butt together tightly and fit snugly to glass panel.
9 Secure the zinc came in place by fastening horseshoe nails around the panel perimeter.

10 Solder the zinc came in place at the points where the ends meet and at each location that a solder seam intersects with the edge of the panel. Heat the zinc well with the soldering iron tip to ensure a good bond between the solder and the zinc.

11 Turn the panel over. A panel of this size may be fragile and a bit flexible at this stage. To prevent breakage

- If you are working on a wood board, position the edge of the board flush with the edge of the work surface. Make sure all surfaces are free of any debris (glass fragments and solder balls) and that a towel or newspaper covers the edge.

- While supporting the panel on either side, carefully pull it towards you until it is suspended halfway over the edge of the work surface.

- Gripping the panel at the top and bottom edges, quickly flip the panel into a vertical position using the covered edge of the work surface as a leverage point.

- While panel is in vertical position, turn it so front side is facing away from you.

- Position the panel so that middle is level with the edge of the work surface and quickly (but carefully) flip it back onto the work surface.

12 Tin and bead solder the seams on the back of the panel. Solder the zinc came to the solder seams at each intersecting point.

Bead solder hanging loops to
zinc came & solder seams

Attaching the Hanging Loops

The size and weight of this panel require that hanging loops, made from 14-gauge tinned copper wire, are secured to both the zinc came and the solder seams. Attaching the loops to only the came will result in the came being pulled away from the edges of the panel.

13 Wrap 14-gauge tinned copper wire several times around a piece of dowel to form a coil. Slide the coil off and use wire cutters to cut individual loops off the coil.

14 On back side of panel solder hanging loops to panel as indicated on pattern. Loops must be soldered securely to abutting solder seams and zinc came.

15 Clean (p22), apply patina (pp22 & 23) and finishing compound or wax (p23).

16 Use linked metal chain to hang the panel. Fasten the heavy-duty screw hooks into the window frame and hang the panel.

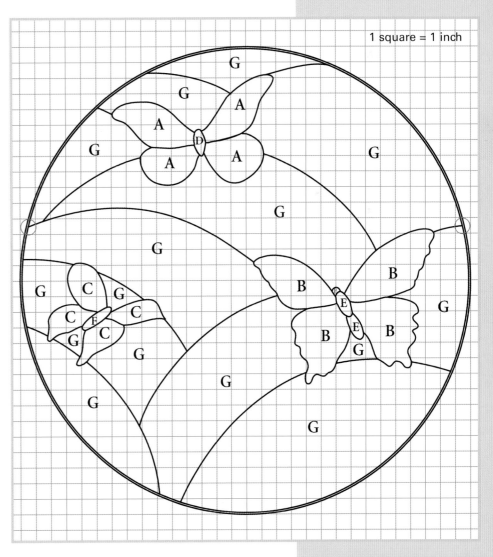

1 square = 1 inch

Dreamweaver
Spinning Garden Panel

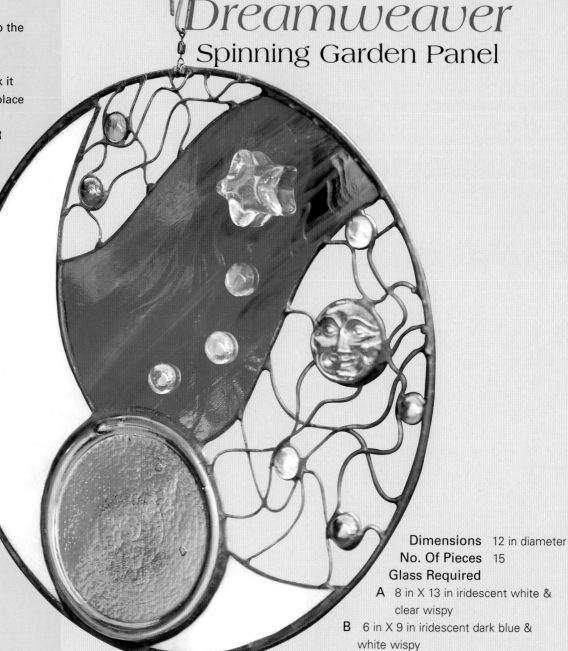

Dimensions 12 in diameter
No. Of Pieces 15
Glass Required

A 8 in X 13 in iridescent white & clear wispy

B 6 in X 9 in iridescent dark blue & white wispy

C 1 – 4¾ in round translucent iridescent amber glass rondel or coaster

D 1 – 1½ in iridescent dark blue glass moon face
E 1 clear glass star
F 5 iridescent clear glass nuggets (medium)
G 2 iridescent dark blue glass nuggets (medium)
H 2 iridescent amber glass nuggets (medium)

Letters identify type of glass used on pattern (p44). The quantity of glass listed is a close approximation of the amount needed for the pattern. You may wish to purchase more glass to allow for matching textures and grain.

Instructions

This stained glass window panel can be hung indoors or outside and has the added novelty of being able to spin. A small swivel secured to the top of the panel allows it to rotate in the breeze or with the touch of the hand.

This window panel is constructed by using the same basic guidelines given for the SPRING TULIP Window Panel (pp31 & 32).

Preparing the Brass Ring

The DREAMWEAVER Spinning Garden Panel fits within a 12 in diameter brass ring that provides structural support and a finished outside border. Before starting this project tin the brass ring with 60/40 solder.

1 Wash the brass ring with soap and water to remove all traces of oil and dirt. Dry with a soft cloth.
2 Apply a thin layer of solder to the entire brass ring. Use a small brush or cotton swab to coat a section of the brass ring with a liberal amount of safety flux. Slowly draw a bead of solder along the fluxed area of the ring with the hot soldering iron tip, coating the outside and the inside of the ring with solder. Move along the perimeter of the brass ring applying flux and solder as necessary. The brass ring will become very hot and this will help the solder flow evenly. Handle with caution, wear work gloves to protect your hands and use pliers to grip the ring.
3 Melt away any bumps of solder by dabbing with flux and drawing the solder off the ring with the iron tip.
4 Let the brass ring cool. Wash off all flux residues and dry with a soft cloth.

Assembling the Panel

5 The border around this stained glass panel is formed by using a 12 in brass ring. To make an accurate pattern, begin by tracing the inside perimeter of the tinned brass ring onto the pattern paper. Continue by tracing the outlines of the glass rondel (**C**) and moon face (**D**) in the appropriate positions before drawing in the remaining pattern lines and making copies of the pattern. Pre-made glass shapes may vary in size, shape, and availability. Substitute with similar shapes or cut stained glass pieces if the glass shapes listed are not available in your area.
6 Tape a copy of the pattern to a wood board or level work surface that is several inches larger than the pattern perimeter.
7 Position the tinned brass ring on the pattern copy and secure in place with several pieces of masking tape.
8 Cut (pp15-20), grind (p21) to fit, and foil (pp25 & 26) each piece of glass required for the panel.
9 Assemble the foiled glass pieces representing the crescent moon (**A**), the milky way (**B**), and the full moon (**C**) on the pattern, verifying the pieces align properly and fit within the tinned brass ring.
10 Tack, tin, and bead solder (pp26 & 27) the glass pieces together and to the tinned ring.
11 Allow panel to cool. Turn the panel over and tin and bead solder the back of the panel.
12 Tin and then solder a finishing bead (p27) along the remaining edges of glass pieces.

Additional Materials & Tools Required

Materials
- 12 in diameter brass ring
- Black-backed copper foil
- 14-gauge tinned copper wire
- Black patina
- Black swivel
- Clear silicone
- Heavy-duty monofilament (fishing line) or linked chain

Tools
- Work Gloves
- Pliers
- Wire cutters

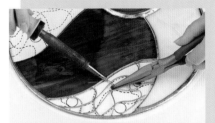

Use needlenose pliers to hold wires & solder wires in place

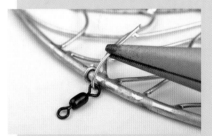

Wrap wire around ring & through swivel loop, then solder wire

Use silicon to adhere glass star & nuggets to Milky Way

Attaching the Wires, Glass Nuggets, and Moon Face in Open Areas

13 Use a pattern copy as a guide to shape and cut the individual pieces of 14-gauge tinned copper wire that will be attached within the open spaces of the glass panel. These wires will form the support structure for the glass nuggets (**F**, **G**, **H**) and moon face (**D**).

14 Wipe excess flux residue from the panel surface and lay it over the pattern taped to the work surface. Starting at the top of the panel, attach one wire at a time, holding each wire in position with needlenose pliers as you tack and bead solder the wire ends to the edges of the glass pieces and the tinned brass ring. Tack and bead solder the glass nuggets and moon face to wires as you reach each placement indicated on pattern. Gently reshape any wires to accommodate glass nuggets or moon face. For additional strength, tack solder wires together at each point that two wires intersect.

Attaching the Hanging Loop and Swivel

15 Refer to pattern for correct placement of hanging loop and swivel. Wrapping a 4-in piece of tinned copper wire around tinned ring forms hanging loop. Wrap wire tightly around ring twice and then thread the swivel onto the wire. Shape a loose loop, threading wire through ring of the swivel a second time, forming a second loose loop. Swivel must move freely on loops without touching tinned brass ring. Complete hanging loop by wrapping remainder of wire tightly around ring. Solder underside of tinned wire to ring, taking care not to solder swivel to hanging loop.

16 Clean (p22) panel and apply patina (pp22 & 23).

17 Apply finishing compound or wax (p23) to solder seams and tinned brass ring and wires only.

18 Fasten star (**E**) and 3 remaining nuggets (**F**) to the clean piece of wispy glass (**B**) representing the Milky Way. Apply a dab of clear silicone to underside of star and each of the nuggets and adhere to the glass piece using pattern as a guide. Wipe away ooze from between the two surfaces with a cotton swab. Allow the silicone to cure for 24 hours.

19 Use heavy-duty monofilament line or linked chain to hang the panel.

1 square = 1 inch

SWIVEL

H
G
E
F
B
F
A
F
F
D
H
F
C
G
A
BRASS RING

- - - - - - WIRE

Dragonfly
Garden Spinner

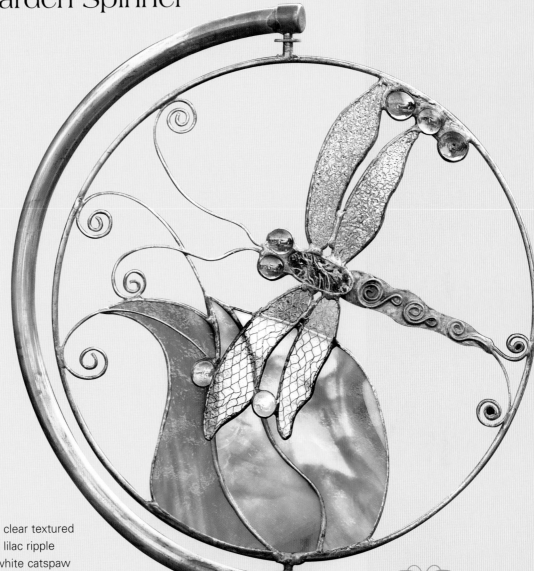

Dimensions

13 in wide X 51½ in high

No. Of Pieces 15

Glass Required

A	5 in X 5 in	iridescent clear textured
B	2 in X 2 in	iridescent lilac ripple
C	5 in X 8 in	green & white catspaw
D	4 in X 8 in	medium green & white ring mottle
E	3	iridescent clear glass nuggets (medium)
F	2	iridescent amber nuggets (medium)
G	1	light blue glass nugget (medium)
H	1	iridescent light green glass nugget (medium)

Letters identify type of glass used on pattern (p49). The quantity of glass listed is a close approximation of the amount needed for the pattern. You may wish to purchase more glass to allow for matching textures and grain.

Note

The DRAGONFLY Garden Spinner can also be displayed as a spinning garden window, as shown on p42. Omit the hoop pivots and the garden spinner stand and attach a hanging loop and swivel (p44) instead.

Additional Materials & Tools Required

Materials

- 12 in diameter brass ring
- Copper foil (regular)
- Decorative copper mesh
- 36-gauge medium weight tooling copper
- 14-gauge tinned copper wire
- $\frac{1}{8}$-in copper tube (2 – 1 in lengths)
- 2 – $\frac{1}{4}$ in flat brass washers
- Copper patina
- $\frac{1}{2}$ in rigid copper pipe (36 in length)
- $\frac{1}{2}$ in malleable copper pipe (23 in)
- 1 – $\frac{1}{2}$ in copper end cap
- 1 – $\frac{1}{2}$ in copper elbow (90°)

Tools

- Work gloves
- Pliers
- Wire cutters
- Pipe cutter
- Med. grade emery cloth or sandpaper
- Propane torch
- Center punch
- Vise
- Power drill with $\frac{17}{64}$ in drill bit

Brass ring is tinned before using as border

Instructions

This is another whimsical garden project that has the ability to spin on its axis in a stand made from plumbing materials found at the local home and garden center or plumbing supply store. The stained glass window panel is constructed in a manner similar to the DREAMWEAVER Spinning Garden Panel (pp43 & 44) with a few additional techniques.

1 Follow steps 1 to 4 for the DREAMWEAVER Spinning Garden Panel (p43) to prepare the brass ring.

2 The border around this stained glass panel is formed by using a 12 in tinned brass ring. To make an accurate pattern, begin by tracing the inside perimeter of the tinned brass ring onto the pattern paper. Continue by drawing in the remaining pattern lines and making copies of the pattern.

3 Tape a copy of the pattern to a wood board or level work surface that is several inches larger than the pattern perimeter.

4 Position the tinned brass ring on the pattern copy and secure in place with several pieces of masking tape.

5 Cut (pp15-20) and grind (p21) to fit each piece of glass required for the panel.

6 Wrap, crimp, and burnish (pp25 & 26) the glass nuggets (**E**, **F**, **G**, **H**) and the stained glass leaves (**C**, **D**) and upper body (**B**) with $\frac{7}{32}$ in copper foil (regular).

Attaching Copper Mesh to the Glass Wings

For a more true-to-life effect, decorative copper mesh is foiled to the front side of the glass wing pieces (**A**). Decorative metals are available in a variety of styles and weights at art and craft supply stores.

7 Place the glass wings face down on the copper mesh and trace the outlines onto the mesh with marker.

8 Use scissors to cut out each piece of wing-shaped mesh.

9 Use several small pieces of masking tape to secure the copper mesh shapes to the front edges of each glass wing.

10 Use $\frac{1}{4}$ in copper foil (regular) to wrap, crimp, and burnish the edges of the copper mesh and the glass wing pieces, adhering the mesh over the front surface of each piece. Carefully remove each piece of masking tape as you come to it with the foil. You do not want to pull the copper mesh away with the tape or foil the tape to the glass or mesh.

11 Shape and cut the pieces of 14-gauge tinned copper wire to form the leaf curlicues, and the dragonfly antennae, tail, and spiral overlays for the body, as indicated on the pattern. These wires are design elements that also lend extra support to hold the glass pieces securely within the tinned brass ring.

Making the Dragonfly Body

12 Place a pattern copy over the piece of tooling copper. Pressing firmly, use a pen to trace the dragonfly body shape onto the copper. Remove the pattern, revealing the body impression on the copper and proceed to cut out the shape with a pair of scissors.

13 Flux and tin solder (p27) both sides of the copper dragonfly body.

14 Fasten the edges of the tinned copper body to the work surface with masking tape to hold it in place.

15 Apply flux to the tinned body and a wire spiral. Referring to pattern lay the spiral on the body and tack in place. Attach the spiral with a thin, flat layer of solder. This is preferable to a thicker bead of solder that may cover the raised detail the wire overlay adds to the tinned copper body. Repeat this procedure to attach each spiral and the dragonfly tail.

Assembling the Panel

16 Apply a spare amount of flux to the foiled edges of the 4 glass wing pieces. Do not get flux on the decorative copper mesh. Tin and then solder a finishing bead (p27) along outside edges of the glass wings. Apply small amounts of solder at one time to avoid filling the copper mesh openings with solder. Wipe off flux residue when done.

17 Assemble foiled glass pieces and tinned dragonfly body and tail on the pattern, but not the 2 left wing pieces (**A**) and 2 iridescent clear glass nuggets (**E**) that are shown overlaying the leaves. Align pieces properly and fit within tinned brass ring.

18 Tack, tin, and bead solder (pp26 & 27) the assembled metal body and glass pieces together and to the tinned ring.

19 Allow the panel to cool. Turn panel over and tin and bead solder the back of the panel.

20 Tin and then solder a finishing bead along all unfinished outer edges of glass leaves, glass nuggets along the tinned outer ring, and dragonfly body and eyes.

21 Tin, then solder a finishing bead around foiled edges of 2 remaining glass nuggets.

22 Use needlenose pliers to hold the wire dragonfly antennae and the leaf curlicues in position. Tack and bead solder the shaped wires in position as shown on the pattern.

Attaching the Wings and the Remaining Glass Nuggets

23 Tack and bead solder together the 2 left wings with glass nugget (**E**) situated between them. Turn over and bead solder back side of the pieces as required.

24 Position wings and attached nugget over soldered glass panel as pattern indicates. While tilting wings slightly upward, tack and bead solder wings to glass body (**B**) and outer edge of glass leaf (**C**), on both sides of panel. Wings and attached glass nugget will be suspended over leaf, protruding slightly from glass panel surface.

25 Tack and bead solder the remaining glass nugget (**E**) to the solder seam between the 2 leaves (**D**, **C**) and edge of overhanging wing. Nugget will provide extra support for elevated wing.

Attaching the Hoop Pivots

26 Measure and mark 1 in from the end of the $1/8$ in copper tube.

27 Fasten pipe cutter to copper tube at the mark. Score and cut tube by continually rotating and tightening the cutter until marked length separates from larger piece.

28 Repeat steps 26 and 27 to cut a second 1 in length of $1/8$ in copper tube.

29 Rub entire surface of 2 pieces of copper tube and two $1/4$ in brass washers with fine steel wool (000).

30 Use heavy-gauge wire cutters to make 2 sets of opposing cuts ($1/8$ in apart and $1/8$ in long), on one end of each copper tube piece. Where each pipe is cut, use pliers to bend the copper back into 90° angle flanges, creating a T shape.

31 Flux and tin solder the outside surfaces of copper tube pieces and brass washers.

32 Refer to pattern and mark placement of both hoop pivots on tinned brass ring.

33 Center and rest the flanges of a copper tube over a mark on the tinned ring. Use pliers to hold tube in position and proceed to tack and bead solder the tube to tinned ring.

34 Thread a tinned brass washer onto attached tube until washer is resting $1/2$ in from top of tube. Hold washer in place with pliers, apply a small bead of molten solder to the juncture of washer and tube, soldering two pieces together to complete pivot.

35 Repeat steps 33 and 34 to attach opposing hoop pivot as marked on tinned ring.

36 Clean (p22) the completed panel and apply the patina (pp22 & 23) and the finishing compound or wax (p23).

Foil decorative copper mesh to front of glass wings

Use scissors to cut dragonfly body from tooling copper

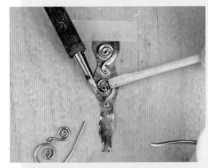
Solder wire spirals in position

Nugget supports wings suspended above leaves

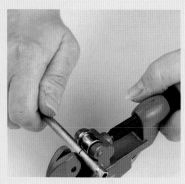

Use pipe cutter to cut tube at mark

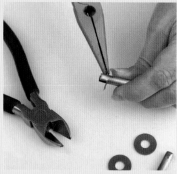

Bend copper back to form flanges

Solder washer to tube to complete hoop pivot

Components of garden spinner stand

Making the Garden Spinner Stand

37 Measure, mark, and cut a 36 in length of $\frac{1}{2}$ in rigid, straight copper pipe, using the method described in step 27.

38 When purchased, the $\frac{1}{2}$ in malleable copper pipe will already be wound in a loose coil. While the pipe is still in the coil, bend one end of the coiled copper into a 14 in diameter circle.

39 The garden stand requires only a half circle of pipe in which the stained glass panel will pivot. From the end of the coiled pipe, mark the opposing halfway point of the circle diameter (approximately 23 in length). Follow the method described in step 27 to cut a half circle from the 14 in diameter coil of copper pipe.

40 Prepare both ends of the half circle of pipe, 1 end of the 36 in pipe length, copper end cap, and copper elbow joint for soldering. Use medium weight emery cloth or sandpaper to remove any burrs and steel wool to rub off any oxidization from copper surfaces.

41 Apply flux to both ends of the half circle of pipe and to the clean end of the straight pipe as well as the inside of the copper end cap and the elbow joint. Place the end cap over the one end of the half circle of pipe and then insert the other end into an opening in the elbow joint. Insert the fluxed end of the straight length of pipe into the remaining opening of the elbow joint.

42 Flux the 3 copper joints and solder together using a propane torch, as described in Soldering Copper Pipe Joints (p82). Make sure the surface the garden stand rests upon while being soldered is non-combustible. (e.g. piece of tile, marble, etc.)

43 Once the copper has cooled, remove residual flux with a neutralizing solution and water. Rub the copper with fine steel wool (000) to remove heat discoloration, oxidation, and manufacturer's labeling.

44 Apply copper patina to the solder at each joint and clean with neutralizing solution and water.

45 For the stained glass panel to rotate in the garden stand, opposing holes must be drilled in center of end cap and center of elbow joint that are at either end of half circle of copper pipe. Clamp garden stand in vise just below the bottom of elbow joint.

46 Use a center punch to mark and make a depression where the hole is to be drilled through the center on the top side of the elbow joint.

47 Use a power drill with a $^{17}/_{64}$ in diameter metal drill bit to make the hole. Fit the drill bit into the depression made by the center punch and drill through the copper. Exercise caution as copper is a soft metal and has a tendency to "grab" at the drill bit.

48 Turn the garden stand upside down. Use the center punch and the power drill to make the opposing centered hole on the underside of the end cap, located at the other end of the half circle of pipe.

49 Use emery cloth or sandpaper to remove any burrs from the drilled holes.

Placing the Stained Glass Panel in the Garden Stand

50 Insert the bottom hoop pivot into the hole at the base of the half circle of copper pipe.

51 Exerting a small amount of pressure, flex open the top end of the half circle, just enough to slip the top hoop pivot into the hole on the underside of the end cap. Once installed, gently push the half circle back in place.

52 Display the finished garden spinner in a favorite spot in the garden. Grasping the straight length of copper tube just below the elbow joint, press the garden spinner several inches into the soil until the spinner sits firmly upright and at the height desired.

Safety Reminders

- Always wear safety glasses while cutting metals and operating power tools. Before operating any power tool, read the manufacturer's instructions and follow all safety guidelines.
- Copper can be sharp along cut edges and becomes hot to the touch during the soldering stage. Wear work gloves or use a cloth or pliers when handling metal, to prevent cuts or burns.

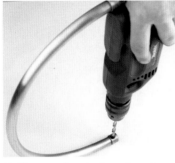

Drill opposing holes at each end of half circle

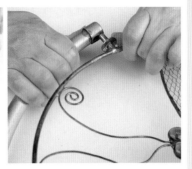

Slip hoop pivot into drilled hole

Helpful Hints
Use a wood stick to hold wire and metal overlays in place while soldering. Some metal implements may adhere to the solder while plastic tools may melt as overlays and wires heat up. Wooden chopsticks or pieces of small wood dowel are excellent, inexpensive tools for this task.

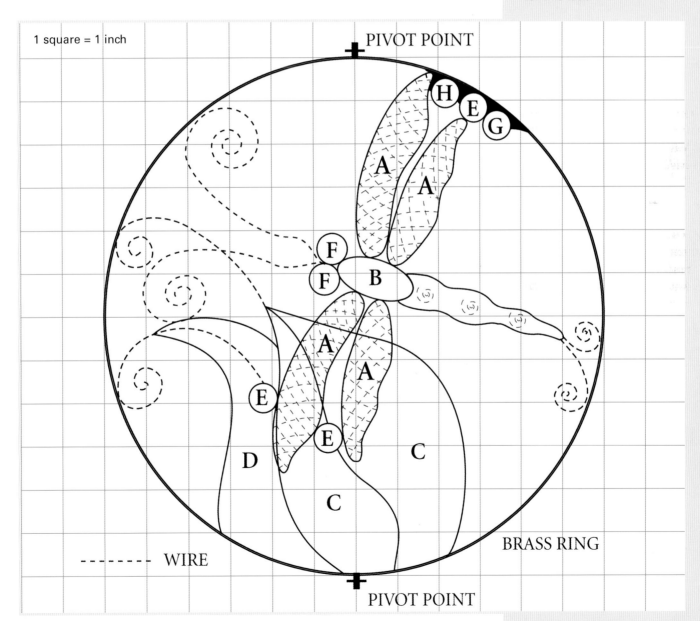

1 square = 1 inch

PIVOT POINT

H E G

A A

F B F

A A

E E

D C

C

WIRE

BRASS RING

PIVOT POINT

Note

ANGELICA can also be displayed indoors. Instead of soldering the angel to the garden jiggle stake, solder a hanging loop to the solder seam that intersects with the outside edge at the top of each wing and hang in a window with heavy-duty monofilament line or linked chain.

Angelica
Garden Jiggle Stake

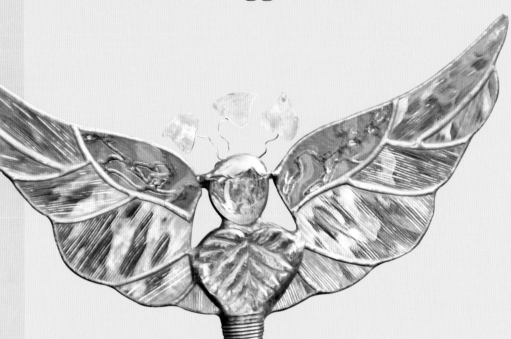

Additional Materials & Tools Required

Materials
- Copper foil (regular)
- 16-gauge tinned copper wire
- 36-gauge medium weight copper sheet
- 2¹/₂-in brass-plated or nickel door stopper spring
- Steel rod (24 in – 36 in)
- Copper patina

Tools
- Work gloves
- 10 coins
- Wire cutters
- Wood dowel or power drill
- Vise
- Empty solder spool
- Needlenose pliers

Dimensions 10³/₄ in wide X 6 in high
No. Of Pieces 16
Glass Required

 A 3 in X 4 in clear 4mm architectural sandblasted Delta pattern)
 B 8 in X 8 in iridescent clear chord
 C 1 iridescent clear glass leaf
 D 1 pale lilac glass nugget (large)

Letters identify type of glass used on pattern (p52). The quantity of glass listed is a close approximation of the amount needed for the pattern. You may wish to purchase more glass to allow for matching textures and grain.

Glass pieces A, B, C are clear but show background garden foliage in photo.

Instructions

The same basic guidelines given for the SPRING TULIP Window Panel (pp31 & 32) are used for constructing the garden stake wings. The completed wings are attached to the glass shapes representing the head and body, the halo and copper leaves are added, and the assembled stained glass garden angel is then soldered to the jiggle stake.

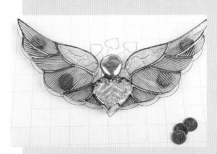

Elevate wings with coins

Assembling the Wings

1. Tape a copy of the pattern to a wood board or level work surface that is several inches larger than the pattern perimeter.
2. Cut (pp15-20), grind (p21) to fit, and foil (pp25 & 26) each piece of glass required for the wings.
3. Assemble the foiled wing pieces on the pattern, verifying the pieces align properly and fit within the pattern outlines.
4. Tack, tin, and bead solder (pp26 & 27) both sides of each wing. Solder each seam all the way to the outside edges.
5. Tin and solder a finishing bead (p27) along the outside edges of the wings. Because the edges are a series of curves, rotate each wing slowly as you apply small beads of solder in a touch-and-lift motion. Keep the area that is being soldered as level as possible so the molten solder does not roll away. Allow the solder to cool and solidify for a few seconds before adding the next bead of solder.

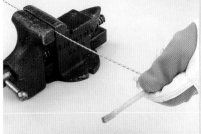

Loop wire over wood dowel & clamp ends in vise. Hold wire taut to twist

Assembling the Head and Body

6. Wrap and burnish (p26) the glass nugget with $7/32$ in copper foil (regular) and the glass leaf with $1/2$ in copper foil (regular).
7. Tin and solder a finishing bead around the perimeter of the glass nugget and leaf.
8. Place the glass leaf and nugget on the pattern, elevating and centering the thinner glass nugget by stacking 2 coins beneath it. The coins should not be in contact with any soldered edge. Tack and bead solder the leaf and nugget together. Turn over and bead solder on the back side. Allow the glass pieces to cool.

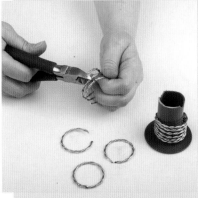

Wind twisted wire around spool. Cut individual halos with wire cutters

Attaching the Wings to the Head and Body

9. Arrange the wings, the head, and body on the pattern. Elevate the wings with coins until centered along the edges of the thicker glass leaf. The coins should not be in contact with any soldered edge or seam. Tack and bead solder the wings to the glass leaf. Carefully turn the assembled pieces over and bead solder the back side.

Making and Attaching the Halo and Copper Leaves

10. To make angel halos bend a 6 ft length of 16-gauge tinned copper wire in half and loop it over the wood dowel. Clamp the ends of the wire in a vise secured to the work surface. Holding the wire taut, turn the wood dowel until the entire length of wire has been completely twisted. Remove the dowel and release the wire from the vise. Use wire cutters to trim the ends of the twisted wire length.
11. To form the halo, wind length of twisted wire around an empty solder spool (that has one end removed). Holding the wire tightly against the spool, use a marker to draw a line on the wound wire from one end of the spool to the other. Slip the coil of wire off the spool and use wire cutters to cut coil at each mark, forming individual halos.
12. Wearing work gloves, hold ends of the halo against one another and solder together. Using needlenose pliers to hold the halo in place (with soldered joint resting against the edge of a wing), tack and bead solder the halo to both sides of glass nugget head and to

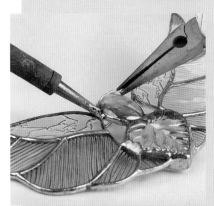

Solder halo to head & both wings

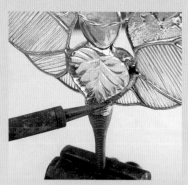

Tack & bead solder leaf to
jiggle stake spring

Helpful Hints

- If the glass leaf is not available, substitute a complementary glass shape or cut stained glass to suit. Adjust pattern.
- Instead of using wider copper foil on thicker glass leaf shape, use a more common width of foil. Wrap overlapping rows of $^7/_{32}$ in or $^1/_4$ in copper foil around perimeter of shape until edges are properly covered.
- Glass becomes hot during the soldering stage. Wear work gloves or use a cloth to handle projects, to prevent burns, while bead soldering edges.
- Instead of using a wood dowel to twist wire, insert the loop into the chuck of your power drill and tighten until wire is firmly secured. With the ends of wire clamped in a vise and wire held tautly, turn power drill on to twist wire.

the edges of the adjacent wings. For a more natural, organic look, use needlenose pliers to grasp and slightly twist the wire halo in several spots until desired affect is achieved.

13 Place a pattern copy over the medium weight copper sheet. Pressing firmly, use a pen to trace the 3 leaf shapes onto the copper. Remove the pattern, revealing the leaf impressions and proceed to cut out the leaves with a pair of scissors.

14 Hold the copper shapes steady, while soldering the tinned wire stems in position, by taping the tips of the leaves to the work surface with masking tape. Cut three $2^1/_2$ in pieces of tinned copper wire to use as leaf stems. Use needlenose pliers to hold the end of a wire stem against a copper leaf and solder in place. A nice flat solder joint is preferable to a raised bead.

15 Bend and curve the wire stems to create a more natural appearance. Tack and bead solder the ends of each wire stem to the halo, behind the glass nugget head.

Making and Attaching the Garden Jiggle Stake

16 Remove all attachments from the spring of the door stopper. The spring must be nickel or brass-plated nickel in order for the solder to adhere to the spring. Wash the spring and the steel rod with soap and water to remove all oil and dirt residues.

17 Insert approximately 1 in of one end of steel rod into the narrow end of the spring. Spread flux on the rod and spring at the point the two meet. Hold hot soldering iron tip on the spring and rod, heating both metal surfaces, and then apply solder to join the two together. More heat will be required to solder these metal pieces together than is required for stained glass soldering so be prepared to reapply flux and solder and go over the area with iron tip more than once. Solder together top 2 or 3 coils at wider end of spring to create a surface that will make attaching stained glass angel easier. Wear work gloves while handling heated metal.

18 Place the completed garden jiggle stake in the vise and clamp it in position, directly beneath the metal spring.

19 Center stained glass angel over the spring and insert bottom tip of the glass leaf body into the wider end of the spring. Tack and bead solder glass leaf securely to spring.

20 Clean (p22), apply patina (pp22 & 23) and finishing compound or wax (p23).

21 Display the finished garden stake in your favorite flower bed or pot. Press the rod several inches into the soil until the garden angel sits firmly in place and at the height desired.

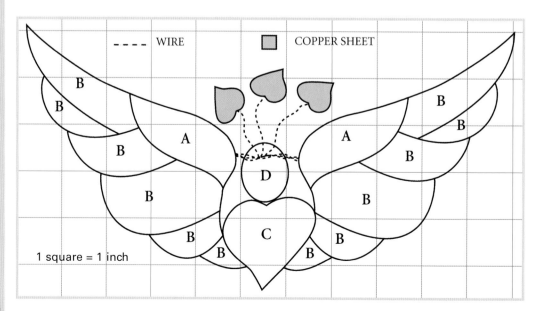

1 square = 1 inch

Bizzy Bee
Garden Jiggle Stake

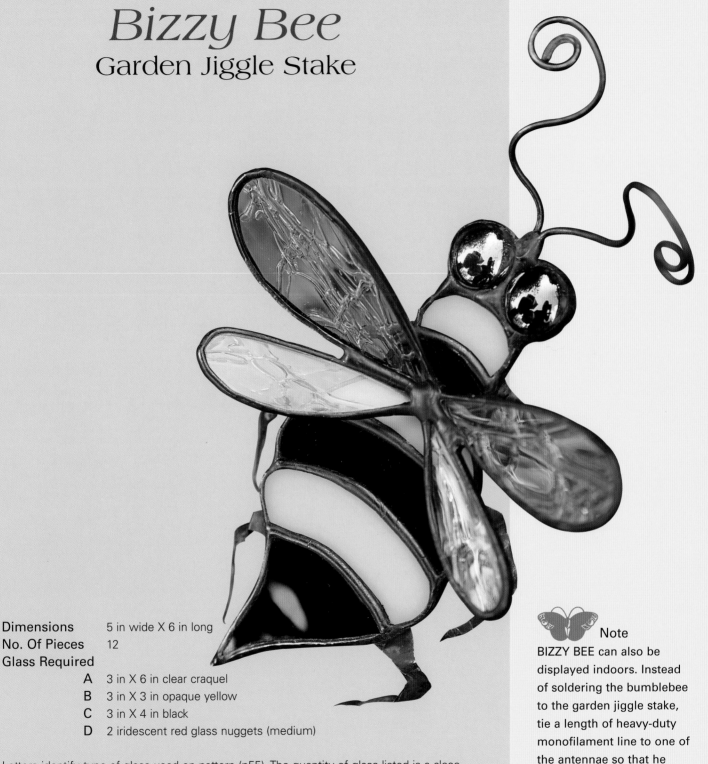

Dimensions 5 in wide X 6 in long
No. Of Pieces 12
Glass Required

A 3 in X 6 in clear craquel
B 3 in X 3 in opaque yellow
C 3 in X 4 in black
D 2 iridescent red glass nuggets (medium)

Letters identify type of glass used on pattern (p55). The quantity of glass listed is a close approximation of the amount needed for the pattern. You may wish to purchase more glass to allow for matching textures and grain.

Glass pieces A (wings) are clear but show background garden foliage in photo.

Note
BIZZY BEE can also be displayed indoors. Instead of soldering the bumblebee to the garden jiggle stake, tie a length of heavy-duty monofilament line to one of the antennae so that he hangs suspended at an angle in the window.

Additional Materials & Tools Required

Materials
- Black-backed copper foil
- 14-gauge tinned copper wire
- 36-gauge medium weight copper sheet
- 2½ in brass-plated or nickel door stopper spring
- Steel rod (24 in – 36 in)
- Black patina

Tools
- Work gloves
- Wire cutters
- Needlenose pliers
- Vise

Bead solder legs to solder seams on underside of body

Helpful Hints
Glass becomes hot to the touch (especially smaller projects) during the soldering stage. Wear work gloves or use a cloth when handling projects, to prevent burns from heat or molten solder, while bead soldering edges.

Instructions

The same basic guidelines given for the SPRING TULIP Window Panel (pp31 & 32) are used for constructing the bumblebee body. The antennae and legs are attached to the body before being joined to the jiggle stake. The upswept wings are the last pieces to be soldered on, giving this bizzy bee the illusion of taking flight.

Assembling the Body

1. Tape a copy of the pattern to a wood board or level work surface that is several inches larger than the pattern perimeter.
2. Cut (pp15-20), grind (p21) to fit, and foil (pp25 & 26) each piece of glass required to complete this project.
3. Assemble the foiled body pieces and the glass nugget eyes on the pattern, verifying the pieces align properly and fit within the pattern outlines.
4. Tack, tin, and bead solder (pp26 & 27) both sides of the bee together. Solder each seam all the way to the outside edges.
5. Tin and then solder a finishing bead (p27) along the outside edges of the body and eyes. Because the edges are a series of curves, rotate the bee slowly as you apply small beads of solder in a touch-and-lift motion. Try to keep the area that is being soldered as level as possible so that the molten solder does not roll away. Allow the solder to cool and solidify for a few seconds before adding the next bead of solder.
6. Tin and solder a finishing bead around the outside edges of the 4 wing pieces. Set the wings aside until required for the last stage of assembly.

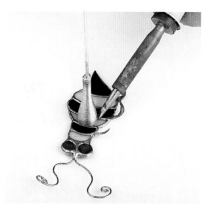

Solder jiggle stake spring to underside of bee body

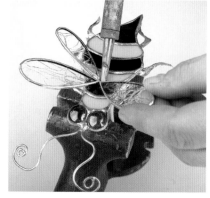

Angle wings upward, & tack solder in place

Attaching the Antennae and Legs

7. Shape and cut 2 pieces of tinned copper wire to form the antennae as shown on the pattern. Use needlenose pliers to hold the antennae as you tack and bead solder the wires to the solder seam between the glass nugget eyes. Turn the bee body over and touch up the solder seam on the underside if necessary.
8. Place a pattern copy over the medium weight copper sheet. Pressing firmly, use a pen to trace the 6 leg shapes onto the copper. Remove the pattern, revealing the leg impressions and proceed to cut out the legs with a pair of scissors.
9. The solder seams of this project are to be treated with black patina so the copper leg shapes must be tinned with solder on both sides. Use needlenose pliers to hold the leg shapes steady and for turning them over while applying a thin, flat layer of solder to the copper.

10 Tack and bead solder the ends of each leg to the appropriate solder seams on the underside of the body.

Making and Attaching the Garden Jiggle Stake

11 To make the garden jiggle stake follow steps 16 and 17 for the ANGELICA Garden Jiggle Stake (p52).

12 Lay the bumblebee body on the work surface with its underside facing upwards. Center the wide end of the spring on the garden jiggle stake over the middle piece of yellow glass. Tack and bead solder the spring to the solder seams on either side of the yellow glass piece at each point where the spring and seams come in contact.

Attaching the Wings

13 Place the garden jiggle stake in the vise and clamp in position, directly beneath the metal spring.

14 Center and tack solder the glass wing pieces to the solder seam shown on the pattern. Tack one wing at a time, angling it slightly upward. Once all four wings are in place, bead solder the point where the pieces all meet and approximately 1 in between each set of wings. Turn the bee on its side and apply a small bead of solder between the wing and the body for additional support. Repeat procedure on the opposite side of the bee.

15 Clean (p22), apply patina (pp22 & 23) and finishing compound or wax (p23).

16 Display the finished garden stake in your favorite flower bed or pot. Press the rod several inches into the soil until the bumblebee sits firmly in place and at the height desired.

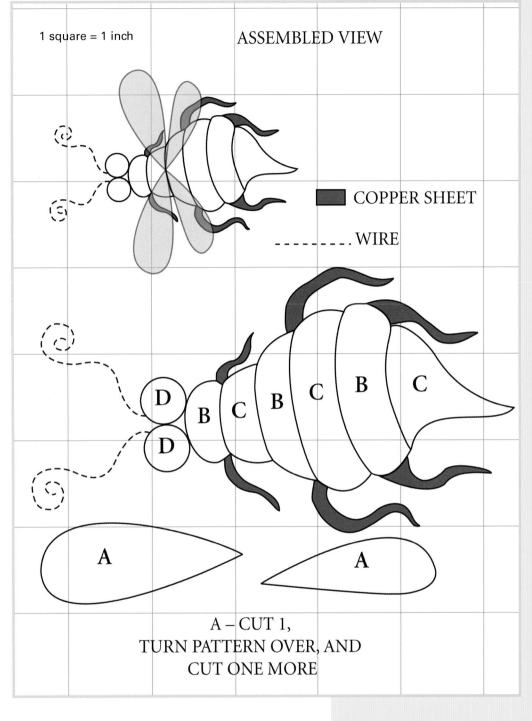

1 square = 1 inch

ASSEMBLED VIEW

▬ COPPER SHEET

- - - - - - - - WIRE

D D B C B C B C B C

A

A

A – CUT 1,
TURN PATTERN OVER, AND
CUT ONE MORE

Starry Night
Candle Lantern

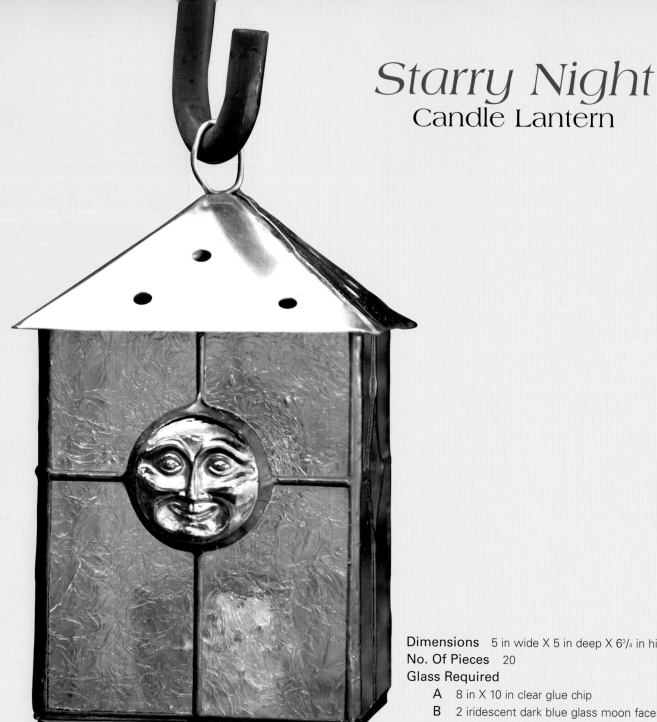

Dimensions 5 in wide X 5 in deep X 6³/₄ in high
No. Of Pieces 20
Glass Required

 A 8 in X 10 in clear glue chip
 B 2 iridescent dark blue glass moon faces
 C 2 – 2 in X 2 in clear star bevels

Letters identify type of glass used on pattern (p59). The quantity of glass listed is a close approximation of the amount needed for the pattern. You may wish to purchase more glass to allow for matching textures and grain.

Glass pieces A are clear but show background garden foliage in photo.

Note
Never leave a burning candle unattended.

Instructions

The STARRY NIGHT Candle Lantern consists of 4 side panels crowned with a vented copper roof. The side panels are constructed following many of the same basic guidelines used when making a stained glass window panel.

Assembling the Side Panels

1. Assemble each of the 4 side panels by following steps 1 to 6 for the SPRING TULIP Window Panel (p31).
 - Separate jigs will be required for the 2 different side panel patterns. Place the wood trim along both sides and the bottom edge, leaving the top edge open for easy access to the jig. It is important that each of the panels be the same size so that the candle lantern will fit together properly and to make soldering easier.
2. Assemble the side panels, one at a time. Arrange the foiled glass pieces in the appropriate jig, verifying that pieces align properly within the pattern outlines.
3. Tack, tin, and bead solder (pp26 & 27) the copper foil seams on the front side. Solder no closer than 1/4 in to the outside edge of any solder seam that intersects with the side edges of the panels. A smooth edge is required for an accurate fit when forming the 4 panels into the candle lantern.
4. Turn the panels over and tin and bead solder the seams on the other side.

Assembling the Candle Lantern

5. Bring 2 panels together so the inside edges are touching and are at a right angle to each other. There are 2 separate panel designs. To arrange the panels correctly, position a moon face panel on the right and a bevel star panel on the left, with the raised surfaces of the moon face and the glass bevel facing outwards. The inside edges of the panels must be touching to form a V-channeled seam. Tack solder together.
6. Bring together and tack the remaining 2 side panels, as above.
7. Bring the 2 halves together to form a square and tack solder together. Each of the 4 corners of the candle lantern should form a right angle. Use a small drawing square or a carpenter's square to verify the angles and adjust if necessary. Tack a solder bead to the top and bottom corners to give the lantern additional support retaining its square shape until the copper roof and the spider have been soldered to the side panels.
8. Tin all inside and outside seams. Tin and then solder a finishing bead along the top edge of the lantern.
9. Carefully turn the lantern upside down. Tin and then solder a finishing bead along the bottom edge of the lantern.

Making the Copper Roof

To add a touch of flair while providing structural support and a means by which to hang the candle lantern, a copper roof has been designed to fit overtop the side panels.

10. Make a template (from cardstock or lightweight cardboard) of the copper roof pattern (p59) required to make the lantern roof. Use a marker to trace the outline of the template onto the copper sheet.
11. Use metal snips to cut the copper sheet along the traced outline. Remove any sharpness along the cut edges with a straight edged metal file.
12. To shape the copper up into the roof shape, the copper must first be bent along the 4 dotted lines drawn on the pattern. Position the copper so that an outside corner aligns with the corresponding inner corner along the edge of the work surface. Place the 4 in

Additional Materials & Tools Required

Materials
- Black-backed copper foil
- Cardstock or lightweight cardboard
- 8 in X 8 in copper sheet (22-gauge)
- 14-gauge copper wire
- 4-way spider
- 36-gauge medium weight tooling copper
- Black patina
- Tea light

Tools
- Drawing or carpenter's square
- Work gloves
- Metal snips
- Small metal files (1 flat & 1 round)
- 4 in wood block
- Power drill with 1/4 in drill bit
- Heavy-gauge wire cutters
- Needlenose pliers
- Vise
- Cardboard box

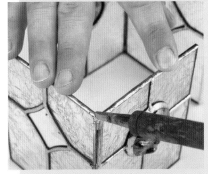

Tack solder moon face & star panels together to form right angle

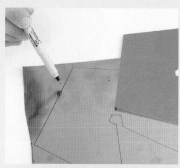

Trace a template of lantern roof onto copper sheet

Bend copper along edge of wood block to form 22½ ° angles

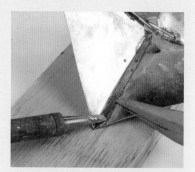

Apply flux & solder edges of copper roof together

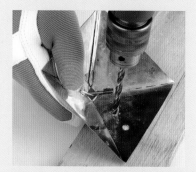

Drill several vent holes in all 4 sides of copper roof

wood block over the copper, aligning one edge of the block with the work surface. Pressing firmly on the wood block to hold the copper in place, bend the portion of copper protruding over the edge of the work surface to approximately 22½°. Bend the copper along all 4 lines to form the roof shape. Wear work gloves during this stage.

13 Apply flux along the top side of the thin flap formed at one end and along the underside of the edge at the opposite end of the copper piece. Use pliers to hold the 2 ends together as the hot iron tip heats the copper and slowly draw molten solder along the fluxed edges (on the underside of the lantern roof), soldering the ends together. Allow the solder to solidify before releasing the copper roof from the pliers.

14 Bend a 4 in length of copper wire into a central loop shape, leaving 1 in of the wire free at either end. Thread ends through opening at the top of the copper roof. Adjust the loop so that the wire ends rest against 2 opposing angles on the underside of the roof.

15 Tack and bead solder the wire ends to the underside of the roof.

16 Drilling from underside and towards outside, make several vent holes in each of 4 sides of copper roof. Remove any sharpness on cut edges with a round edged metal file.

Attaching the Copper Roof to the Candle Lantern

17 With underside facing upwards, clamp hanging loop at top of copper roof in the vise. Holding candle lantern upside down, center the top of lantern onto copper roof.

18 Tack and bead solder roof to both interior and exterior of lantern side panels. Solder 4 corners and each juncture where solder seams of side panels meet the roof. Copper requires more heat than solder seams. Rest hot iron tip on roof first, to heat copper. Once heated, apply solder to join solder seams of side panels to copper roof.

19 Tin and bead solder all seams on interior and exterior of candle lantern. Keep each seam level as it is soldered to achieve an even solder seam. Fill a cardboard box with crumpled newspaper. Use the crumpled newspaper to prop the lantern at the appropriate angle to keep the seam being soldered level.

Making and Attaching the Votive Holder

A tea light will light the interior of the candle lantern. A votive holder to house the tea light is made from a 4-way brass spider and tooling copper.

20 Wash the spider with soap and water to remove oil and dirt residues.

21 Mark a point on each of the 4 arms, 2¾ in from the center of the spider.

22 Center the spider over the bottom opening of the lantern and verify that the marks on the arms will meet with the inside corners. Mark any adjustments that need to be made to the length of the arms to achieve the correct fit. Once trimmed to fit, the spider should measure 5 in across, from end to end.

23 With a heavy-gauge wire cutter, cut each spider arm at the mark.

24 Flux and tin surface of the spider. Allow spider to cool to room temperature.

25 Use scissors to cut a ¾ in X 6½ in strip of tooling copper.

26 Flux and tin copper strip if black patina is to be applied to solder seams of lantern.

27 Once the copper has cooled, form the strip into a circle, overlapping the ends by ½ in. Flux and bead solder the ends together.

28 Center the tinned circle over the spider. Tack and bead solder the circle to the arms of the spider to create a votive holder.

29 Turn the candle lantern upside down and insert votive holder just enough so that holder does not protrude from bottom edge. Tack and then bead solder spider arms securely to interior solder seams at 4 bottom corners of lantern.

30 Clean (p22) and apply patina (pp22 & 23) to solder seams and votive holder only, leaving

lantern roof its natural copper color. Apply finishing compound or wax (p23) to entire candle lantern.

31 Place a tea light in the votive holder and hang in the desired location. The tea light is lit by inserting a lit fireplace match through a vent hole in copper roof.

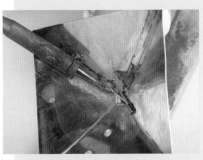

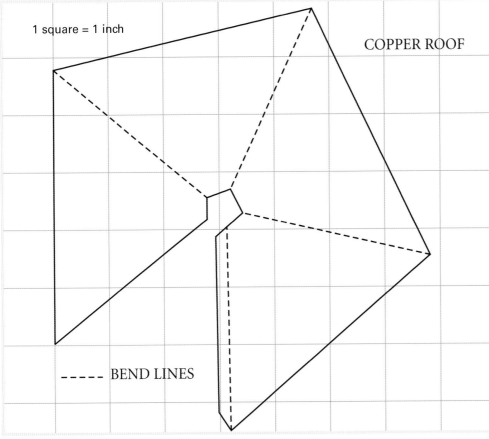

1 square = 1 inch

COPPER ROOF

- - - - - BEND LINES

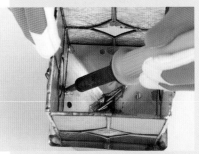

Thread wire ends through roof hole & solder loop for hanging

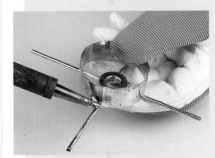

Lantern is centered & soldered onto copper roof

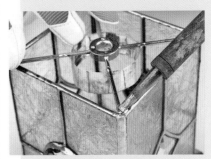

Tack & bead solder tinned copper circle to spider arms

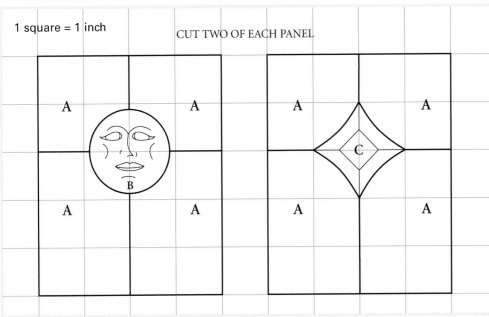

1 square = 1 inch

CUT TWO OF EACH PANEL

A A A A

B

A A

C

A A

A A

Tack & bead solder arms of votive holder to solder seams

Helpful Hints
See Helpful Hints on p62

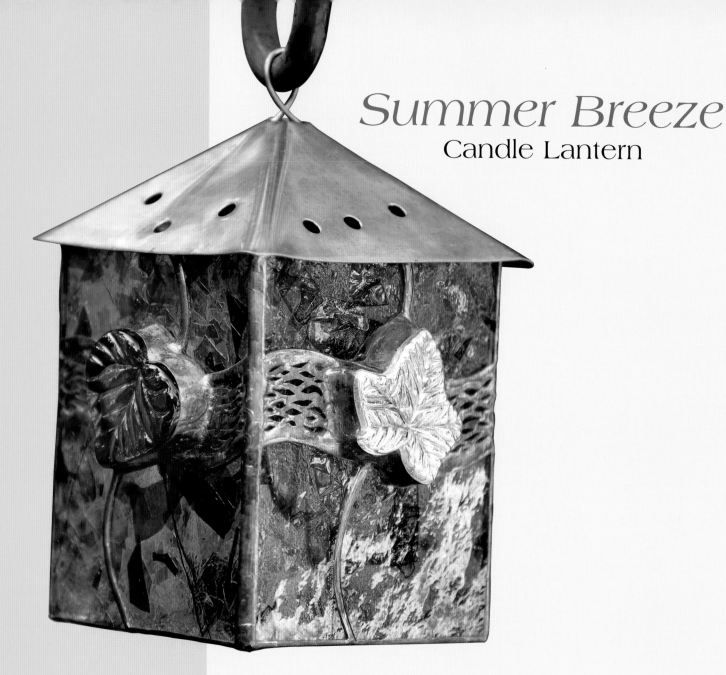

Summer Breeze
Candle Lantern

Note

Never leave a burning
candle unattended.

Dimensions	5 in wide X 5 in deep X 6¾ in high	
No. Of Pieces	28	
Glass Required		
	A	8 in X 9 in clear with green & pink fractures & green streamers
	B	4 in X 8 in translucent rose pink glue chip
	C	2 iridescent clear glass leaves
	D	2 dark green glass leaves

Letters identify type of glass used on pattern (p62). The quantity of glass listed is a close
approximation of the amount needed for the pattern. You may wish to purchase more glass to
allow for matching textures and grain.

Glass pieces A have a clear base but show background garden foliage in photo.

Instructions

This candle lantern project is constructed using the same instructions given for the STARRY NIGHT Candle Lantern (pp57-59).

1 Follow steps 1 to 4 for the STARRY NIGHT Candle Lantern (p57) making the following changes.

Wrapping the Glass Pieces with Copper Foil

Use $7/32$ in copper foil (regular) for the stained glass pieces (**A**) and $1/2$ in copper foil (regular) for the glass leaves (**C, D**).

Creating the Copper Foil Overlay

Create a copper foil overlay on the rose pink glue chip glass pieces (**B**).

- Place each glass piece face down (with the textured side facing upwards) on a piece of copper foil sheet cut approximately $1/4$ in larger than the outside perimeter of the piece.
- Burnish (p26) the copper foil to the top surface of each glass piece.
- Wrap (p25), crimp (p26), and burnish the foil overlap around the outside edges.
- Trim away excess foil with a utility knife, leaving a $1/8$ in overlap on the back of each piece.
- To create the open spaces that candlelight will shine through, use a utility knife with a fresh blade. Cut the outline of designs, similar to those indicated on the pattern, through the copper foil overlay on the front of each glass piece. Take care not to press the blade too hard through the foil, scoring the glass beneath. Use the knife tip to lift away the foil cutouts, revealing the glass underneath.
- When soldering the side panels together, apply a very thin layer of solder to the copper foil overlay taking care not to cover the open design shapes with solder.

2 Bring 2 panels together so the inside edges are touching and are at a right angle to each other. There are 2 separate panel designs. To arrange the panels correctly, position a panel with a dark green leaf on the right and a panel with an iridescent clear leaf on the left, with the raised surfaces of the leaves facing outwards. The inside edges of the panels must be touching to form a V-channeled seam. Tack solder (p26) together.

3 Follow steps 6 to 31 for the STARRY NIGHT Candle Lantern (pp57-59), omitting step 26 if using copper patina on this project.

Additional Materials & Tools Required

Materials

- Copper foil (regular)
- Cardstock or lightweight cardboard
- 12 in X 12 in copper foil sheet
- 14-gauge copper wire
- 4-way spider
- 36-gauge medium weight tooling copper
- Copper patina
- Tea light

Tools

- Drawing or carpenter's square
- Work gloves
- Metal snips
- Small metal files (1 flat & 1 round)
- 4 in wood block
- Power drill with $1/4$ in drill bit
- Heavy gauge wire cutters
- Needlenose pliers
- Vise
- Cardboard box

Burnish copper foil to top surface & around edges of each glass piece

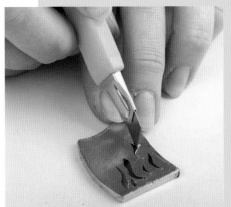

Trim away excess foil with utility knife. Lift away foil cutouts to reveal glass underneath

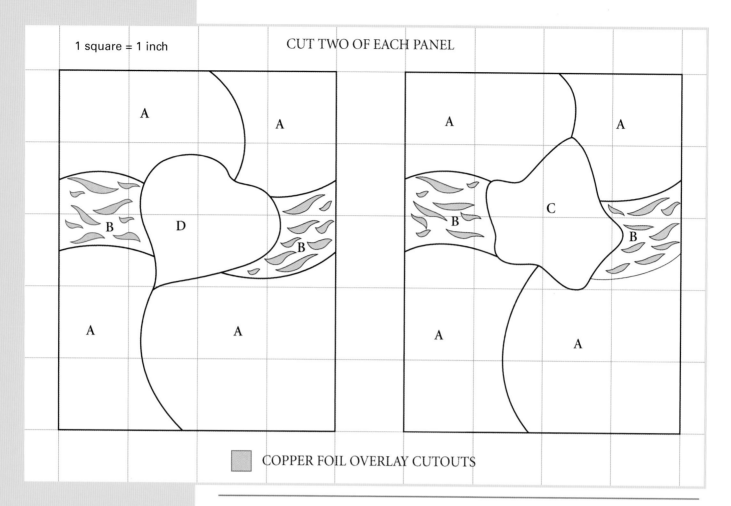

1 square = 1 inch

COPPER FOIL OVERLAY CUTOUTS

Helpful Hints

- If the glass shapes indicated are not available in your area, substitute with complementary glass shapes or cut pieces of stained glass to suit. Adjust the pattern accordingly.
- Instead of using wider copper foil on thicker glass shapes (like the glass leaves in this project) use a more common width of foil. Wrap overlapping rows of $7/32$ in or $1/4$ in copper foil around the perimeter of the shape until the edges are properly covered
- Copper can be sharp along cut edges and becomes hot to the touch during the soldering stage. Wear work gloves or use a cloth or pliers when handling metal, to prevent cuts or burns.
- Instead of making the copper roof, a 6 in diameter round vented vase cap can be used. Remember to tin the vase cap (step 16, p68) before attaching it to the candle lantern.
- Other ways to make soldering small 3-dimensional projects easier and less cumbersome, are to use soft work cloths or a wood soldering block instead of a cardboard box to keep the project seams level. To make a wood soldering block, use a table saw to cut an 8 in length of 4 in X 4 in lumber. Set the blade of the table saw at a 45° angle and cut a V into one side of the block. Small lamp shades, lanterns, and candleholders can be set into the V of the wood block to keep the seams level while soldering. Use the leftover V-shaped cutout as a prop when additional leverage is needed.

Zen
Sand Garden

Dimensions 11 in wide X 8 in high X 13 in deep (with tree)
No. Of Pieces 21
Glass Required

A	12 in X 8 in blue, green, & white ring mottle	
B	101/8 in X 121/8 in clear 4mm clear architectural (Sycamore pattern)	
C	2 dark green glass leaves	
D	1 iridescent amber glass leaf	
E	1 iridescent red glass leaf	

Letters identify type of glass used on pattern (p65). The quantity of glass listed is a close approximation of the amount needed for the pattern. You may wish to purchase more glass to allow for matching textures and grain

Additional Materials &
Tools Required

Materials
- Copper foil (regular)
- 14-gauge copper wire
- 1/8 in copper tube
- Copper patina
- Sand & rocks

Tools
- Cardboard box
- Wire cutters
- Needlenose pliers
- Pipe cutter

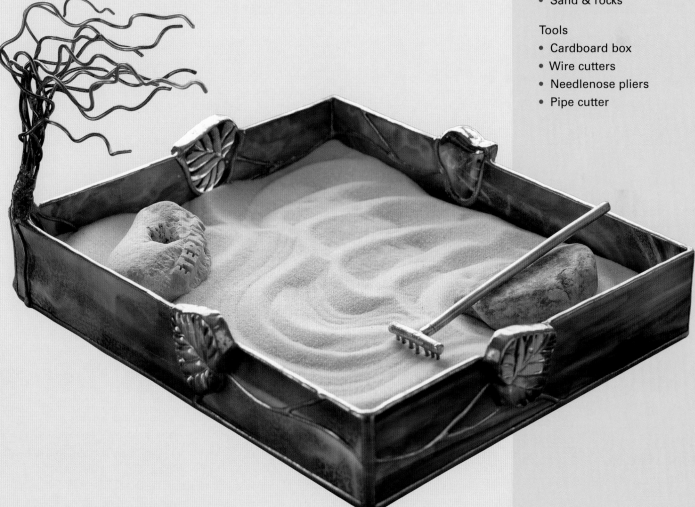

Side panels & bottom piece
form right angles

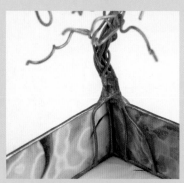

Wire tree is soldered to
interior & exterior seams

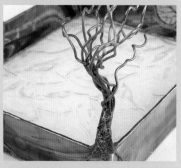

Apply molten solder to trunk,
simulating tree bark

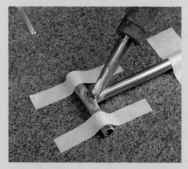

Hold hot soldering iron to
joint until solder flows
smoothly

Instructions

The container for the ZEN Sand Garden consists of 4 side panels with an attached bottom piece. The side panels are constructed using many of the same basic guidelines as those given for making a stained glass window panel.

Assembling the Side Panels

1 Assemble each of 4 side panels (follow steps 1 to 6 for SPRING TULIP, p31).

• Separate jigs will be required for the 2 different side panel patterns. Place the wood trim along both sides and the bottom edge, leaving the top edge open for easy access to the jig. It is important that each of the panels be the correct size so that the sand garden will fit together properly and to make soldering easier.

• When foiling, use $7/32$ in copper foil (regular) for the blue, green, and white ring mottle glass pieces (**A**), $1/4$ in copper foil (regular) for the clear bottom piece (**B**), and $1/2$ in copper for the glass leaves (**C**, **D**, **E**).

2 Assemble side panels, one at a time. Arrange the foiled glass pieces in the appropriate jig, verifying the pieces align properly within the pattern outlines.

3 Tack, tin, and bead solder (pp26 & 27) the copper foil seams on the front side. Solder no closer than $1/4$ in to the outside edge of any solder seam that intersects with the side and bottom edges of the panels. A smooth edge is required for an accurate fit when forming the 4 panels into the rectangular container.

4 Turn the panels over and tin and bead solder the seams on the other side.

Assembling the Sand Garden Container

5 To assemble container bring 2 panels together so inside edges are touching and are at a right angle to each other and the bottom piece (**B**). There are 2 separate panel designs. To arrange panels correctly, position a shorter panel on the right and the longer panel on the left, with the raised surface of glass leaves facing outwards. The inside edges of panels must be touching to form a V-channeled seam. Tack solder together.

6 Bring together and tack the remaining 2 side panels, as above.

7 Bring the 2 halves together to form a rectangle and tack solder together. Each of the 4 corners of the container should form a right angle.

8 Tin the copper foil along the bottom edges of the box as well as the foil on the bottom piece. Do not leave any bumps of solder on the foil.

9 Carefully, slide the joined halves onto the bottom piece (positioned with the texture facing upwards), aligning the corners and the bottom edges of each side piece with a corresponding edge of the base. Tack the sides to the base in several spots.

10 Tin all outside and inside seams.

11 Fill a cardboard box with crumpled newspaper to hold the container at the appropriate angles for bead soldering. Place the container inside and proceed to bead solder all inside and outside seams. Keep the seams level as they are being soldered.

12 Tin and then solder a finishing bead along the top edges of the container.

Making and Attaching the Wire Tree

13 Cut 12 to 15 pieces of copper wire, varying in lengths from 10 in to 15 in.

14 Create a tree reminiscent of a bonsai. Use needlenose pliers to twist and twine wires until desired look is achieved. Use the accompanying photographs for inspiration.

15 The tree is attached by soldering several wires from the base of the tree to a corner of the sand garden container. Use wire cutters to trim away approximately $2^{1}/_{2}$ in from the base of the wires in the middle of tree trunk. Leave 7 wires untrimmed – 4 to be soldered to interior solder seams close to the corner and 3 to be soldered to exterior

seams. Refer to photographs for placement of wires and proceed to tack and bead solder the 7 wires to solder seams at top and bottom of the corner. One wire is soldered directly to interior corner seam. Apply molten solder to base of tree trunk to simulate a bark-like texture and for additional support.

Making a Sand Rake

16 Use a pipe cutter (pp47 & 48) to cut one 6 in length and one 1½ in length of ⅛ in copper pipe. Form the 2 pieces of copper pipe into a T shape and secure to the work surface with masking tape. Flux and solder the copper pieces together, holding the hot soldering iron tip against the joint until the solder flows smoothly.

17 Remove masking tape from the shortest piece of pipe and begin tacking and bead soldering tines to the rake. Solder 1 end of a piece of copper wire to the pipe. Cut all but ½ in of wire away to form a tine. Repeat this step, forming 7 or 8 tines to complete rake.

18 Clean (p22), apply patina (pp22 & 23) and finishing compound or wax (p23) to container and rake.

19 To create a sand garden fill the container with sand, stones, and found objects. Use the rake to produce patterns in the sand. Gently shake the container to smooth out the sand when it is time to create anew.

Solder end of copper wire to pipe to make tine of rake

Helpful Hints
- If the glass leaves indicated are not available in your area, substitute with complementary glass shapes or cut pieces of stained glass to suit. Adjust the pattern accordingly.
- Instead of using wider copper foil on thicker glass shapes (like the glass leaves in this project) use a more common width of foil. Wrap overlapping rows of 7/32 in or ¼ in copper foil around the perimeter of the shape until the edges are properly covered.
- Copper becomes hot to the touch during the soldering stage. Wear work gloves or use a cloth or pliers when handling metal, to prevent burns from molten solder or heated copper pipe & wire.

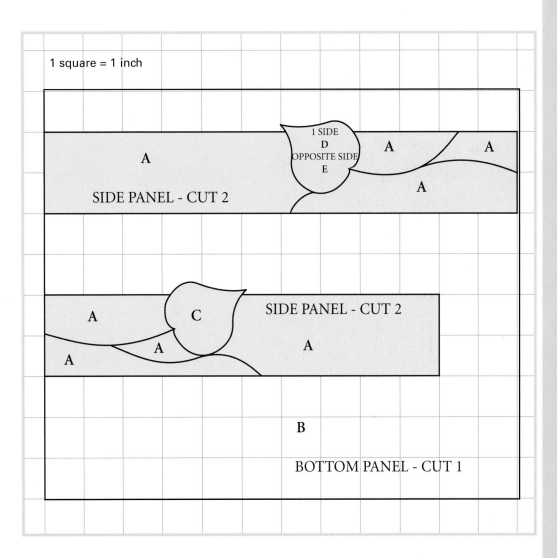

1 square = 1 inch

A
SIDE PANEL - CUT 2

1 SIDE
D
OPPOSITE SIDE
E

A A

A

A C SIDE PANEL - CUT 2

A A

A

B

BOTTOM PANEL - CUT 1

Green Leaf
Patio Lanterns

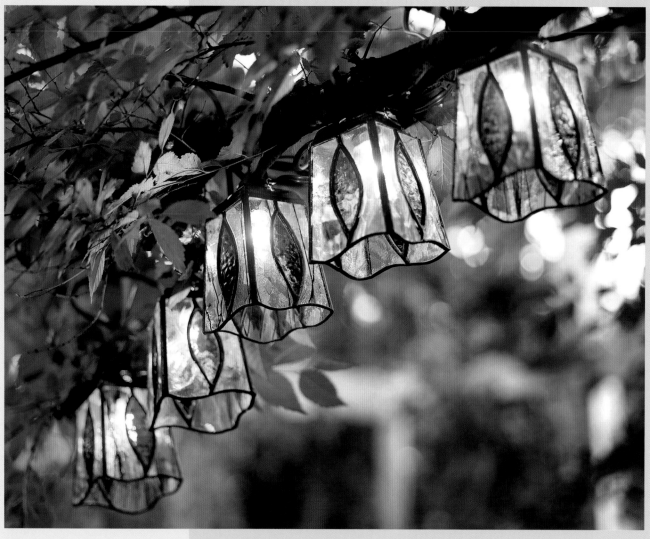

Dimensions	Height 4³/₄ in	Bottom Diameter 3¹/₂ in square
No. Of Panels	4	
No. Of Pieces	12	

Glass Required

A	6 in X 4 in sage green cathedral	
B	13 in X 5 in clear 4mm clear architectural (Autumn pattern)	
	Or	
A	6 in X 4 in sage green cathedral	
B	13 in X 5 in clear with green & yellow fractures & black streamers	

Letters refer to the type of glass used on pattern (p69). The quantity of glass listed is a close approximation of the amount needed for the pattern. You may wish to purchase more glass to allow for matching textures and grain.

Note
Be sure that the patio light set meets all government electrical regulations.

Instructions

The quantities of glass and materials listed are for completing 1 patio lantern shade. Adjust these amounts based on the number of patio lanterns required to complete your patio light set. The featured set has 5 shades using the same pattern but made with alternating glass selections for added interest.

A patio lantern shade consists of 4 stained glass panels that are soldered together and hung by an attached vase cap.

Assembling the Lantern Shade

1 Make 2 copies (p14) of the pattern on p69. Use one copy as a guide for cutting the glass pieces to the required shape and size. Use the second copy for fitting and soldering the panels together. If opalescent glass is used in this project, you may wish to make a third copy and cut out the necessary pattern pieces for use as tracing templates.

2 Use marker to trace (p15) each pattern piece on the glass to be cut. Make sure that the grain of the glass is positioned similarly in each of the panels.

3 Cut (pp15-20) each piece of glass required, making sure to cut inside the marker line. Use a cork-backed straightedge to assist in scoring straight lines (p17).

4 Make a jig (p25) to fit the pieces of each panel together accurately. Wood trim should be placed along the top edge and both side edges, leaving the bottom edge open for easy access to the jig. Each of the 4 panels must be the same size so the lantern shades will fit together properly and make soldering easier.

5 Grind (p21) and fit the pieces for one panel at a time, labeling each set with the marker.

6 Wrap, crimp, and burnish (pp25 & 26) each glass piece with the appropriate copper foil, taking into consideration the thickness of the glass and the color of the finished solder seams. Use $1/4$ in black-backed copper foil for clear architectural glass pieces and $7/32$ in black-backed copper foil for all other glass pieces.

7 Solder together each of the panels. Begin by arranging the foiled pieces for one panel on the pattern in the jig and tack solder (p26) the pieces together.

8 Tin (p27) all exposed copper foil on the interior seams.

9 Bead solder (p27) the seams of the panel.

10 Turn the panel over and repeat steps 8 and 9.

11 Tin and then solder a finishing bead along the bottom edge of the panel, leaving $1/4$ in from the side edges free of solder. Because the bottom edge is not even you will have to rotate the panel slowly to keep it level as you apply small beads of solder with a touch-and-lift motion. Allow the solder to cool and solidify for a few seconds before adding another molten bead. This may take a bit of practice but is easily mastered.

12 Repeat steps 7 to 11 for each of the 4 panels.

13 Remove all traces of flux residue with a damp cloth and a small amount of neutralizing solution. Rinse with warm water and wipe dry with a soft cloth. Take care not to lift the exposed copper foil along the side and top edges.

Preparing the Vase Cap

Prepare the vase cap before assembling the 4 panels into a lantern shade. A solid brass vase cap with several vent holes is recommended and will allow heat from the light bulb to dissipate. If vented vase caps are not available, drill 4 holes in the cap. The center hole in the vented vase caps must be enlarged to accommodate the light sockets and the cap must be tinned before soldering it to the panels to form a shade.

Additional Materials & Tools Required

Materials
- Commercial patio light set
- 2 $3/4$ in square vented vase cap
- Black-backed copper foil
- Electrical tape
- Black patina
- 14-gauge tinned copper wire
- Plastic-coated cable
- Plastic wire ties

Tools
- Power drill with $7/8$ in step drill bit
- Small metal file
- Wire cutters
- Needlenose pliers
- Cardboard box

 Note

In cold climates, store the patio lanterns indoors during winter and freezing conditions.

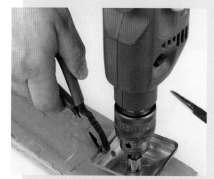

Drill hole in vase cap large enough for socket to fit

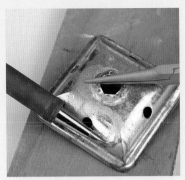

Hold vase cap with pliers &
apply thin coat of solder

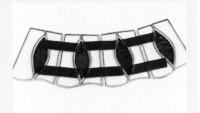

Align panels & tape together
with electrical tape strips

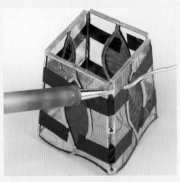

Pull panels into a cone, tape,
& tack solder together

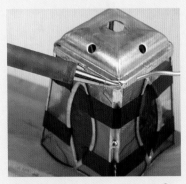

Center vase cap on lantern &
tack solder in place

14 Remove the plastic shades from an inexpensive set of patio lights purchased from a local hardware store or home and garden center.

15 Measure the outside diameter of the light sockets – a common size for a patio light socket is $^7/_8$ in. Use a power drill with the appropriate-sized step bit ($^7/_8$ in in this case) to make the hole just large enough for the socket to fit through. To avoid compressing the vase cap, drill outwards from the inside of the cap. Use a small metal file to remove any burrs around the perimeter of the hole.

16 Clean the vase cap with soap and water to remove any oily residue or grime. Use cotton swabs or a small brush to liberally coat the top side of the vase cap with safety flux and apply a thin coat of solder. To get an even coating of solder, start at the top of the vase cap and slowly draw the hot iron tip to the bottom, repeating this process until you have gone around the entire cap. Vase cap will become very hot and this will help the solder flow evenly. Use needlenose pliers to safely handle the hot vase cap. Let the cap cool and then wash off flux residue with warm water and neutralizing solution.

17 Lay the panels side by side on the worktable with an $^1/_8$ in space between the side edges of each panel. Align the panels so that the bottom edges match. The vase cap that will be attached to the top of the lantern shade can cover small discrepancies in the height of the panels.

18 Cut 8 pieces of electrical tape, approximately 3 in length. Tape the adjoining panels together in 2 locations, pressing the tape firmly to the glass surface. Electrical tape is used for this stage of construction because of its ability to stretch.

19 Pull the panels up into a cone shape by slowly lifting the top edges of the panels and matching the inside edges of the 2 end panels together, top and bottom. Use the remaining 2 pieces of electrical tape to join the 2 end panels together, keeping the shade as square as possible.

20 Tack solder each adjoining edge together in several locations.

21 Center the vase cap on top of the lantern shade. Once it is level and centered, tack solder the vase cap securely in place at each solder seam. If the cap seems too small, use pliers to pull out the side edges and corners of the vase cap until it fits over the top edges of the shade sides.

22 Remove electrical tape and tin the adjoining panel seams with a liberal coating of solder.

23 Fill a cardboard box, large enough to accommodate the size of the shade, with crumpled newspaper. Turn the shade over and prop it inside the cardboard box. Tin the 4 adjoining copper foil seams on the lantern shade interior.

24 Bead solder the seams, making sure to join the seams to the inside of the vase cap as well. Use newspaper to prop the lampshade at an angle that will keep the seams level while soldering.

25 Turn the shade over and bead solder the outside seams.

26 Turn the lantern shade upside down and complete the bead soldering on the adjoining bottom edges. Check the bottom edge for an even bead along the perimeter and complete any necessary touch ups.

27 Clean (p22) the shade and apply patina (pp22 & 23). Apply finishing compound or wax (p23) to protect and polish the solder seams.

Hanging the Patio Lanterns
Once the shades have been completed, each lantern must be secured to the light set.

28 Cut two - 3 in lengths of tinned copper wire for each lantern. Patina the wire to match the color of the solder seams. Bend the wires at the halfway point into a narrow loop.

29 Fit a light socket through the central hole in the vase cap. Fasten the lantern to the light set by fitting a wire loop over the plastic-coated electrical wire on either side of the socket. Thread the ends of the each loop through a vent hole on vase cap and pull through to the inside of lantern. Bend wire ends flat against underside of vase cap, securing lantern in place. Trim the ends of the wire to fit within the cap.

30 Due to the weight of the stained glass shades, we recommend fastening the finished patio lantern set to a plastic-coated metal cord such as a clothesline or aircraft cable. Attach the light set to the cable using plastic wire ties. Fasten the ties on either side of each lantern and at several points along the electrical cord. The patio lantern set is now ready to be hung in your garden.

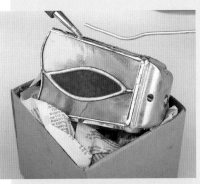

Prop lantern inside box filled with crumpled newspaper

Fit wire loops over plastic-coated electrical wire

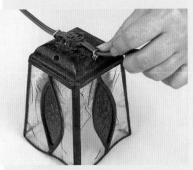

Bend wire ends flat against inside of vase cape

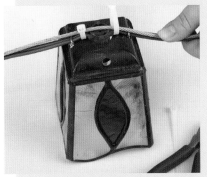

Attach shade to cable using plastic wire ties

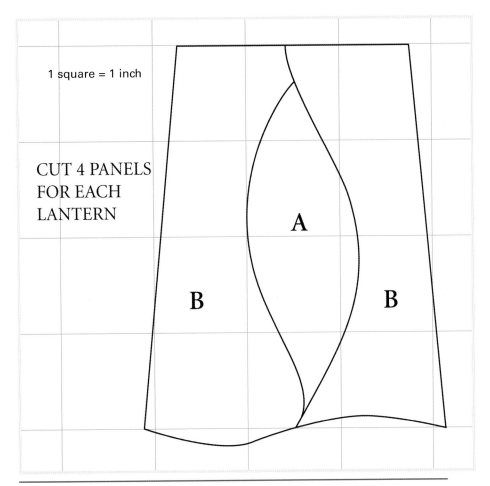

1 square = 1 inch

CUT 4 PANELS FOR EACH LANTERN

A

B B

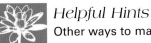

Helpful Hints
Other ways to make soldering small 3-dimensional projects easier and less cumbersome, are to use soft work cloths or a wood soldering block instead of a cardboard box to keep the project seams level. To make a wood soldering block, use a table saw to cut an 8 in length of 4 in X 4 in lumber. Set the blade of the table saw at a 45° angle and cut a V into one side of the block. Small lamp shades, lanterns, and candleholders can be set into the V of the wood block to keep the seams level while soldering. Use the leftover V-shaped cutout as a prop when additional leverage is needed.

Blue Diamond
Hanging Planter

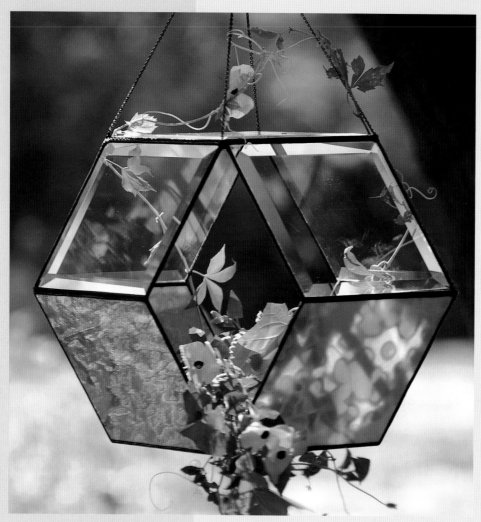

Additional Materials & Tools Required

Materials
- Black-backed copper foil
- 34 in fine-link nickel chain
- Black patina

Tools
- Cardboard box
- Wire cutters
- Needlenose pliers

Dimensions	14³/₄ in wide X 10 in high X 6¹/₄ in deep
No. Of Pieces	10
No. Of Sides	4
Glass Required	
A	5 – 6 in X 9 in clear diamond bevels
B	20 in X 15 in robin's egg blue & white ring mottle

Letters refer to the type of glass used on pattern (p72).
The quantity of glass listed is a close approximation of the amount needed for the pattern. You may wish to purchase more glass to allow for matching textures and grain.

Instructions

1 Make 1 copy (p14) of the pattern on p72.

2 Use the marker and a straightedge to trace (p15) the 5 diamond shaped pieces of glass to be cut.

3 Cut (pp15-20) each piece of glass required, making sure to cut inside the marker line. Use the cork-backed straightedge to assist in scoring straight lines (p17).

4 As required, grind (p21) each piece of glass to fit the pattern. Align the 5 bevels (**A**) on the pattern and grind to fit if necessary.

5 Wrap each bevel and glass piece with copper foil, crimp, and burnish down the edges (pp25 & 26).

6 Tin (p27) the copper foil of each glass piece and bevel on the side that will be turned towards the interior of the hanging planter. To ensure an accurate fit, make sure the solder is smooth and free of bumps.

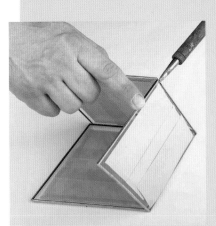

Bring side pieces of planter together & solder. Use another diamond shape as a guide

Assembling the Top and Bottom Halves of the Planter

7 The 5 pieces of ring mottle glass (**B**) are the sides and the base that shape the lower half of the planter. To assemble the bottom half, use the base piece as a guide and bring 2 of the side pieces together to form one half of the diamond shape. The inside edges of the pieces must be touching to form a V-channeled seam. Tack solder (p26) together. Bring together and tack the remaining 2 pieces.

8 Bring the open ends of the 2 halves together and tack solder the bottom 2 points where the halves meet.

9 Carefully, place the bottom piece onto the joined halves, aligning the corners and the top edge of each side piece with a corresponding edge of the base. Tack the sides to the base in several spots.

10 Tin all inside seams of the bottom half of the planter.

11 Repeat steps 7 to 10 using the clear bevels (**A**) to create the upper half of the planter.

12 Place the upper half of the planter onto the bottom half. Making sure the corners and edges of the 2 halves are aligned correctly, tack solder the halves together.

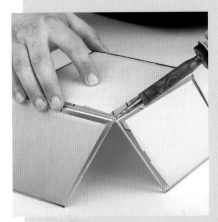

Solder side pieces to top to shape upper half of planter

13 Tin and bead solder (p27) all seams on the inside of the planter first and then proceed to tin and bead solder the outside seams. Keep each seam level as it is being soldered in order to achieve an even solder seam. Fill a cardboard box, large enough to accommodate the size of the planter, with crumpled newspaper. Use the crumpled newspaper to prop the planter at the appropriate angle to keep the seam you are soldering level.

14 Tin and apply a finishing bead of solder (p27) to the foiled glass edges surrounding the opening on either side of the planter.

To Make A Hanging Planter

This planter is designed to be a tabletop model or transformed into a hanging planter that can be displayed in your home or garden simply by adding fine-link chain to the planter.

15 Use wire cutters to cut the fine-link chain into one 16 in length and one 18 in length.

16 Flux and solder ½ in of each end of the chains solid. Use pliers to hold the chain taut while soldering.

17 Attach the ends of the 16 in chain to the seams at the top of the opposing openings of the planter. Use the needlenose pliers to hold each end of the chain steady while tacking and bead soldering the ends securely into the solder seams. The 18 in chain length crisscrosses over the attached chain and is soldered into the corners at either end of the

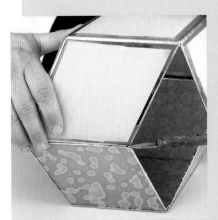

Tin & bead solder all seams & edges once halves are tacked together

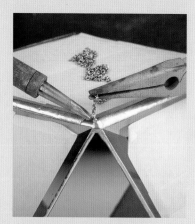

Hold chain in place with needlenose pliers & solder to corners of planter

planter top. If the planter does not hang evenly, shorten the appropriate length of chain by removing some of the links until it hangs correctly.

18 Clean (p22), apply patina (pp22 & 23) and finishing compound or wax (p23).

19 Place plants (potted in a watertight container) inside planter and hang in the garden or an appropriate location indoors. Do not place soil directly in the planter because solder seams may leak if moisture collects in the bottom.

Helpful Hints

Precut bevels reduce the time and effort required when cutting pieces of glass for a stained glass project. However, if the appropriate bevels are not available in your area or if you prefer to substitute a colored and/or textured glass, do not hesitate to do so. Take care when grinding or handling these precut glass pieces as scratches can noticeably mar their appearance. Place masking tape on the underside and over the raised surface of bevels. Make sure grinding and work surfaces are clean and free of glass fragments and debris.

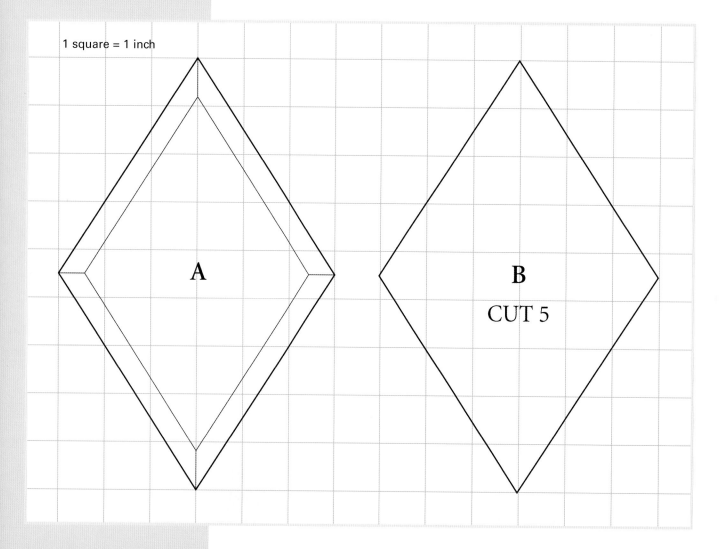

1 square = 1 inch

A

B
CUT 5

Pelican Pete
Hanging Mobile

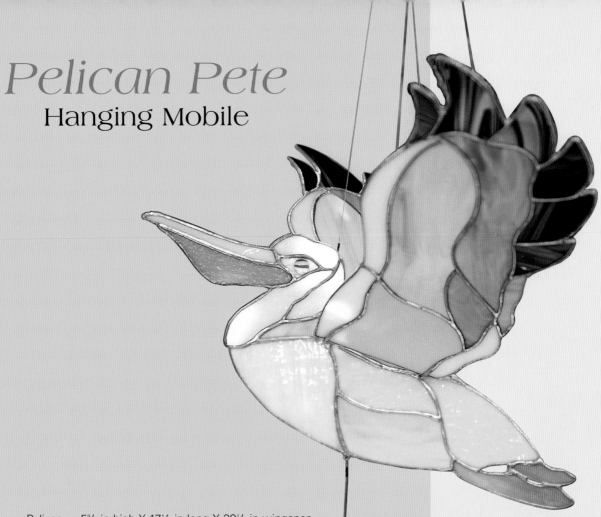

Dimensions	Pelican	5³/₄ in high X 17¹/₄ in long X 29¹/₂ in wingspan
	Fish	2³/₈ in high X 4³/₈ in long

No. Of Pieces 52

Glass Required

A	12 in X 12 in black, white, & clear swirl
B	12 in X 12 in gray & white translucent
C	12 in X 16 in white and light gray
D	14 in X 14 in white wispy
E	2 – 15mm clear with multi-color swirl circular smooth jewels
F	2 in X 5 in ivory wispy
G	6 in X 6 in opaque orange & white wispy
H	3 in X 4 in dark purple cathedral

Letters identify type of glass used on pattern (p77). The quantity of glass listed is a close approximation of the amount needed for the pattern. You may wish to purchase more glass to allow for matching textures and grain.

Helpful Hints
Wear leather work gloves while bead soldering the irregular bottom edge of the panels, wings & body. This will prevent burns should the molten solder roll off the edge of the panels.

Materials

- Silver- or black-backed copper foil
- 14-gauge tinned copper wire
- 18-gauge tinned copper wire
- Clear silicone
- 9 in length of ³/₈ in wood dowel
- 8 ft nylon coated stainless steel fishing wire (20 lb test)
- 11 connector sleeves
- 1 swivel

Tools

- Horseshoe nails or pushpins
- Wire cutters
- Fine grit sandpaper
- Wood saw (hand or power)
- Power drill with ¹/₈ in drill bit
- Needlenose pliers

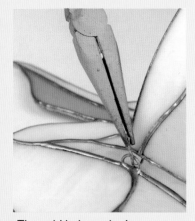

Thread U-shaped wire
through loops on
pelican body

Instructions

This hanging mobile features a flying pelican with wings that flap up and down when the dangling fish is pulled and then released. Summer breezes and air movement within the home cause further motion as the pelican and fish slowly rotate suspended from a mobile apparatus equipped with a small swivel.

The pelican body and wings as well as the small fish fob are essentially individual stained glass panels constructed using many of the same basic guidelines given for the SPRING TULIP Window Panel (pp31 & 32).

Assembling the Pelican Panels and the Fish

1 Tape a pattern copy of the fish and the pelican body and the 2 wings to a wood board or level work surface that is several inches larger than the pattern perimeters.

2 Cut (pp15-20), grind (p21) to fit, and foil (pp25 & 26) each piece of glass required for the 3 pelican panels as well as the small fish .

3 Assemble the foiled glass pieces on the patterns, verifying the pieces align properly and fit within outlines of the patterns. Horseshoe nails or pushpins can be fastened along the irregular contours of panels to help glass pieces retain the outlines of each pattern.

4 Tack, tin, and bead solder (pp26 & 27) both sides of the fish and the pelican panels. Solder each seam right to the outside edges.

5 Tin and then solder a finishing bead (p27) along the outside edges of the panels and the fish. Because the edges are not straight and level, rotate each panel slowly as you apply small beads of solder in a touch-and-lift motion. Keep the area that is being soldered as level as possible so that the molten solder does not roll away. Allow the solder to cool and solidify for a few seconds before adding the next bead of solder.

6 Use 18-gauge tinned copper wire to make 2 small hanging loops for attaching the fish fob. Make 8 loops from 14-gauge wire for attaching the wings to the body panel and for fastening the hanging mobile apparatus to the wings. Follow step 16 on p31 for instruction about making the loops required.

7 Attach a small hanging loop to the fish at the location marked on the pattern. Grip an edge of the loop in the jaws of the needlenose pliers and position the loop at the juncture where the vertical seam running through the fish body intersects with the upper edge and the bottom corner of the dorsal fin.

8 Attach 2 hanging loops on the top side of each wing at the solder seam junctures indicated on the pattern. Use the pliers to grasp the loops and hold them perpendicular to the seam junctures as they are soldered in position.

9 Solder a small hanging loop to the bottom edge of the pelican body

10 Use the method described above to solder 2 attachment loops on each side of the pelican body as indicated on the pattern. The round loops must be flattened slightly to form more of an oval shape so that they lay closer to the pelican body. With the split of the loop held within the plier jaws, gently squeeze each loop just enough to mold it into an oval.

11 Clean (p22) fish and pelican panels with neutralizing solution and warm, running water.

12 Use clear silicone to glue an eye (**E**) to each side of the pelican's head. Hold the smooth, colorful jewels in place with masking tape until the silicone sets approximately 24 hours. Read the manufacturer's instructions for specific details.

13 Eyes can be glued to the fish fob if desired. Glue small glass beads or solder balls on both sides of the fish. An alternative method is to attach wire overlays as described for the PELICAN Garden Sprinkler on p119.

Attaching the Wings to the Pelican Body

Once the silicone fastening the eyes to the pelican and the fish fob has set completely the wing panels can be attached to the pelican body.

14 Cut four 2¼ in lengths of 14-gauge tinned copper wire.

15 Bend the 4 wire lengths into U shapes. Center the wire in the jaws of the needlenose pliers and bend each end 90° to form a U shape.

16 Slip 2 U-shaped wires over the straight edges of each wing. Slide a sheet of paper between the wires and the solder seams on the undersides of the wings. Lay the wings on the work surface with the top sides facing upward.

17 Align a U-shaped wire over surface of a solder seam as indicated on pattern. The bent wire end must protrude approximately ¼ in from the edge of a wing to form a loop for attaching wing to pelican body. Use pliers to hold wire in position and tack solder wire to solder seam. Bead solder over length of the wire and corresponding solder seam.

18 When all 4 U-shaped wires are soldered to the top sides, turn the wings over and remove the paper from the underside.

19 Lay the pelican body on the work surface, positioned with the underbelly towards you and the head facing left. Hook the free ends of the U-shaped wires on the underside of the left wing through the top of the 2 attachment loops soldered to the body. Use pliers to gently squeeze the U-shaped wires until the free ends are resting over the solder seams on the underside.

20 Place several layers of padding (newspaper or cloth) over the upper portion of the pelican body. Rest the wing, with the underside facing upward, on the padding and tack the wires in place. The padding will protect the glass body from the heat of the molten solder. Complete the attachment of the wing by bead soldering the wires to the solder seams. Let the wing rest in place until the solder cools.

21 Place several layers of padding on the work surface. Turn the body and attached left wing over and lay the assemblage on the padded surface.

22 Attach the right wing to the other side of the pelican body using the methods described in steps 19 and 20.

23 Clean areas that have just been soldered with neutralizing solution and warm, running water. Buff dry with a clean cloth and apply finishing compound or wax (p23) to the entire project.

Attaching the Fish Fob to the Pelican

24 Use wire cutters to cut a 10 in length of nylon coated stainless steel fishing wire.

25 Insert 1 end of the fishing wire through the hanging loop soldered to the bottom edge of the pelican body. Thread a connector sleeve onto the long end of the fishing wire and slide it close to the hanging loop. Push the shorter end of the wire through the sleeve until it protrudes from the opposite end approximately ¼ in. Pull the long end of the wire taut until the sleeve is approximately ¼ in from the hanging loop.

26 Use wire cutters to gently squeeze the center of the connector sleeve until it is crimped enough that the fishing wire is held firmly in place within the sleeve and cannot be pulled free from either end. Use caution while crimping the sleeve to prevent cutting through the metal or the nylon coated wire with the cutter blades.

27 Place a second connector sleeve onto the free end of the wire. Thread the wire through the hanging loop soldered to the fish and back through the sleeve. Pull the wire taut until only ⅛ in extends from the opposite end of the sleeve and the sleeve is ¼ in from the fish hanging loop. Crimp the sleeve closed as described in step 26. The fish fob will now hang freely from the pelican body.

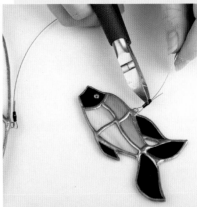

Thread line through connector sleeve, then loop on fish, & back through sleeve. Crimp closed

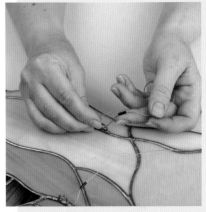

Thread line through sleeve, loop on wing & then back through sleeve

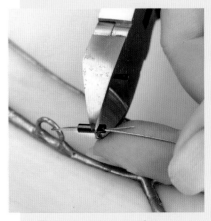

Thread connector sleeve onto fishing wire & slide it close to hanging loop

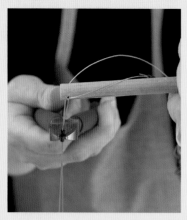

Carefully crimp wires to maintain the desired length

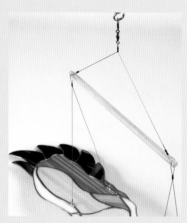

Overhead view of hanging mobile apparatus attached to wing

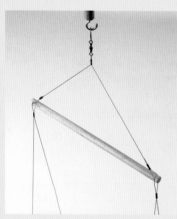

Close-up of upper portion of mobile apparatus

Assembling the Pelican and the Hanging Mobile Apparatus

A hanging mobile apparatus allows the pelican to hang suspended in mid-flight with its wings outstretched. A swivel at the top of the hanging apparatus allows the bird to pivot with the slightest movement of air while a tug on the fish fob will cause the wings to flap gracefully up and down.

28 Begin by cutting a 9 in length of $^3/_8$ in diameter wood dowel with a wood saw.

29 Measure and mark $^1/_4$ in from the ends of the wood dowel and use a power drill with a $^1/_8$ in bit to drill holes at the 2 marks. Smooth away any rough edges or wood burrs with fine grit sandpaper.

30 Use wire cutters to cut 1 – 18 in and 2 – 34 in lengths of nylon coated fishing wire.

31 Thread the swivel onto the 18 in length of wire. Put the wire ends together, bending the wire in half and causing the swivel to slide to the center. Slip a connector sleeve over the 2 wire ends and push it to within $^1/_2$ in of the center. Crimp the sleeve closed as described in step 26.

32 Slide a sleeve over each wire end. Thread a wire through the hole drilled into each end of the wood dowel. Loop the free end of each wire around the dowel and back through the connector sleeve. Pull the free wire ends out through the opposite ends of the sleeves, approximately 2 in. Do not crimp the sleeves at this time, as the lengths of the wires may need adjusting before the pelican mobile is hung.

33 Thread a 34 in length of wire through the lower portion of a hole in the wood dowel. Clasp the ends of the wire together and slide a connector sleeve overtop, pushing it up the wire to within 1 in of the dowel. Do not crimp the sleeve closed at this time.

34 Slide a connector sleeve onto the free end of 1 wire. Slip the wire end through a hanging loop on a wing and back through the sleeve. Pull the wire taut until only $^1/_8$ in extends from the opposite end of the sleeve and the sleeve is $^1/_4$ in from the hanging loop. Crimp the sleeve closed and proceed to attach the remaining free end of the wire to the second hanging loop on the wing.

35 Repeat steps 33 and 34 to attach the second 34 in length of wire to the other end of the wood dowel and to the opposing wing.

36 Carefully lift the pelican by the wood dowel and observe how the body and wings are suspended. To adjust the angle of the body, slide the wires attached to the wings back and forth through the holes in the wood dowel and the adjacent connector sleeve until the desired position is found. The pelican featured is hung with the wings and head slightly elevated as though it has just taken to the air. To tilt the body upward slide the wires so that the ends attached to the front of the wings are shorter than the back.

37 Crimp the connector sleeves beneath the wood dowel to secure the pelican in the preferred position.

38 Verify that the length of the wire with the attached swivel is the correct length for hanging the pelican mobile before crimping the last 2 connector sleeves closed. Shorten the wire by pulling more of it through the holes in the dowel. Adjust and crimp the sleeves accordingly before trimming away excess wire with wire cutters. Replace the fishing wire with a longer piece if additional length is required.

39 Put the pelican mobile on display year round. In cooler months, suspend Pelican Pete from a secure ceiling hook in a sunny room. During the summer months, enjoy watching him gently flap his wings under the strong branch of a sheltering tree in the garden.

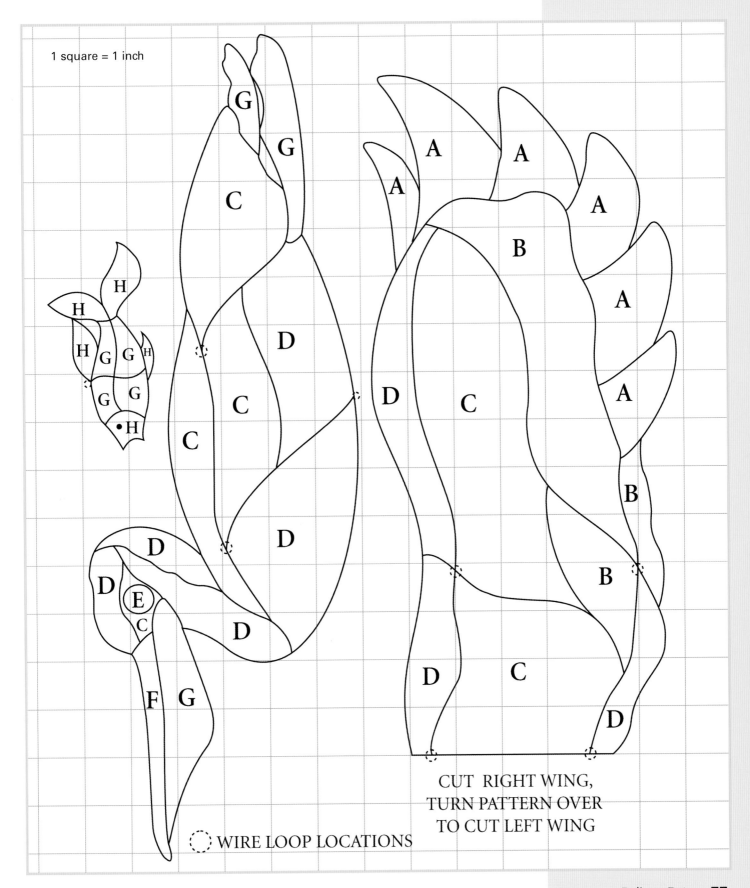

1 square = 1 inch

G

G

C

H
H
H
G G H
G G
G G
•H

C

D

C

C

D

D

A
A
A
A
B
A
A
A
B
D
C
B
B

D
D
E
C
D

F G

⊙ WIRE LOOP LOCATIONS

D C
D C
D

CUT RIGHT WING,
TURN PATTERN OVER
TO CUT LEFT WING

3D Lead Came Construction

Construct stained glass projects in this section by wrapping lead U-channel came around each glass piece, instead of applying copper foil. Pieces are then assembled and soldered together in a particular sequence for a 3-dimensional composition not achieved using the copper foil method.

- A pattern is drawn to the correct scale and 2 or 3 accurate copies are made.
- The glass pieces are cut and then ground to fit the pattern as required.
- Lead U-channel came is wrapped around the perimeter of each glass piece.
- When indicated on the pattern, tinned copper wire is shaped and soldered to the lead wrapped glass pieces to provide decorative elements as well as additional structural support.
- Glass pieces and display/support structures are assembled using the pattern and accompanying illustrations as a guideline.
- Finished project is cleansed with water and neutralizing solution. Applying patina and a protective coating of finishing compound or wax depends on the projects.
- The finished project is installed in the garden

Safety Reminder: Working safely with lead came is not difficult if the craftsperson is aware of proper handling procedures and has a separate area in which to work. Review the material presented in The Work Area (p12) and Safety Practices and Equipment (p13) before beginning any 3D Lead Came Project.

About Lead Came

Inexpensive and pliable, lead is one of the easiest metals to cut, bend, and solder. It is the material traditionally used to manufacture cames, the strips of lead channel that form the structural backbone of a stained glass window. The term "leaded glass" refers to the original, centuries-old method of using lead cames to join and hold together the many pieces of colored glass that have created some of the world's most glorious pieces of religious and secular art.

Cames are produced in a variety of metals and in different lengths, widths, and profiles. There are 2 types of came that are commonly used – H-channel and U-channel. H-channel came consists of 2 back-to-back channels that hold adjoining glass pieces together to create a stained glass window. U-channel has only one channel and has traditionally been used as a border around the perimeter of smaller windows. To assemble the 3-dimensional projects shown in this book, lead U-channel came is used exclusively.

Approximately 6 ft in length, lead U-channel came is comprised of three components – the leaf, the heart (also known as the spine) and the channel. The leaf refers to the flanges on either side of the came that overlaps onto the surfaces of the glass. It has either a flat or a rounded profile and its width is the measurement given when a came size is listed. The channel is the space between each leaf that runs the length of the came. The heart (spine) forms the backbone and is the part of the came that a glass piece rests against inside the channel.

 Note Additional listings of materials and tools will be given for those projects with specific requirements.

Materials

2 copies of pattern
Newspaper
Masking tape
Glass for project
Glass cutter oil
Lead U-channel came
Safety flux
60/40 solder
Neutralizing solution
Wax or finishing compound

Tools

Apron
Safety glasses
Work gloves
Utility knife and/or scissors
Permanent waterproof fine-tipped marker
Cork-backed straightedge
Glass cutter
Breaking/combination pliers
Running pliers
Glass grinder or carborundum stone
Lead vise
Lead cutters or lead knife
Lathekin
Container for lead scraps
Soldering iron and stand
Natural fiber sponge
Flux brush or cotton swabs
Wire cutters or hacksaw
Needlenose pliers
Wood stick (approximately 6 in long)
Rubber or latex gloves
Fine steel wool (000)
Toothbrush
Polishing cloths

Materials and Tools

On p78 side bar is a list of the basic materials and tools required for assembling a stained glass garden project using **3D Lead Came Construction** technique.

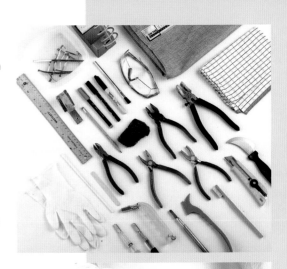

How-To Techniques
Getting Started

Many techniques required to assemble 3-dimensional lead came projects are the same or similar to those demonstrated in previous chapters. See **Basic Techniques** (pp14-23) for detailed instructions on

- making copies of the patterns
- transferring patterns onto glass
- cutting the glass pieces
- smoothing or grinding jagged glass edges
- cleaning the project
- finishing the project – applying patina and finishing compound or wax
- maintaining the project

Techniques specific to **3D Lead Came Construction** are described and illustrated through step-by-step instructions in the following pages.

Stretching Lead Came

Before using, lead came must be stretched to straighten it, remove kinks, and eliminate slack. Stretched came is more rigid and helps prevent the lead from sagging after the stained glass project is assembled and installed.

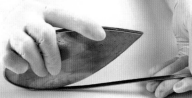

Stretching lead came in vise

1 Lay full length of came on work surface, channel facing up.
2 Manually untwist kinks and straighten the length.
3 Clamp one end of came into lead vise that is securely fastened to end of the work surface.
4 Grasp opposite end of lead came with pliers and slowly pull until it becomes straight and firm. Jaws of pliers should have a serrated surface to maintain a firm grip on the came. Lead should stretch 2 to 3 in, becoming taut. Use a smooth even pulling motion. Do not break the came by jerking or pulling too much.
5 Once stretched, handle lead came carefully to prevent crimps and twists. For easier handling, cut the full length of came into 2 or 3 shorter, more manageable pieces.

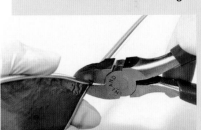

Wrap lead came around glass

Cutting Lead Came

For a tight fit around each glass piece, cut lead came cleanly and evenly, without crushing channels. Use lead came cutters or a lead knife. Practice with scrap lead.

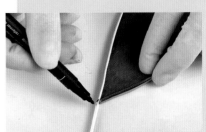

Mark initial cut & angle

Lead Cutters (lead dykes or knippers) look like pliers but have a set of sharp, pointed jaws, ground flat on one side. Lead came can be snipped at a straight or mitered angle.

1 Stretch lead U-channel came (see above) and determine length required to wrap around the perimeter of the glass piece.
2 Mark for initial cut and required angle.
3 Lay came on work surface with channel facing upwards. Hold lead cutters perpendicular to length of came and position the initial mark on the came between cutter blades. Flat side of blades must be facing portion of came being trimmed to fit glass piece and away from excess length being cut away.
4 Use a scissors-like motion to cut lead came to the maximum length required.
5 Trim the top leaf and the bottom leaf to the angle marked.

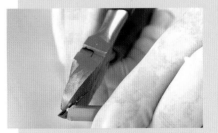

Cut with scissors-like motion

Trim top leaf & bottom leaf to angle marked

When lead came is stretched, the channel may become too narrow to accommodate the width of the glass pieces. Use a lathekin to open up and widen the channel. Insert the end of a lathekin all the way into the came so that it is resting against the bottom of the channel. Gripping the handle, run the lathekin the length of the came, widening the channel as you go.

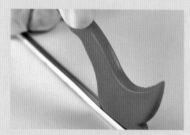

Widening lead came channel with lathekin

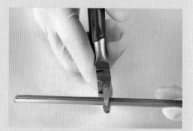

Hold lead cutters perpendicular to lead channel

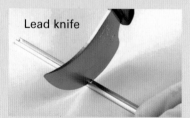

Lead knife

Align blade on mark & use back-and-forth motion to cut came

Lead Knife has a sharp, curved blade with a short, weighted handle and is the traditional implement used for cutting lead came.

1 Stretch the lead U-channel came (p79).
2 Determine the length of came required to wrap around the perimeter of the glass piece.
3 Mark the lead came with a marker for the position and angle of the cut.
4 Position the came on a flat, level work surface. With the leaf of the came facing upward, align the curved knife blade on the cutting mark.
5 Rock the knife in a back-and-forth motion, exerting an even, gentle pressure until the blade slices completely through the lead.

Regardless of cutting tool used, leaves of lead came channel may become slightly compressed at the end that has just been cut. Use the lathekin to re-open and widen channel again.

Helpful Hints

Cutting lead came dulls the blades of any type of lead cutting tool. Frequent sharpening on a carborundum stone is recommended when using a lead knife. Place a few drops of lightweight machine oil on the top surface of the stone. Holding the blade almost parallel to the stone surface, use a circular motion to sharpen the blade. Always sharpen both sides of the knife blade. Lead dykes do not wear as quickly and should be taken to a professional tool-sharpener when sharpening is required.

Wrapping Glass Pieces With Lead Came

Each piece of glass necessary for assembling a 3D lead came project must be wrapped with the appropriate lead U-channel came. The size and function determines the width of lead came necessary to construct each garden project. The materials listed for each project will specify which of the two widths – $1/8$ in or $5/64$ in – are to be used.

Before you begin, cut each glass piece (pp15-20) required for the project and smooth any jagged edges and bumps along the perimeter of each piece (pp20 & 21).

1 Stretch (p79) lead U-channel came and cut (pp79 & 80) into 2 or 3 shorter lengths.
2 Lay the stretched came on the work surface with the channel facing upwards.
3 Slide an edge of the glass piece into the stretched came to verify that the channel is wide enough to receive the glass. If the glass does not slip easily into the came, widen the channel using a lathekin or bevel thick glass edges. Use a glass grinder (p21) to bevel the edges by holding the glass at a 45° angle to the diamond-coated bit. Bevel both sides of the glass until the piece fits within the came channel.
4 Fit a corner of the glass piece into 1 end of the lead channel. The end of the came may need to be trimmed at an angle so that it will butt neatly against the other end of the came once the glass piece is wrapped. Mark the angle with a marker and snip both the front leaf and the back leaf of the end of the came with lead cutters.
5 Begin fitting the came to the perimeter of the glass, making sure the glass is firmly seated within the channel and the trimmed end of came is positioned correctly. Use your hands and the work surface to help the lead conform to the contours of the glass shape.
6 Once lead came has been wrapped around entire piece, use a marker to mark position and angle where wrapped portion of lead needs to be cut away from longer length of came.
7 Cut piece of lead came at the mark and trim top leaf and bottom leaf as necessary. Both ends of came should now butt together forming a neat lead joint without any gaps.
8 Proceed to wrap each piece of glass with lead U-channel came. Once all pieces are wrapped with came, the lead joint on each piece can be soldered together.

Soldering the Project

Once each piece of glass required for a garden project is wrapped with lead, the juncture where the 2 ends of the cames butt together must be soldered. By soldering the lead came ends together, the glass piece and the lead came are held securely in position, creating a sturdy framework for the stained glass garden project. Use a soldering iron designed for stained glass crafting that is equipped with a narrow chisel-type tip and has some form of temperature control. Soldering a lead came project requires an iron that can maintain a slightly lower temperature than needed for soldering the seams of a copper foil project. Popular models include 100-watt soldering irons with temperature controls built into the iron handle or interchangeable tips of varying size and temperatures. A rheostat can also regulate irons without built-in temperature controls. Always solder in a well-ventilated area and on a level work surface. Wear your safety glasses and a work apron. Please review Safety Practices and Equipment (p13) before soldering.

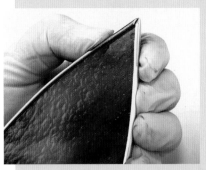

Ends of came are trimmed & butt together to form a neat lead joint

1 Plug in soldering iron. Moisten a natural fiber sponge with water and place in holder on soldering iron stand.

2 Examine the came joint for gaps. The ends of the came should be flush against each other. Cut a new piece of came if the gap cannot be bridged with solder.

3 Pour a small amount of safety flux into a separate container and replace the cap on the flux bottle to prevent spills. Unwind several inches of the solder wire from the spool.

4 Using a cotton swab or a small brush dab flux onto the came joint. Grasp the soldering iron handle like a hammer, in your writing hand. Hold glass piece in opposite hand (covered with a work glove), pressing the 2 came ends together to form the joint. Apply hot iron tip to solder wire and melt a small bead onto tip. Lightly press the tip to the came, melting the solder to the joint. Hold the iron tip to the joint long enough for the solder to melt evenly, joining the 2 ends of the came together. This should only take a few seconds, depending on how hot iron tip is and the type and thickness of came being soldered. Lift iron tip away from the came and allow joint to cool. A properly soldered came joint should be smooth and slightly rounded. Apply more solder, if required.

5 Turn the glass piece over. Apply solder to the underside of the came joint if required.

6 Check the outer edge of the wrapped glass piece. If a slight gap remains where the lead came ends meet, solder the space closed.

7 Solder together the came joints of all the wrapped glass pieces in the same manner. At regular intervals, wipe the soldering iron tip on the water-moistened sponge to remove flux residue and to cool the tip. An overheated tip can melt lead came upon contact.

8 After the soldered joints have cooled, wipe off excess flux with a damp cloth and neutralizing solution.

9 Follow the instructions given to assemble and solder the wrapped glass pieces into the garden project of your choice.

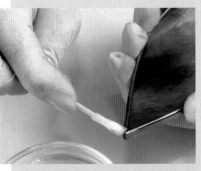

Dab flux onto came joint with cotton swab

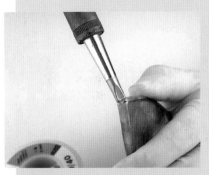

Melt a small bead of solder to the joint

Helpful Hints for Soldering

Soldering a 3D lead came project is a skill easily mastered in a short period of time. Refer to the accompanying photos to see how the came joints should look when properly soldered. Here are some soldering guidelines

- Holding soldering iron tip to lead came longer than necessary can cause lead to melt away. Take a few minutes to practice soldering together scraps of lead came before attempting to solder your project. If you do happen to melt the lead came, allow lead to cool. Cut and wrap glass with a new piece of lead came or cut a small piece of lead to place over the hole in the came, apply flux, and solder the joint as normal.

A smooth & slightly round solder joint

- Hold wire overlays in place with 6 in wood stick (chopsticks, dowel, or craft stick) while soldering to prevent wire from moving until solder has solidified and to avoid burning hands.
- If solder will not melt and flow smoothly while soldering the came joints, one of several factors could be the cause. Remember to
 – Apply flux to came joint. This is most common reason solder will not melt to lead came.
 – Clean dirty lead came surfaces joints by gently rubbing them with a fine steel wool (000) to remove oxidation and apply flux so the solder will flow and bond smoothly to the came.
 – Maintain the iron tip at the proper temperature for the type of came being soldered. An iron tip that is too hot will melt away the leaf on lead cames. A tip that is too cool will not heat the solder and the came thoroughly enough for an adequately bonded joint and the solder will form rough peaks instead of a smooth surface. Frequently wipe the hot iron tip on the water-moistened sponge to remove flux residue and to cool the tip.

Soldering Copper Pipe Joints

Several of the projects require soldering copper fittings and lengths of copper pipe together. In particular, the solder joints on the garden sprinkler hardware must be watertight to maintain the necessary water pressure in order for the sprinkler to consistently spray streams of water. Wear work gloves with a leather palm when handling hot copper pipes and fittings.

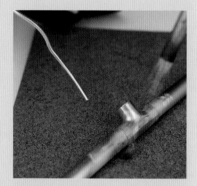

Pass torch flame slowly back & forth over copper pipe joint until flux bubbles

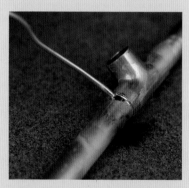

Heat until solder wicks into fitting & seals copper joint

1 Use a pipe cutter to cut (pp47 & 48) the required lengths of copper pipe for the project. Other tools may crush or warp the ends of the pipe. Remove any burrs from the ends of the pipe using the de-burring tool on the pipe cutter or a small metal file.

2 Clean the copper pipe and the fittings to facilitate a good solder joint. Rub copper surfaces with a medium weight emery cloth or fine steel wool (000) to remove dirt and oxidation. The end of the pipe must be cleaned at least $1/2$ in past the edge of the fitting once the 2 pieces are put together.

3 Apply a generous amount of flux to the inside of the fitting and to the outside of the copper pipe. Insert the pipe all the way into the fitting.

4 Place the pipe joint on a noncombustible surface such as concrete, stone, or an old ceramic tile. Unroll an 8 in to 10 in length from the solder spool and set it aside but have it within reach.

5 A propane torch is used to solder the copper joint due to the amount of heat it can generate. Read and follow the manufacturer's operating instructions and safety precautions before lighting the torch. Once lit, pass the torch flame slowly back and forth over the joint of the copper pipe and the fitting. The flame is composed of several "feather" shapes that are actually varying degrees of heat within the flame. Position so that the copper joint is being heated with the expanse of the flame just ahead of the innermost "feather". Heat the copper joint until the flux starts to bubble.

6 Pick the solder spool up with your free hand. Place the end of the unrolled solder where the pipe and the fitting meet, melting a small amount of solder onto the copper joint. Continue heating until the solder flows all around the end of the pipe and wicks into the fitting, sealing the copper joint.

7 Remove the flame and allow the solder to solidify before moving the copper pieces. If there is more than 1 joint, continue soldering joints while there is still residual heat in the copper. This will lessen the amount of time needed to heat and solder the remaining joints. Turn the propane torch off immediately after the soldering is complete.

8 Remove any flux residue with warm water and neutralizing solution. Fine steel wool (000) can be used to rub off any unwanted heat discoloration marks that may have occurred while soldering the copper joint.

Replacing Cracked or Broken Glass Pieces

If a glass piece breaks and needs replacing, location of the broken piece will dictate how the glass is removed and a substitute put in its place.

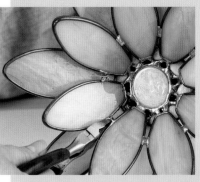

1 Mark the lead came joints that need to be severed to separate the broken glass piece and the came surrounding it from the rest of the project.
2 Use lead cutters to cut through each of the marked solder joints at the point where the cames butt against each other.
3 Remove any wire attached to lead came and extract the broken glass piece.
4 Use project pattern to cut a new glass piece. If original came wrapped around broken glass piece is still intact, insert replacement glass into the came, smoothing jagged edges (pp20 & 21). Wrap glass with a fresh piece of came if lead is bent and misshapen.
5 Flux and solder the juncture where the 2 ends of the came butt up against each other. Reattach all applicable wire overlays to the lead came wrapped around the new piece.
6 Flux any bumps of solder that remain on the surrounding lead cames. Apply the hot soldering iron tip to the came just long enough to smooth the bumpy surface.
7 Position new glass piece in appropriate location on project. Flux and solder each juncture where replacement piece rests adjacent to another wrapped piece of glass.
8 Clean the soldered area with warm water and neutralizing solution. Dull the brighter finish of the fresh solder by rubbing with fine steel wool (000).

Use lead cutters to cut through solder joints to separate the broken glass

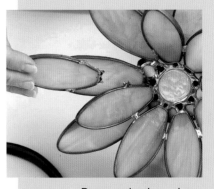

Remove broken glass

Helpful Hints

• When cutting through a solder joint with a pair of lead cutters is not possible, use this alternative method

1 Use a pair of utility scissors to cut a strip of aluminum from an empty soda can and wrap one end of the aluminum strip with masking tape.
2 Apply a hot iron tip to the came joint, taking care not to melt the underlying came. As the solder on the joint becomes molten, draw the iron tip across the joint, pulling solder away with the iron tip. Wipe the excess solder off the tip and onto the water-moistened sponge used for cleaning the tip.
3 Heating the joint with the hot iron tip, separate the cames butted together at this point by wedging the aluminum strip between them. To prevent burns or cuts, grasp the aluminum strip by the end wrapped with masking tape.

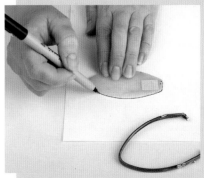

• When a pattern copy is not available make a template of the broken glass piece to trace the required shape onto a new piece of glass.
A If all the fragments of the broken piece are present and are not too small, assemble and tape the fragments together to form a template and trace outline of taped piece onto new sheet of glass.

Or

B If lead came remains intact and in the correct shape (glass is missing or cannot be pieced), position a sheet of cardstock under the space and trace along the inside of lead came for the outline of the missing glass shape. Make traced outline slightly larger to accommodate the depth of lead came channel that will surround the perimeter of the glass shape. Insert ruler end into came channel to determine the extra width needed, enlarge template perimeter by amount required, and cut template from sheet of cardstock. Use lead cutters to separate lead came joint and pry the ends of came apart just enough to place template into opening. Press lead came ends back together to verify that template is accurate. Adjust the template if necessary.

Assemble & tape fragments together to form a template

3D Lead Came

Projects & Patterns

Lazybug
Garden Stake

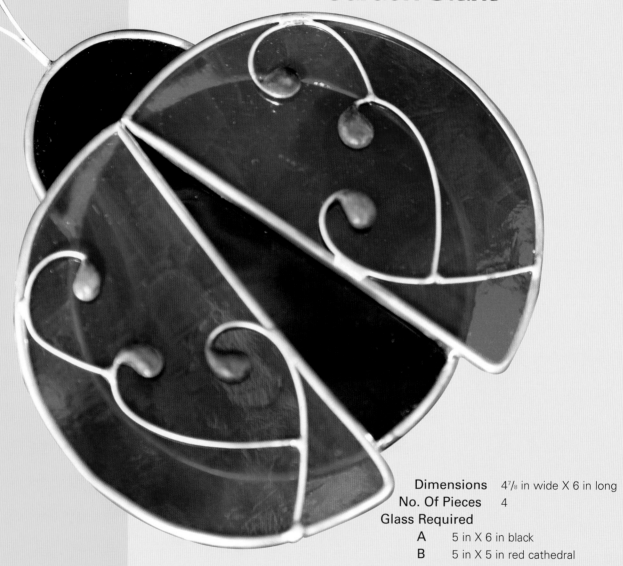

Dimensions	4⁷⁄₈ in wide X 6 in long
No. Of Pieces	4
Glass Required	
A	5 in X 6 in black
B	5 in X 5 in red cathedral

Letters identify type of glass used on pattern (p86). The quantity of glass listed is a close approximation of the amount needed for the pattern. You may wish to purchase more glass to allow for matching textures and grain.

Instructions

1. Make 2 copies (p14) of the pattern on p86. Use one copy as a guide to cut the glass pieces to the required shape and size. Use the second copy to fit and solder the project together. If opalescent glass is used in this project, make a third copy and cut out the necessary pattern pieces for use as tracing templates.

2. Use the marker to trace (p15) each pattern piece on the glass to be cut.

3. Cut (pp15-20) each piece of glass required, making sure to cut inside the marker line.

4. As required, grind (p21) or smooth any jagged edges (pp20 & 21) so that each glass piece fits within the pattern lines. Rinse each piece under clean running water to remove any grinding residue and dry with a clean cloth.

5. Wrap (p80) each glass piece with lead U-channel came.

6. On each wrapped glass piece, solder (pp81 & 82) together the juncture where the 2 ends of the lead came butt together.

Joining the Head and Body Pieces

7. Position the head and body pieces on the pattern. Tack solder (p26) the 2 pieces together.

8. Bead solder (p27) over adjacent lead cames, forming a solder seam that joins body and head securely. Due to the thinness of the lead came, do not leave the hot iron tip on the came for any length of time or the lead may melt away. Let the solder seam cool.

9. Turn body and head over. Solder a seam along adjacent lead cames on opposite side.

Attaching the Wire Curlicues and Antennae

10. Shape and cut the pieces of 16-gauge tinned copper wire to form the antennae and the curlicue overlays for the wingbacks, as indicated on the pattern. The wire curlicues are design elements that also help hold the lead came tightly around the glass wingbacks.

11. Holding the 2 antenna wires together with needlenose pliers, tack solder the straight ends of the wire together. Let the soldered wires cool.

12. Center the soldered ends of the antennae against the lead came wrapped around the lazybug head. Flux and solder the antennae to the lead came.

13. Lay the wire curlicues over the pattern and fasten in position with masking tape.

14. Apply flux and large beads of solder to the loops formed at the end of each wire curlicue. Add molten solder until the loops are completely filled and form rounded spots of solder. Let the solder cool.

15. Solder the 3 wire curlicues for each wingback together as shown on the pattern.

16. Once the wires have cooled, position the curlicues on the wingbacks and bead solder in place.

17. Position the wingbacks over the lazybug body as shown on the pattern. Bead solder the wings to the center of the solder seam that joins the body and head together and at the junctures where the wingbacks touch the lead came wrapped around bottom of body.

Attaching the Garden Stake

18. Use wire cutters to cut 2 pieces of zinc U-channel came (pp21 & 22) - 1 piece $3\frac{1}{2}$ in; 1 piece $1\frac{3}{4}$ in.

19. Turn the lazybug upside down and position the $3\frac{1}{2}$ in piece of zinc came horizontally across the middle of the body. Apply flux and solder zinc came securely to the lead came wrapped around the glass body.

Additional Materials & Tools Required

Materials
- 1 length of $\frac{5}{64}$ in lead U-channel came
- 16-gauge tinned copper wire
- 1 length of $\frac{1}{8}$ in zinc U-channel came
- $\frac{3}{16}$ in steel rod (24 in – 36 in)
- Black patina

Tools
- Heavy-gauge wire cutters

Note

Quantities of cames listed are based on a 6 ft length.

Note

LAZYBUG can also be displayed in a window. Instead of attaching the lazybug to a garden stake, solder a hanging loop to the center of the solder seam (on underside of Lazybug) that joins the head and body pieces. Thread heavy-duty monofilament line through the hanging loop and suspend the lazybug from a cup hook screwed into the window frame.

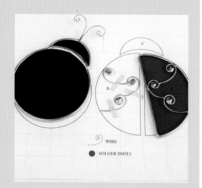

Solder wire curlicues together
before soldering to
wing backs

20 Butt 1 end of the 1³⁄₄ in length of zinc came against the center of the zinc already attached and the other end to the center of the solder seam joining the head and the body. Flux and solder the ends of the zinc came in place, forming a T shape.

21 Use heavy-gauge wire cutters to cut the desired length of steel rod to complete the garden stake.

22 Position the steel rod perpendicular to the lazybug body and place 1 end into the channel of the long piece of zinc. Solder the rod securely to the zinc cames at the juncture where the 2 pieces of zinc meet.

23 Apply black patina (pp22 & 23) to rounded spots of solder on wing backs with cotton swab.

24 Clean (p22) the project and apply a protective coat of finishing compound or wax (p23).

25 Display the finished garden stake in the garden or a flower pot. Press the rod several inches into the soil until the lazybug sits firmly in place and at the height desired.

Helpful Hints

• Use a wood stick to hold wire and metal overlays in place while soldering. Some metal implements may adhere to the solder while plastic tools may melt as overlays and wires heat up. Wooden chopsticks or pieces of small wood dowel are excellent, inexpensive tools for this task.

• Metal rods and cames become hot to the touch during the soldering stage. Wear work gloves or use a cloth to hold steel rods or when holding the ends of lead came together to solder the joints.

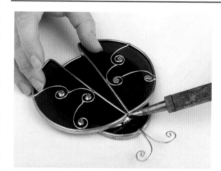

Bead solder wing backs to solder
seam & lead came around
the body

1 square = 1 inch

- - - ꞔ WIRE

● SOLDER INFILL

A

A

LAYOUT LINES FOR
ZINC CHANNEL

B B

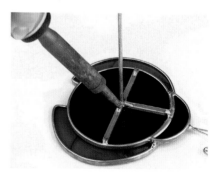

Solder zinc came pieces & steel
rod to back of lazybug to
complete garden stake

Luna Moth
Garden Jiggle Stake

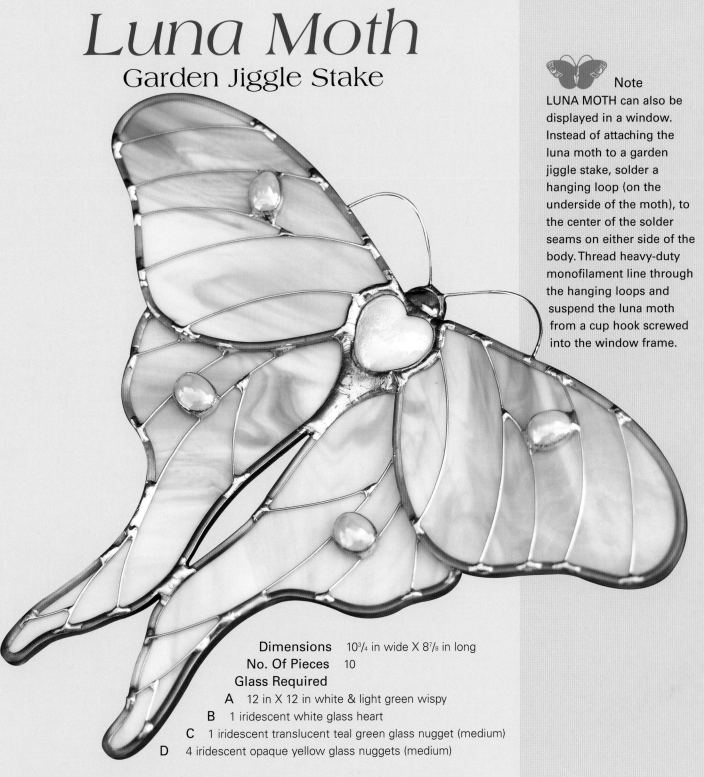

Note
LUNA MOTH can also be displayed in a window. Instead of attaching the luna moth to a garden jiggle stake, solder a hanging loop (on the underside of the moth), to the center of the solder seams on either side of the body. Thread heavy-duty monofilament line through the hanging loops and suspend the luna moth from a cup hook screwed into the window frame.

Dimensions $10\frac{3}{4}$ in wide X $8\frac{7}{8}$ in long

No. Of Pieces 10

Glass Required

A 12 in X 12 in white & light green wispy

B 1 iridescent white glass heart

C 1 iridescent translucent teal green glass nugget (medium)

D 4 iridescent opaque yellow glass nuggets (medium)

Letters identify type of glass used on pattern (p89). The quantity of glass listed is a close approximation of the amount needed for the pattern. You may wish to purchase more glass to allow for matching textures and grain.

Additional Materials & Tools Required

Materials
- Black-backed copper foil
- 1 length of ⅛ in lead U-channel came
- 16-gauge tinned copper wire
- 2½ in zinc brass-plated or nickel door stopper spring
- ³⁄₁₆ in steel rod (24 in – 36 in)
- Black patina

Tools
- Heavy-gauge wire cutters

Note
Quantities of cames listed are based on a 6 ft length.

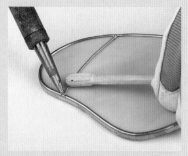

Hold wire in place with wood stick & solder wire end to lead came

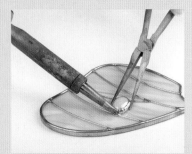

Tack & bead solder glass nugget to the wires on upper wing

Instructions

1 Follow steps 1 to 6 as given for the LAZYBUG Garden Stake (p85) with these additional instructions.
- Grind the glass nugget (**C**) to form the head shape.
- Glass wing pieces (**A**) are wrapped with lead U-channel came. Wrap glass nuggets (**C**, **D**) and glass heart (**B**) with copper foil, crimp, and burnish down edges (pp25 & 26).

Preparing the Upper Wing Pieces
Using the pattern (p89) as a guide, attach the glass nuggets and the decorative wire accents to the upper wing pieces. The wire accents also serve to hold the lead came tightly to the contours of the glass wing shape as well as provide a strategic spot to attach the glass nuggets. Start at one end of a wing and work towards the other end as you attach the tinned copper wires to the lead U-channel came.

2 Tin (p27) and then solder a finishing bead (p27) around the foiled edges of the 4 iridescent yellow glass nuggets (**D**). Set aside to cool.

3 Use wire cutters to cut a length of tinned copper wire (approximately 16 in).

4 Tack (p26) and bead solder one end of the wire to lead came at the top edge of a wing.

5 Shape the wire as shown on the pattern. Use wire cutters to sever the wire where it contacts the lead came at the lower edge of the wing.

6 Hold the wire in place with a wood stick and solder the free end to the lead came.

7 Attach the remaining wire accents in the same manner.

8 Tack and bead solder a glass nugget (**D**) to the attached wires as indicated on pattern.

9 Repeat steps 3 to 8 to attach the wires and a glass nugget (**D**) to the second upper wing. The 2 remaining glass nuggets (**D**) will be attached to the lower wings in step 17.

Assembling the Lower Wings, Head, and Body
10 Tin the copper foil around the glass heart (**B**) and the glass nugget (**C**).

11 Position the head, body, and the 2 lower wings on the pattern. Tack and bead solder the pieces together at all points where they rest adjacent to each other.

12 Fill the gap between base of body and wings with solder. Allow solder to cool.

13 Turn the attached pieces over and bead solder the underside in the appropriate locations.

Attaching the Upper Wings
14 Referring to the pattern, position an upper wing over attached head, body, and lower wing pieces. Tilt outer edges of upper wing slightly upward and forward. Lead came around lower portion of upper wing must contact the came on the outermost edge on lower wing and the solder around the body. Tack and bead solder wing in place.

15 Turn the attached pieces over and bead solder the underside in the appropriate locations.

16 Attach the remaining upper wing following steps 14 and 15.

Completing the Luna Moth
17 Attach the decorative wire accents and the 2 remaining glass nuggets (**D**) by following the instructions given in steps 3 to 9. Wires are soldered to lead came around lower portion of upper wings and to the came along the sides of the lower wings.

18 Apply a finishing bead of solder around the top of the glass nugget head.

19 Shape and cut 2 pieces of tinned wire to form the moth antennae as indicated on the pattern. Use needlenose pliers to hold the wire antennae as you tack and bead solder them in position to the head and the lead came around the upper wings.

Making and Attaching the Garden Jiggle Stake

20 To make the garden jiggle stake follow the instructions given in steps 16 and 17 for the ANGELICA Garden Jiggle Stake (p52).

21 Place luna moth face down on work surface. Center the wide end of the jiggle stake spring on solder seams around the base of the body and adjacent lower wings.

22 Holding the jiggle stake perpendicular to the luna moth, tack and bead solder the spring to solder seams at each point where the spring and seams come in contact.

23 Apply black patina (pp22 & 23) to the jiggle stake spring and steel rod to camouflage the varying colors of metal.

24 Clean (p22) the project and apply a protective coat of finishing compound or wax (p23).

25 Display the finished garden stake in the garden or a flowerpot. Press the rod several inches into the soil until the luna moth sits firmly in place and at the height desired.

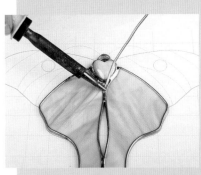

Bead solder head, body, & wings together. Fill gap between base of body & wings with solder

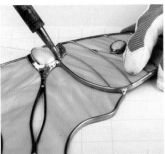

Tilt upper wing slightly upward & bead solder to lower wing & body

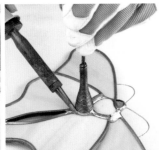

Solder jiggle stake to underside of body & lower wings

Helpful Hints

• Use a wood stick to hold wire and metal overlays in place while soldering. Some metal implements may adhere to the solder while plastic tools may melt as overlays and wires heat up. Wooden chopsticks or pieces of small wood dowel are excellent, inexpensive tools for this task.

• If the glass heart indicated is not available in your area, substitute with a complementary glass shape or cut a piece of stained glass to suit. Adjust the pattern accordingly.

• Instead of using wider copper foil on thicker glass shapes (like the glass heart in this project), use a more common width of foil. Wrap overlapping rows of $^7/_{32}$ in or $^1/_4$ in copper foil around the perimeter of the shape until the edges are properly covered.

• Metal rods and cames become hot to the touch during the soldering stage. Wear work gloves or use a cloth to hold steel rods or when holding the ends of lead came together to solder the joints.

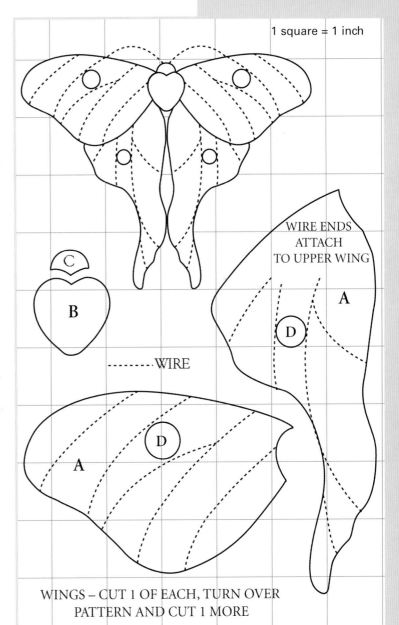

1 square = 1 inch

WIRE ENDS ATTACH TO UPPER WING

C

B

A

D

------ WIRE

D

A

WINGS – CUT 1 OF EACH, TURN OVER PATTERN AND CUT 1 MORE

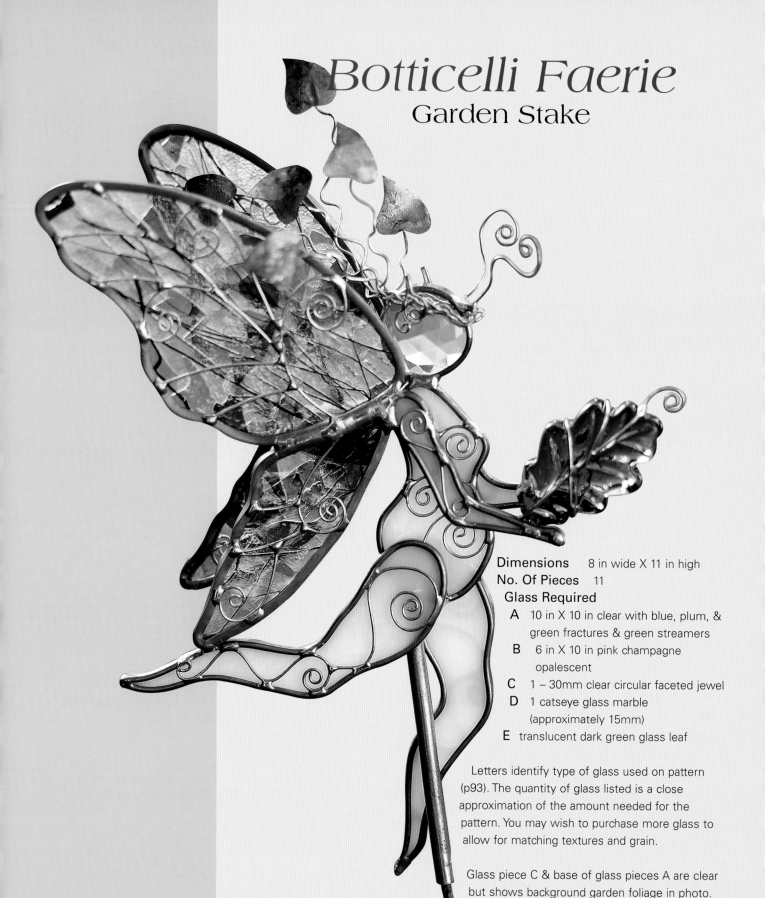

Botticelli Faerie
Garden Stake

Dimensions 8 in wide X 11 in high
No. Of Pieces 11
Glass Required

A 10 in X 10 in clear with blue, plum, &
 green fractures & green streamers
B 6 in X 10 in pink champagne
 opalescent
C 1 – 30mm clear circular faceted jewel
D 1 catseye glass marble
 (approximately 15mm)
E translucent dark green glass leaf

Letters identify type of glass used on pattern
(p93). The quantity of glass listed is a close
approximation of the amount needed for the
pattern. You may wish to purchase more glass to
allow for matching textures and grain.

Glass piece C & base of glass pieces A are clear
but shows background garden foliage in photo.

Instructions

1 Follow steps 1 to 6 as given for the LAZYBUG Garden Stake (p85) with these additional instructions.

Glass wing pieces (**A**) are wrapped with the heavier ¹/₈ in lead U-channel came. Wrap the glass body pieces (**B**), the faceted jewel head (**C**), and the catseye marble (**D**) with the thinner ⁵/₆₄ in lead U-channel came.

2 Shape and cut pieces of 16-gauge tinned copper wire to form the spirals and curlicues that decorate the glass torso, arms, and legs (**B**) as well as wing pieces (**A**), as indicated on pattern (p93). Use needlenose pliers to form spiral shapes. The wires are design elements that also provide support to hold lead came tightly to the contours of glass pieces.

3 Referring to the pattern and the accompanying photos, bead solder (p27) the shaped wires to the lead came wrapped around each glass piece.

Assembling the Wings and the Faerie Body

In order to display the Botticelli Faerie in the garden, a 4 in copper tube sleeve is soldered to the lower portion of the faerie torso and the legs. Once the faerie is completely assembled, one end of a steel rod is pushed into the garden soil and the other end is inserted into the copper sleeve attached to the faerie.

4 To cut the required piece from a longer length of ¹/₄ in copper tube, measure and mark 4 in from the end of the tube.

5 Fasten pipe cutter to copper tube at the mark. Score and cut tube by continually rotating and tightening the cutter until the 4 in length separates from larger piece. See photo p48.

6 Clean the entire surface of the copper tube by rubbing with fine steel wool (000).

7 Use heavy-gauge wire cutters to make 2 opposing cuts (¹/₄ in long) at one end of copper tube piece. Use needlenose pliers to bend cut ends of tube back until they conform to lower edge of torso. Smooth away any burrs or rough edges with a metal file.

8 Flux and tin solder (p27) the outside surface of the copper tube piece. Set the tinned copper tube aside to cool until required for assembly in step 14.

9 Place one set of upper and lower wing pieces on the pattern. Tack (p26) and bead solder (p27) the pieces together where the lead cames rest adjacent to each other. Use masking tape or a wood stick to hold the 2 wires (that are attached to the lead cames being soldered) in position. Allow the solder to cool.

10 Turn the attached wing pieces over and bead solder the seam on the underside.

11 Assemble the second pair of wings following steps 9 and 10.

12 Position the faerie torso and jewel head (**C**) on the pattern. Tack and bead solder head to torso where the lead cames rest adjacent to one another. Allow the solder to cool before turning attached pieces over and bead soldering seam on underside.

13 Turn faerie front side up. Lay the right arm and right leg pieces in the correct positions over the torso and bead solder in place.

14 Turn the faerie over, front side facing down. Center copper tube flanges (see photo) against lead came on lower portion of faerie torso. Wear work gloves or use a cloth to hold tube in position. Tack and bead solder tube to lead came of the lower torso and where tube contacts the came on underside of attached right leg.

15 Lay left arm and left leg pieces over the torso (see pattern). Bead solder in place at each point that the lead came wrapped around the pieces contacts torso came or copper tube.

Additional Materials & Tools Required

Materials

- 1 length of ⁵/₆₄ in lead U-channel came
- 1 length of ¹/₈ in lead U-channel came
- 16-gauge tinned copper wire
- 4 in length of ¹/₄ in copper tube
- 36-gauge medium weight tooling copper
- ³/₁₆ in steel rod (24 in – 36 in)

Tools

- Heavy-gauge wire cutters
- Pipe cutter
- Metal file
- Wood dowel or power drill
- Vise

Note

Quantities of cames listed are based on a 6 ft length.

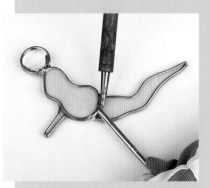

Conform flanges to lower edge of torso. Tin tube, then solder in place

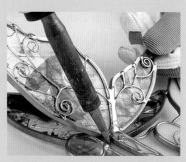

Solder wings securely to faerie at each contact point

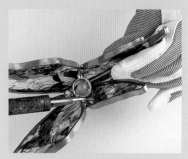

Marble soldered between wings gives additional support to faerie

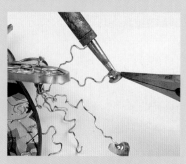

Hold copper leaves with needlenose pliers & solder to ends of wire strands

Solder ears to halo & the antennae to lead came & front of halo

16 Place the faerie body front side up and use the pattern and the photos as a reference to begin attaching the wings. Position the front wing with the lower tip resting on the front leg, the edge of the solder seam connecting the wing pieces resting on the front shoulder, and the came above the solder seam where it comes in contact with the lower back portion of the head. Tilt the wing slightly forward to allow the lead came surrounding each piece to come in contact. Flux and bead solder in place.

17 Turn the faerie over and bead solder the contact points on the opposite side.

18 Rest the outer edge of the back wing solder seam on the left shoulder. Tilt the wing slightly forward so that it rests higher than the front wing.

19 Place the catseye marble (**D**) between the solder seams of the two wings. Adjust the position of the back wing as needed and then tack and bead solder the wings to the lead came around the marble. Bead solder the back wing securely to the shoulder and head.

Attaching the Halo and the Copper Leaves

20 Twist ends of three – 15 in lengths of tinned copper wire together. Clamp twisted wire ends in a vise secured to work surface. Pull wires tight and wrap free ends several times around a piece of wood dowel. Holding wires taut, turn wood dowel until entire length has been twisted. Cut twisted wire away from the dowel and release other end from the vise. Use wire cutters to trim ends of twisted wire length.

21 Form a loose loop in the middle of the twisted wire. Drape the loop around the faerie head, crossing the ends of the loop behind the head. Bead solder the wire to the lead came at the front and at the back of the head to form an irregular halo. Create a natural, organic look, using the needlenose pliers to grasp and slightly twist the wire halo in several spots until the desired affect is achieved.

22 Unravel the twisted wire ends to create curly strands of hair. Use wire cutters to trim the strands to varying lengths.

23 Place a pattern copy over the medium weight copper sheet. Press firmly, use pen to trace 6 leaf shapes onto the copper. Remove pattern, revealing leaf impressions on copper surface. Cut the leaves from the copper sheet with a pair of scissors.

24 Use needlenose pliers to hold the copper leaves steady against the ends of the wire strands and solder them in place. A nice flat solder joint is preferable to a raised bead. Refer to the accompanying photo. Bend and curve the wire stems and the copper leaves to create a more natural appearance.

Attaching the Glass Leaf and the Faerie Antennae and Ears

25 Use the pattern as a guide to shape and cut the pieces of 16-gauge tinned copper wire to form the antennae and the ear shapes.

26 At the front of the head, bead solder the antennae to the lead came and the top of the wire halo just above the solder joint where the halo is already attached.

27 Using needlenose pliers, rest the front wire ear shape against the halo and bead solder in place as shown in the photos (pp90 & 92).

28 Bead solder the other ear shape to the halo on the opposite side, slightly forward of front ear so that both ears are visible when viewed from either side of the faerie.

29 Cut a 14-in length of tinned copper wire. Beginning with 1 end pressed into a curve at the top of the leaf tip, wrap the wire tightly around the glass leaf several times. Crisscross back and forth until the wire loops around back to the starting position.

30 Bead solder first wire end to the last wire loop that returned to the tip of the leaf. To keep wire loops securely in position, bead solder at each juncture that wire crisscrosses over itself.

31 Cut the wire so that 1½ in remains free at the tip of the leaf. Use needlenose pliers to form a spiral at the end of the wire.

32 Place the glass leaf in the faerie's arms. Bead solder at each point that the wire surrounding the leaf touches the lead came wrapped around the arms.

33 Apply copper patina (pp22& 23) to silver wire ends and solder visible on copper leaves.

34 Clean (p23) the project and apply a protective coat of finishing compound or wax (p23).

35 Display the finished BOTTICELLI FAERIE in the garden or a favorite flowerpot kept indoors. Press the steel rod several inches into the soil. Slip the tinned copper sleeve attached to the faerie over the upper end of the rod. The faerie can be rotated on the rod into the preferred pose.

Solder wire of glass leaf to faerie arms

Helpful Hints

- Use a wood stick to hold wire and metal overlays in place while soldering. Some metal implements may adhere to the solder while plastic tools may melt as overlays and wires heat up. Wooden chopsticks or pieces of small wood dowel are excellent, inexpensive tools for this task.

- Glass as well as metal rods and cames become hot to the touch (especially smaller projects) during the soldering stage. Wear work gloves or use a cloth when handling projects, to prevent burns (from hot metal and glass or molten solder) while soldering, or when holding the ends of lead came together to solder the joints.

- If the glass leaf or the faceted jewel indicated is not available in your area, substitute with a complementary glass shape or cut a piece of stained glass to suit. Adjust the pattern accordingly.

- A power drill can be used to twist lengths of wire, quickly and uniformly. Instead of using a wood dowel, twist the ends of the wire together and insert into the chuck of the drill, tightening the chuck until the wire is firmly secured. With the other ends of the wires clamped in a vise and the wires held taut, turn the power drill on to twist the wires.

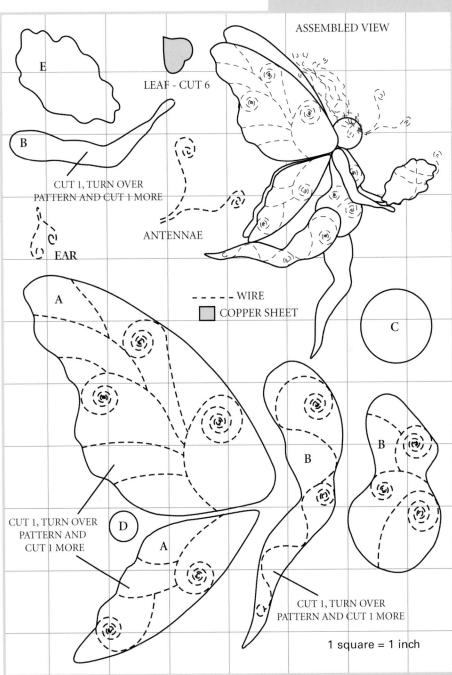

ASSEMBLED VIEW

E

LEAF - CUT 6

B

CUT 1, TURN OVER
PATTERN AND CUT 1 MORE

ANTENNAE

EAR

A

- - - - WIRE

COPPER SHEET

C

B

B

CUT 1, TURN OVER
PATTERN AND
CUT 1 MORE

D

A

CUT 1, TURN OVER
PATTERN AND CUT 1 MORE

1 square = 1 inch

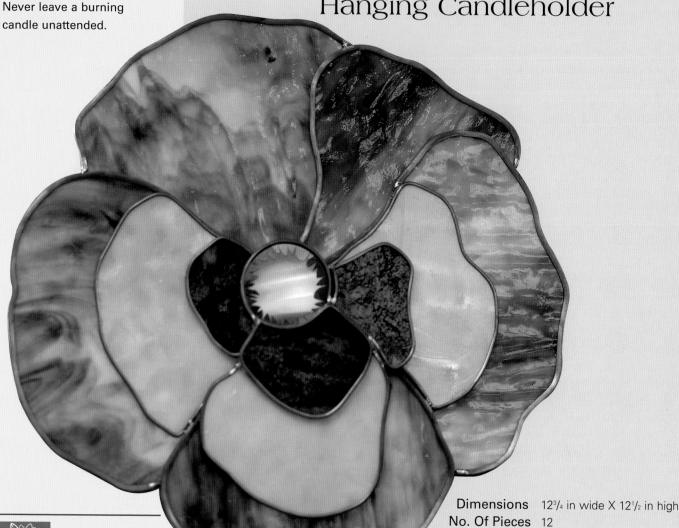
Pansy
Hanging Candleholder

Dimensions 12³/₄ in wide X 12¹/₂ in high

No. Of Pieces 12

Glass Required

A 18 in X 12 in purple & white ring mottle

B 9 in X 10 in iridescent white ring mottle

C 3 in X 10 in royal purple & silver yellow streaky

D 3 in X 3 in translucent medium amber or mirrored amber semi-antique

Letters identify type of glass used on pattern (p96). The quantity of glass listed is a close approximation of the amount needed for the pattern. You may wish to purchase more glass to allow for matching textures and grain.

Helpful Hints

Glass, metal hoops, and lead cames become hot to the touch during the soldering stage. Wear work gloves or use a cloth when handling projects, to prevent burns (from hot metal, glass, and molten solder) while soldering or when holding the ends of lead came together to solder the joints.

Instructions

This 3D lead came candleholder is another project that can be enjoyed indoors or in the garden, both day and night. The colorful glass selection is beautiful in full sunlight yet this candleholder will also shine in the twilight hours. The center of the flower is illuminated by candlelight, emitting a golden glow that is surrounded by the muted colors of the purple pansy.

1 Follow steps 1 to 6 for LAZYBUG Garden Stake (p85) with these added instructions.
- There are 2 glass options for the flower center (**D**)

 Option 1 If translucent medium amber is used for the flower center cut and wrap the glass piece as instructed.

 Option 2 Mirrored amber semi-antique glass is used for the project illustrated in the accompanying photos. The mirror coating on the glass is covered with heavy-duty masking tape and a starburst pattern is drawn on the tape. Use a utility knife to cut the masking tape along the marked pattern. The central portion of the masking tape is pulled from the glass surface, revealing the mirror coating below. The exposed coating can be removed by sandblasting the surface. For hobbyists and artisans who do not have sandblasting equipment, glass etching cream is an efficient and inexpensive alternative. Following the manufacturer's instructions, apply the etching cream to the exposed area until the mirrored backing dissolves and can be washed away. The etched flower center will enable the candlelight to pass through the glass, revealing the starburst pattern.
- The 5 glass flower petals (**A**) are wrapped with heavier $^1/_8$ in lead U-channel came. Wrap remaining glass pieces (**B**, **C**, and **D**) with thinner $^5/_{64}$ in lead U-channel came.

2 Follow steps 1 to 4 as given for the DREAMWEAVER Spinning Garden Window (p43) to prepare the 10 in diameter brass ring. The ring provides the structural support for the candleholder and must be tinned (p27) before the lead wrapped glass pieces can be assembled to form a pansy flower shape.

Assembling the Glass Pieces

3 Place a full-size copy of the assembled view of the pansy on the work surface. With the photos and the pattern for reference, assemble the glass petals over the pattern to get a preview of how the pieces fit together. The assembled petals will radiate outwards forming a circular opening that the amber flower center (**D**) will be positioned over. Once familiar with layout, disassemble pieces and prepare to solder them into pansy shape.

4 Begin by placing piece **A1** over the pattern. Position the remaining 4 pieces of purple and white ring mottle as indicated on the pattern and in the following order: **A2** and **A3** over **A1**, **A4** over **A3**, **A5** over **A2** and **A4**.

5 Solder (pp26 & 27) pieces together at each juncture that 2 or more lead cames meet.

6 Turn the assemblage over and solder the came joints on the opposite side.

7 Facing front side up, position and solder together the glass pieces listed in the following order: **B1** over **A2**, **C1** over **B1**, **B2** over **A4**, **B3** over **A5**, **C2** over **B2**.

8 Place the flower center (**D**) over the circular opening in the middle of the pansy and on the section of lead came on **C1** that is adjacent to the opening. The flower center should also butt against **B3** and **C2**. Solder the pieces together. The central opening should not be visible when viewed face on.

9 Position **C3** over **B3** and lead came along bottom of flower center. Solder in place.

10 Verify that each glass piece is soldered at each lead came juncture and that the soldered joints are smooth.

Additional Materials & Tools Required

Materials
- 10 in diameter brass ring
- Heavy-duty masking tape (optional)
- Glass etching cream (optional)
- 2 lengths of $^1/_8$ in lead U-channel came
- 1 length of $^5/_{64}$ in lead U-channel came
- Glass votive cup (3 in diameter)
- Linked chain
- Tea light

 Note

Quantities of cames listed are based on a 6 ft length.

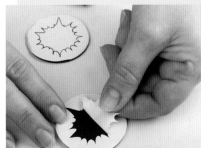

Pull out masking tape to reveal mirror backing on flower center

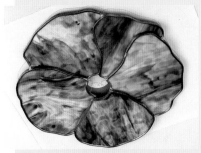

Step 4 - assemble & solder base petals together

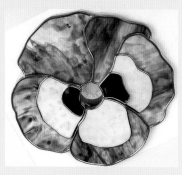

Step 7 - assemble & solder next layer of petals

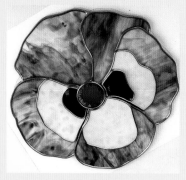

Step 8 - solder flower center over center opening

11 Turn assembled pansy over and center tinned brass ring on underside of flower. Solder ring to lead cames at each point of contact. Heat ring with hot iron tip and then melt a bead of solder to the ring and the lead came to ensure a secure joint.

Attaching the Votive Holder

12 Wrap a piece of ⅛ in lead U-channel came around perimeter of the widest portion of glass votive cup. Trim came with lead cutters so ends butt together. Solder came ends together to form a circle.

13 Place votive cup (with came circle around it) upside down on work surface. Shape and cut a length of lead came to fit over bottom of votive cup with came ends butted against underside of came circle. Solder opposing came ends to came circle.

14 Shape and cut 2 lengths of lead came that butt against underside of came circle and to the center of the lead came that fits over bottom of votive cup. Solder lead cames in position forming a holder for the votive cup.

15 Position the votive holder over the lower portion of center opening on the back side of the pansy. Solder the holder to the section of the lead cames of petal pieces **A2** and **A3** that face the center opening.

16 Thread a length of linked chain around top of tinned brass ring. Use wire cutters to trim chain to the desired length and solder ends of the chain together.

17 Clean (p22) the project and apply a protective coat of finishing compound or wax (p23).

18 Place a tea light in the glass votive cup sitting in the votive holder. Display the PANSY Hanging Candleholder suspended from the attached linked chain.

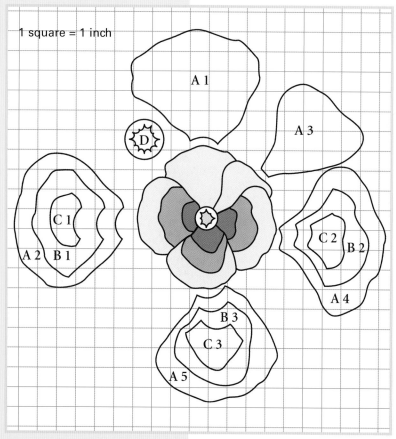

1 square = 1 inch

A 1
A 3
D
C 1
A 2 B 1
C 2 B 2
A 4
B 3
C 3
A 5

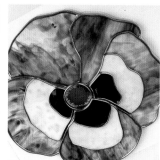

Step 9 - add petal C3 & solder in place

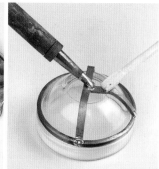

Step 13 - shape votive cup holder from lead came

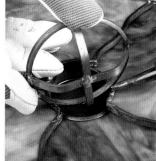

Step 15 - solder votive holder to assembled pansy

View of assembled pansy hanging candleholder from back side

Pink Aster
Bird Feeder

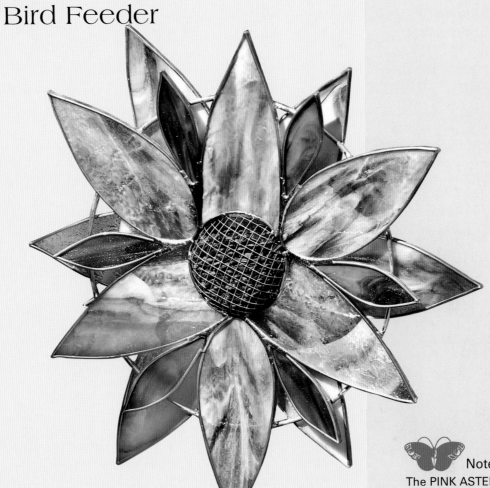

Note
The PINK ASTER Bird
Feeder can also be
suspended from a tree or
garden stand for hanging
flowering baskets. Omit
attaching the copper pipe
stake. Thread a length of
linked metal chain around
the tinned brass hoop on
either side of the petals and
solder the chains to the
hoop. Solder the ends of
the chains together, clean,
and then hang from a tree
branch or a garden stand.

Dimensions	14¹/₂ in diameter X 46 in high (approximately)		
No. Of Pieces	24		
Glass Required	A	18 in X 14 in translucent pink & white granite	
	B	18 in X 4 in green & white opaque streaky	

Letters identify type of glass used on pattern (p99). The quantity of
glass listed is a close approximation of the amount needed for the
pattern. You may wish to purchase more glass to allow for matching
texture and grain.

Materials

- 10 in diameter brass ring
- $\frac{1}{4}$ in galvanized hardware cloth (4 in X 8 in)
- 5 lengths of $\frac{1}{8}$ in lead U-channel came
- $\frac{1}{2}$ in rigid copper pipe (36 in)
- Birdseed

Tools

- Compass
- Metal or glass bowl with an inside diameter of 3 in
- Pipe cutter
- Metal file
- Hammer

Note
Quantities of cames listed are based on a 6 ft length.

Helpful Hints

Glass as well as metal hoops, pipes, and cames become hot to the touch during the soldering stage. Wear work gloves or use a cloth when handling projects, to prevent burns (from hot metal and glass or molten solder) while soldering or when holding the ends of lead came together to solder the joints.

Instructions

1 Follow steps 1 to 6 as given for the LAZYBUG Garden Stake (p85) to prepare the glass pieces for assembly.

Making the Mesh Flower Center

The flower center functions as the birdseed holder and is made from a galvanized hardware cloth with $\frac{1}{4}$ in square openings between each wire strand. Hardware cloth is available at home and garden centers and hardware stores.

2 Draw a $3\frac{1}{2}$ in circle with compass in center of a sheet of paper. With a marker trace 2 circles onto galvanized hardware cloth and cut out circles with wire cutters.

3 Mold each mesh circle into a rounded dome shape. Gently press mesh into bottom of bowl until all wire strands conform to rounded shape. Wire dome shape should now be 3 in diameter.

Preparing the Copper Stake

4 Measure and mark a 36 in length from one end of the copper pipe.

5 Fasten pipe cutter to copper pipe at the mark. Score and cut pipe by continually rotating and tightening the cutter until the pipe separates into two pieces (see photo p48).

6 Clean the entire surface of the 36 in copper tube by rubbing with fine steel wool (000).

Preparing the Brass Ring

7 Follow steps 1 to 4 of DREAMWEAVER Spinning Garden Window (p43) to prepare the 10 in diameter brass ring. The ring provides structural support for bird feeder and must be tinned (p27) before glass pieces wrapped with lead came can be assembled to form aster flower shape.

Assembling the Flowers

To make the bird feeder, 2 separate glass flowers are soldered together. The asters are then attached, one on either side, to the brass ring. The copper pipe stake and the wire mesh domes are soldered in place to complete the bird feeder.

8 Draw a 3 in circle in the center of a sheet of paper.

9 The asters for the project are comprised of 6 pink glass petals, 3 of each petal shape. Arrange the petals around the circle, alternating the shapes.

10 Tack (p26) and then solder (p27) the pieces together (see photos).

11 Turn the flower over and solder the adjacent lead joints on the underside.

12 Next attach 6 green leaves to complete the flower. Center a glass leaf between 2 petals with the pointed end of the leaf butting against the solder joint attaching the petals. Tilt the leaf slightly forward and solder it to the 2 adjacent petals. Solder 5 remaining leaves to flower in the same manner.

13 Turn the flower over and solder the underside.

14 Follow steps 9 to 13 to assemble the second flower but do not attach the 6th leaf.

15 Lay first flower face down on work surface. Center tinned brass ring over underside. Solder ring to flower at points the ring touches the lead came wrapped around petals. Apply hot iron tip to ring to heat it and then touch solder to tip and lead came to form a solid solder joint.

16 Turn the flower face forward and solder the joints on the front side.

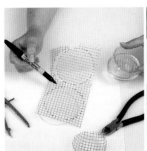

Make flower center with galvanized hardware cloth

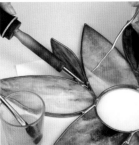

Tilt leaves slightly forward when soldering to assembled petals

Center & solder tinned brass ring to back of 1st flower

Position 2nd flower over ring & solder in place

Solder end of copper pipe to ring & adjacent petals

17 Turn flower and attached ring face down on a cushioning layer of cloths placed on work surface. Center second flower over ring and position so that each petal is centered over a green leaf on opposing flower attached to ring. Solder flower to each point the ring touches lead came wrapped around petals.

18 Turn the attached flowers over and solder the joints on the other side.

Attaching the Copper Pipe Stake

19 Place aster with the second flower facing upwards. Place one end of copper pipe over opening created by the absence of the 6th leaf. Mark length of pipe that reaches from between the petals to the point that it rests against the outside edge of ring.

20 Use a hammer to pound the marked end of the pipe flat.

21 Place flattened pipe end over opening between petals. Mark pipe to trim flattened end to fit the opening. Cut with heavy-duty wire cutters.

22 Tin marked length of trimmed pipe end. Apply flux and proceed to heat pipe with a hot soldering iron tip, coating pipe with a thin layer of solder. When the pipe has cooled, wash away flux residue with warm water and neutralizing solution.

23 Slide the tinned end of the copper pipe into the opening between the petals and rest the pipe against the ring. Solder the pipe in position.

24 Center the remaining green leaf between the pink petals and over the copper pipe end. Tilt the leaf forward as necessary and solder in place at each point the lead came wrapped around the glass pieces touch each other and the copper pipe.

Attaching the Wire Mesh Domes

25 Place mesh dome within lead cames surrounding open center of front flower. Secure in place by soldering wires to lead cames in several locations around flower center.

26 Turn the flower around and place the second wire mesh dome into center opening of the back flower. Position dome so that wire strands woven in one direction are running horizontally across flower center and the perpendicular wires are running vertical.

27 Solder mesh dome to surrounding lead cames only within bottom half of opening.

28 Remove approximately $1/2$ in of the wire mesh from the top of the dome. Trim away the vertical wires just above 1 horizontal wire strand. Use a metal file to remove any sharp wire ends that cannot be removed with the wire cutter.

29 Solder any remaining wires that need to be secured to the lead came around the flower center. There is now an opening for placing birdseed into the feeder.

30 Clean (p22) the project and apply a coat of finishing compound or wax (p23).

31 Place the finished bird feeder in the garden and fill with birdseed appropriate for the feathered friends in your area.

Solder mesh dome in place

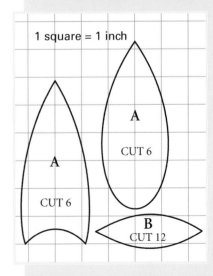

Cut opening for putting birdseed in mesh dome

1 square = 1 inch

A
CUT 6

A
CUT 6

B
CUT 12

Tulip
Torchiere

Dimensions	4½ in sq X 5½ in high	
No. Of Pieces	8	
Glass Required	A	14 in X 6 in yellow & white wispy
	B	5 in X 4 in translucent yellow
	Or	
	A	14 in X 6 in purple & white wispy
	B	5 in X 4 in translucent purple
	Or	
	A	14 in X 6 in iridescent pale white glue chip
	B	5 in X 4 in translucent pale white

Letters identify type of glass used on pattern (p102). The quantity of glass listed is a close approximation of the amount needed for the pattern. You may wish to purchase more glass to allow for matching textures and grain.

Note

Never leave a burning candle unattended.
Insert tea lights into glass votive cups before placing them inside a stained glass candleholder. This will contain melted wax and prevent stained glass pieces from cracking due to the heat given off by the candle flame.
In colder climates, store the torchiere indoors during winter and freezing temperatures.

Instructions

Illuminated by candlelight within or by warm rays of sunshine, the TULIP Torchiere will add color and light to your garden, night and day.

Making the Base

The base for this garden light is made by attaching a vase cap to a length of rigid ¹/₂ in copper pipe. Use a solid brass vase cap with vent holes to allow moisture and rain water to drain from the basin of the garden torchiere. Wear work gloves while handling heated metal parts.

1 Measure and mark the ¹/₂ in copper pipe to the height desired for the torchiere – 24 in and 36 in are popular lengths.

2 Fasten the pipe cutter to the copper pipe at the mark. Score and cut the pipe by continually turning and tightening the cutter. See photo on p48.

3 Use a metal file to remove any burrs and steel wool to rub off any oxidization from end of the copper tube.

4 The center opening of the vase cap is flat and should be flared outward slightly to fit within the copper pipe. A center punch, just larger in diameter than the opening, and a hammer are required. Center the vase cap with the underside facing up, over one end of the copper tube. Position the punch in the vase cap opening and strike it with the hammer until the cap opening is flared enough to fit into the copper pipe.

5 Tin (p27) the inside and the outside of the vase cap as described in step 16 for the GREEN LEAF Patio Lanterns (p68).

6 Tin the first ¹/₂ in of the copper pipe end. Apply flux and heat the copper with the hot iron tip, coating the pipe with a thin layer of solder.

7 Position the tinned vase cap with outside facing upwards. Center the tinned copper pipe end over the flared vase cap opening. Flux and solder the two pieces together. Ensure that the pieces are firmly attached by soldering the outer surfaces together and then soldering the flanged cap opening to the inside of the pipe. Allow the base to cool.

8 Once the base has cooled, remove residual flux with a neutralizing solution and water. Rub the copper with fine steel wool (000) to remove heat discoloration, oxidation, and manufacturer's labeling.

Preparing the Glass Petals

9 Follow steps 1 to 6 as given for the LAZYBUG Garden Stake (p85) to prepare the glass pieces for assembly.

10 Use wire cutters to cut a length of tinned copper wire (approximately 24 in).

11 Tack and bead solder (pp26 & 27) one end of wire to lead came at top edge of a large petal (**A**).

12 Shape the wire as shown on the pattern. Use wire cutters to sever the wire where it contacts the lead came at the lower edge of the petal.

13 Hold the wire in place with a wood stick and solder the free end to the lead came.

14 Attach the wire accents to the 3 remaining large petals (**A**), following steps 11 to 13.

Attaching the Petals to the Base

15 Place the completed torchiere base in the vise and clamp it in position, directly beneath the attached vase cap.

16 Center a large petal (**A**) along the inside of one edge of the tinned vase cap. Flux and tack solder the petal to the inside of the cap.

Additional Materials & Tools Required

Materials
- ¹/₂ in rigid copper pipe (24 in –36 in)
- 2³/₄ in square vented vase cap
- 2 lengths of ¹/₈ in lead U-channel came
- 16-gauge tinned copper wire
- Glass votive cup & tea light

Tools
- Pipe cutter
- Metal file
- Center punch
- Hammer
- Vise

Note
Quantities of cames listed are based on a 6 ft length.

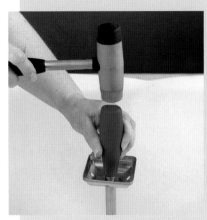

Flare opening of vase cap with punch & hammer to fit copper pipe

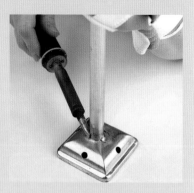

Flux & solder pipe to vase cap

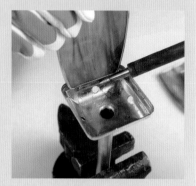

Center petal along inside edge of vase cap

17 Position and center a second large petal (**A**) in the same manner along an adjacent side of the vase cap. The inside edges of the lead cames on the abutting sides of the petals must be touching and at a right angle to one another. Flux and tack solder the second petal to the inside of the vase cap and the first petal.

18 Tack solder the remaining two large petals (**A**) to the inside of the vase cap and to the adjacent petals to form the main body of the tulip.

19 Bead solder the inside seams created by the adjoining lead cames at each of the 4 corners. Solder the bottom of each seam onto the vase cap to ensure the tulip is securely attached to the base.

20 Allow the solder to cool and continue by bead soldering the outside corner seams as described in step 19.

21 From the inside of the tulip, place a small petal (**B**) over the back of the corner opening between two of the large petals (**A**). Only the glass and the lead came along the top edge of the small petal should be visible between the two larger petals. Refer to the accompanying photos for the exact position. Flux and tack solder the top edges of the small petal to the sides of the two adjacent large petals. Solder the point of the small petal to the inside corner solder seam.

22 Solder the remaining 3 small petals in place as described in step 21 to complete the flower.

23 Clean (p22) the project and apply a protective coat of finishing compound or wax (23).

24 Display the finished garden torchiere in an area of the garden that could use the addition of color. Grasping the straight length of copper tube just below the vase cap, press the torchiere several inches into the soil until it sits firmly upright and at the height desired.

Helpful Hints

• Glass, metal, and lead cames become hot to the touch during the soldering stage. Wear work gloves or use a cloth when handling projects, to prevent burns (from hot metal, glass, and molten solder) while soldering or when holding the ends of lead came together to solder the joints.

• Use a wood stick to hold wire and metal overlays in place while soldering. Some metal implements may adhere to the solder while plastic tools may melt as overlays and wires heat up. Wooden chopsticks or pieces of small wood dowel are excellent, inexpensive tools for this task.

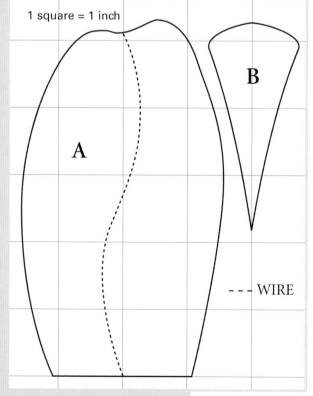

1 square = 1 inch

A

B

- - - WIRE

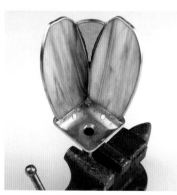

Inside view of small petal placement

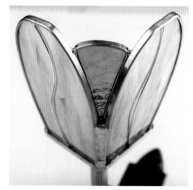

Placement of small petal viewed from outer side

Water Lily
Torchiere

Dimensions	10 in diameter X 3 in high	
No. Of Pieces	26	
Glass Required	A	15 in X 8 in pink & white wispy
	B	1 translucent yellow glass nugget (large)
	C	9 translucent yellow glass nuggets (medium)
	Or	
	A	15 in X 8 in flamingo pink streaky
	B	1 iridescent white glass nugget (large)
	C	9 iridescent white glass nuggets (medium)

Letters identify type of glass used on pattern (p105).
The quantity of glass listed is a
close approximation of the amount
needed for the pattern. You may
wish to purchase more glass to
allow for matching
textures and grain.

Note
Never leave a burning
candle unattended.
Insert tea lights into glass
votive cups before
placing them inside
a stained glass
candleholder. This will
contain melted wax and
prevent stained glass
pieces from cracking
due to the heat given
off by the candle flame.
In colder climates,
store the
torchiere
indoors during
winter and
freezing temperatures.

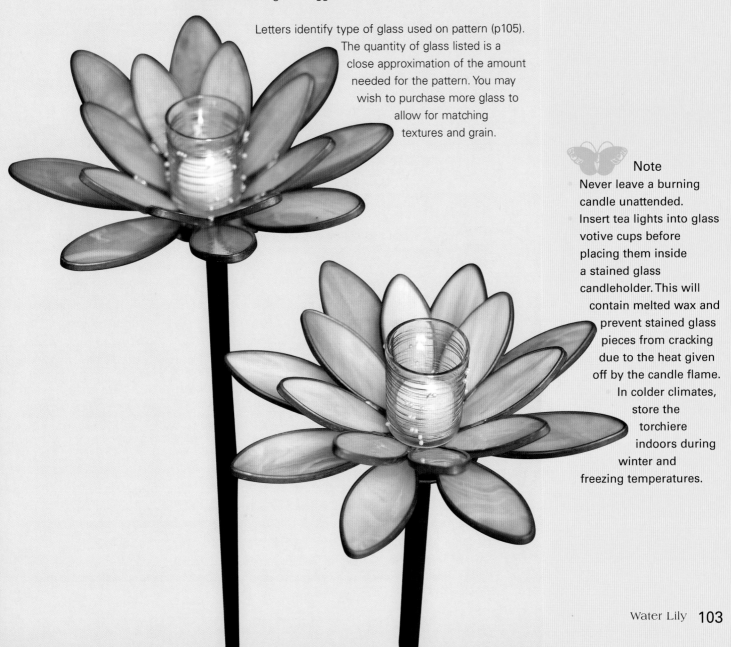

Materials

- ¹/₂ in rigid copper pipe
 (24 in –36 in)
- 8-sided vented vase cap
- 2 lengths of ⁵/₆₄ in lead
 U-channel came
- 1 length of ¹/₈ in lead
 U-channel came
- Glass votive cup &
 tea light

Tools

- Pipe cutter
- Metal file
- Center punch
- Hammer
- Vise

 Note

Quantities of cames listed
are based on a 6 ft length.

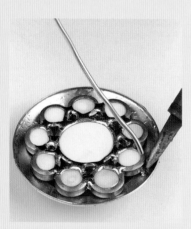

Solder glass nugget cluster to
inside of vase cap. A round
vase cap can be used if 8-
sided cap is not available

Instructions

The WATER LILY Torchiere has been designed so that it may be displayed without the votive
cup and tea light if illumination is not desired.

1 Follow steps 1 to 8 as given for the TULIP Torchiere (p101) to assemble the base for
this project.

2 Follow steps 1 to 6 as given for the LAZYBUG Garden Stake (p85) to prepare the glass
pieces for assembly.

- Wrap (p80) the glass petals with the thinner ⁵/₆₄ in lead U-channel came.
- Wrap all of the glass nuggets with the thicker ¹/₈ in lead U-channel came. Use this time
 saving method to wrap the glass nuggets:

When a pattern requires the use of a number of glass jewels or nuggets of the same size,
tightly wind a piece of stretched lead came several times around a cylindrical object that is
similar in size to the pieces being leaded. Wood dowel and empty solder spools are ideal. Slip
the lead spiral off the cylinder and insert a nugget into the end coil. Mark and trim the lead coil
(pp79 & 80) so that it completely encases the circumference of the nugget. Repeat for each
required piece.

Assembling the Water Lily

3 Place the torchiere base in the vise and clamp it securely beneath the attached vase cap.

4 In the vase cap, arrange the 9 medium glass nuggets around the large glass nugget to
form the flower center. The lead came wrapped around a nugget should touch the large
center nugget and the nuggets on either side. Nugget sizes vary so check that the
nugget cluster fits within the side edges of the vase cap. If required, remove or add
another nugget to shape the center of the water lily.

5 Remove the nuggets from the vase cap and reassemble on the work surface.

6 Flux and tack solder (p26) the nuggets together at each point a nugget comes in contact
with the center and adjacent nuggets.

7 Turn the cluster of nuggets over and tack solder the contact points on the other side.

8 Place the flower center in the vase cap with the flat side of the nuggets facing upwards.
The flat side will provide a level surface for the votive cup and tea light to rest on.

9 Flux and tack solder the perimeter of the nugget cluster to the vase cap. Apply the hot
soldering iron tip to the vase cap to heat it and then touch the solder to the tip and the
lead came to form a solid joint.

10 Tape the bottom of the votive cup to the middle of the flower center and begin tack
soldering the inner layer of petals (**A1**) to the nugget cluster. Align each petal with one
of the 8 corners of the vase cap and tilt the petal upward at a 40° to 45° angle. As the
petals are soldered to the flower center adjustments in angle or position can be made to
accommodate the votive cup.

11 Remove the votive cup once all small petals (**A1**) are tacked in place and take the
torchiere out of the vise.

12 Solder the petals together at each point the lead cames come in contact, on both the
top and undersides of the petals. Tilt the torchiere at the necessary angles to keep the
molten solder level until it solidifies.

13 Place the torchiere back in the vise and begin soldering the outer layer of petals (**A2**) to
the flower. Center a large petal (**A2**) beneath the gap between two adjoining smaller
petals (**A1**) and tilt upward at a slight angle. Tack solder the bottom edge of the petal to
the flower center below. Proceed to tack all the large petals in place, altering the upward
angle slightly for added visual interest.

14 Remove the torchiere from the vise. Apply a finishing bead of solder to the underside of the bottom edge of each petal (**A2**) where the lead came comes in contact with the cames around the flower center. Tilt the torchiere as required to keep the molten solder level until it solidifies.

15 Verify that each petal of the water lily is securely soldered in place. Add solder and touch up solder seams and joints as necessary.

16 Clean (p22) the project and apply a protective coat of finishing compound or wax (p23).

17 Install the finished torchiere by a pond or water feature. Grasping the straight length of copper tube just below the vase cap, press the torchiere several inches into the soil until it sits firmly upright and at the height desired.

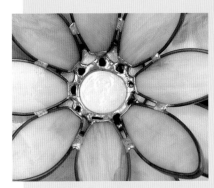

View from above water lily
showing petal placement

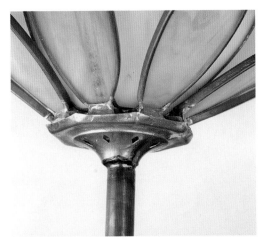

Outside view of assembled water lily
petals

Helpful Hints

- Glass, metal, and lead cames become hot to the touch during the soldering stage. Wear work gloves or use a cloth when handling projects, to prevent burns (from hot metal, glass, and molten solder) while soldering or when holding the ends of lead came together to solder the joints.

- Use a wood stick to hold wire and metal overlays in place while soldering. Some metal implements may adhere to the solder while plastic tools may melt as overlays and wires heat up. Wooden chopsticks or pieces of small wood dowel are excellent, inexpensive tools for this task.

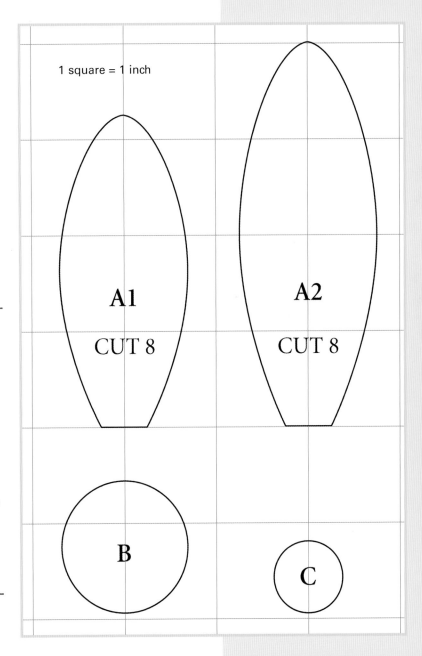

1 square = 1 inch

A1
CUT 8

A2
CUT 8

B

C

Tiger Lily Trio
Candelabra

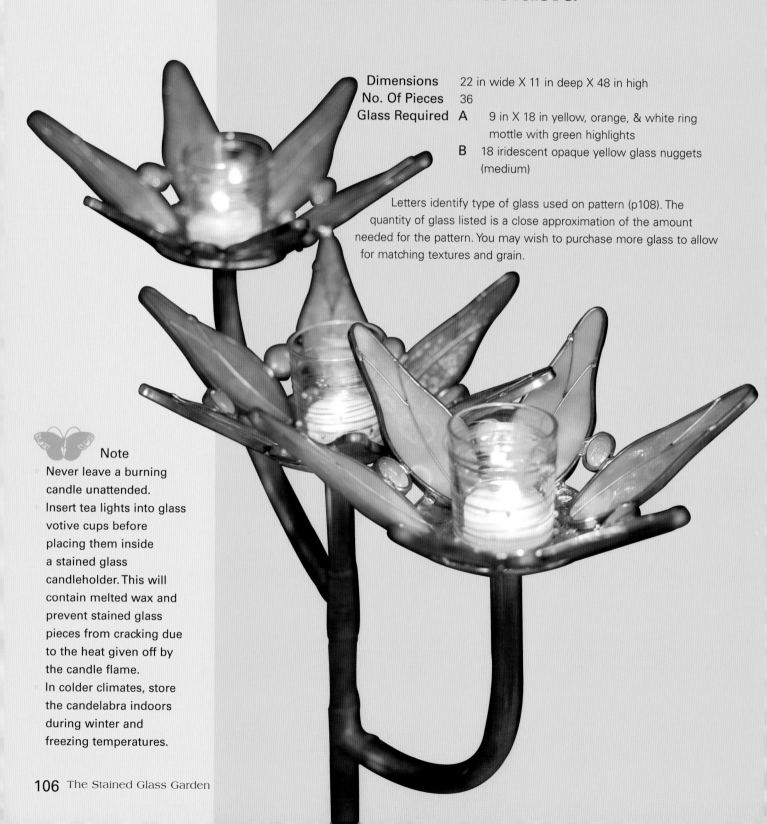

Dimensions	22 in wide X 11 in deep X 48 in high
No. Of Pieces	36
Glass Required	**A** 9 in X 18 in yellow, orange, & white ring mottle with green highlights
	B 18 iridescent opaque yellow glass nuggets (medium)

Letters identify type of glass used on pattern (p108). The quantity of glass listed is a close approximation of the amount needed for the pattern. You may wish to purchase more glass to allow for matching textures and grain.

Note

Never leave a burning candle unattended. Insert tea lights into glass votive cups before placing them inside a stained glass candleholder. This will contain melted wax and prevent stained glass pieces from cracking due to the heat given off by the candle flame.

In colder climates, store the candelabra indoors during winter and freezing temperatures.

Instructions

A stained glass candelabra is another option for adding interest to areas of the garden that may need to be perked up with color and light.

Preparing the Glass Petals

1. Follow steps 1 to 6 of LAZYBUG Garden Stake (p85) to prepare pieces for assembly.
 - Wrap glass nuggets using method in step 2 for WATER LILY Torchiere (p104).
2. Use wire cutters to cut a 24 in length of tinned copper wire.
3. On each glass petal, tack and bead solder (pp26 & 27) longest length of wire overlay first, then attach shorter length. Begin by soldering one end of wire to lead came near top right side. Shape wire (as shown on pattern). Use wire cutters to sever wire where it contacts with lead came at base of petal.
4. Hold the wire in place with a wood stick and solder the free end to the lead came.
5. Use this method to attach shorter length of wire overlay to lead came on top left side and to wire it intersects with below.
6. Attach the wire overlays to the remaining glass petals as described in steps 3 to 5.

Preparing the Base

To make candelabra base attach vase caps to a series of copper tube armatures and pipe joints connected to a rigid ½ in copper pipe. Use solid brass vase caps with vent holes that allow moisture and rain water to drain from candleholder basins. Wear work gloves.

7. The center openings of the 3 vase caps are flat and should be flared outward slightly to fit within the copper pipe armatures. Use a hammer and center punch slightly larger in diameter than the opening. Center a vase cap, underside facing up, over one end of a piece of copper pipe. Position the punch in vase cap opening and strike it with the hammer until the cap opening is flared enough to fit into copper pipe (see photo p101).
8. Tin inside and outside of vase caps (see step 16, GREEN LEAF Patio Lanterns p68).
9. Measure and mark ½ in rigid copper pipe into 1 length 36 in and 2 pieces 3 in long.
10. When purchased, ½ in malleable copper pipe is in a loose coil. Measure and mark 9 in piece and 13 in piece for candelabra armatures.
11. Score and cut copper pipes. Fasten pipe cutter to copper pipes at lengths marked, continually turning and tightening (not too much pressure) the cutter until pieces are cut.
12. Prepare both ends of armatures and the 3 in pieces of rigid copper tube, 1 end of 36 in pipe length, and both ½ in copper T-joints for soldering. Use medium weight emery cloth or sandpaper to remove burrs and steel wool to rub off oxidization.
13. Tin first ½ in of one end of the 2 armature pieces and 1 of the 3 in lengths of rigid copper pipe. Flux and heat the copper pipe with the hot iron tip, applying a thin layer of solder on one end of each piece.
14. Solder vase cap to tinned end of each of 3 copper pipes. Place vase caps, outside face up, on work surface. Center tinned end of copper pipe piece over flared opening of vase cap. Flux and solder outer surfaces together, then flanged cap opening to inside of pipe.

Attaching the Petals

Each of the 3 tiger lily flowers consists of 6 glass petals alternating with 6 glass nuggets.

15. Place a copper armature in the vise and clamp it securely beneath attached vase cap.
16. Flux and tack solder (p26) 2 glass petals to vase cap. Position so that lower ¾ in of each petal lies on vase cap and petals are positioned directly opposite each other. Tack solder petals to base of cap and on each side where lead came rests against edge of cap.

Materials
- 3 – 3½ in vented vase cap
- ½ in rigid copper pipe (42 in)
- ½ in malleable copper pipe (20 in)
- 2 – ½ in copper T-joints
- 4 lengths of 5/64 in lead U-channel came
- 16-gauge tinned copper wire
- Copper patina (optional)
- 3 glass votive cups & tea lights

Tools
- Pipe cutter
- Center punch
- Hammer
- Med. grade emery cloth or sandpaper
- Vise
- Propane torch

 Note

Quantities of cames listed are based on a 6 ft length.

Coil of malleable copper pipe

Components of candelabra

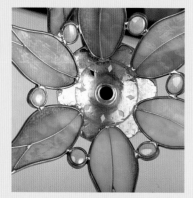

**View from above of
assembled flower**

17 Center, space, and solder remaining 4 petals evenly around the perimeter of vase cap.

18 Flux & tack solder a glass nugget between each petal so that lead came around nugget rests against came around the petals on either side.

19 Following steps 15 to 18 assemble a tiger lily flower to the vase caps on the second copper armature and the 3 in length of copper pipe.

20 Remove residual flux from flowers with neutralizing solution and water.

Assembling the Candelabra

The various components are now ready to be put together and permanently attached to complete the candelabra.

21 Starting from the bottom and working upward, put the candelabra parts together in the following order: 36 in length of copper pipe, copper T-joint, 3 in copper pipe, copper T-joint, 3 in copper pipe with attached tiger lily. Fit end of 9 in copper armature into top T-joint and 11 in armature into lower T-joint. Gently bend copper armatures to correct arc if attached tiger lilies are not level.

22 Rotate each armature into a position that permits the attached flower to touch or rest between the petals of the center tiger lily in as many locations as possible. An armature can be taken off the central base structure and the appropriate copper fittings turned until a satisfactory arrangement of the 3 flowers is made.

23 Flux and solder where the lead cames around petals of one flower contact petals of another.

24 As described in Soldering Copper Pipe Joints (p82), use a propane torch to solder each joint where a copper pipe or fitting connects with another to attach flowers and copper pieces securely and finish candelabra base.

25 Remove residual flux with a neutralizing solution and water. Rub the copper with fine steel wool (000) to remove heat discoloration, oxidation, and manufacturer's labeling.

26 The solder at each copper pipe joint can be left to acquire a natural and weathered finish or copper patina can be applied (pp22 & 23) to match the coloration of the pipe.

27 Apply a protective coat of finishing compound or wax (p23).

28 To install TIGER LILY TRIO Candelabra grasp copper tube below the center tiger lily and press several inches into soil to height desired. Place a votive cup and tea light inside each flower to illuminate the candelabra at night.

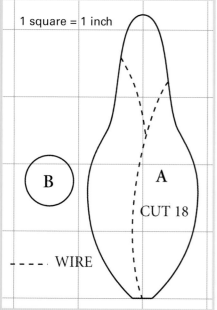

Helpful Hints

• Glass, metal, and lead cames become hot to the touch during the soldering stage. Wear work gloves or use a cloth when handling projects, to prevent burns (from hot metal, glass, and molten solder) while soldering or when holding the ends of lead came together to solder the joints.

• Use a wood stick to hold wire and metal overlays in place while soldering. Some metal implements may adhere to the solder while plastic tools may melt as overlays and wires heat up. Wooden chopsticks or pieces of small wood dowel are excellent, inexpensive tools for this task.

Daisy Bouquet
Candelabra

Dimensions 18 in wide X 18 in deep X 54 in high
No. Of Pieces 32
Glass Required A 20 in X 24 in translucent pale white

Letters identify type of glass used on pattern (p110). The quantity of glass listed is a close approximation of the amount needed for the pattern. You may wish to purchase more glass to allow for matching textures and grain.

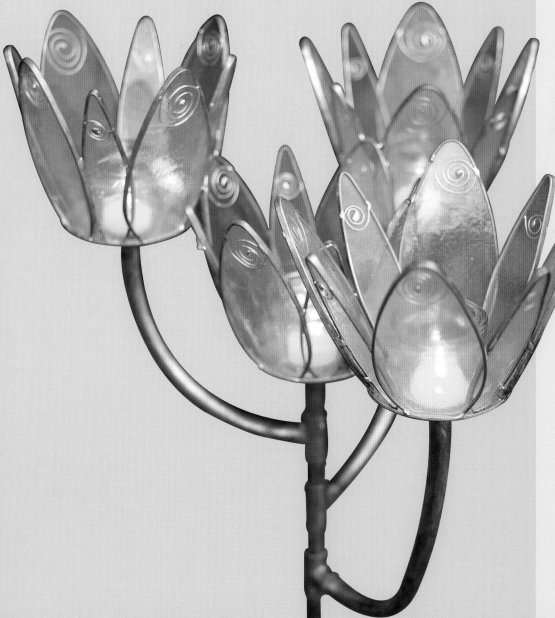

Note
- Never leave a burning candle unattended.
- Insert tea lights into glass votive cups before placing them inside a stained glass candleholder. This will contain melted wax and prevent stained glass pieces from cracking due to the heat given off by the candle flame.
- In colder climates, store the torchiere indoors during winter and freezing temperatures.

Helpful Hints
- Glass, metal, and lead cames become hot to the touch during the soldering stage. Wear work gloves or use a cloth when handling projects, to prevent burns (from hot metal, glass, and molten solder) while soldering or when holding the ends of lead came together to solder the joints.
- Use a wood stick to hold wire and metal overlays in place while soldering. Some metal implements may adhere to the solder while plastic tools may melt as overlays and wires heat up. Wooden chopsticks or pieces of small wood dowel are excellent, inexpensive tools for this task.

Additional Materials & Tools Required

Materials
- 4 – 4 in vented vase cap
- ¹/₂ in rigid copper pipe (42 in)
- ¹/₂ in malleable copper pipe (34 in)
- 3 – ¹/₂ in copper T-joints
- 7 lengths of ⁵/₆₄ in lead U-channel came
- 16-gauge tinned copper wire
- Copper patina (optional)
- 4 glass votive cups & tea lights

Tools
- Pipe cutter
- Center punch
- Hammer
- Metal file
- Med. grade emery cloth or sandpaper
- Vise
- Propane torch

 Note

Quantities of cames listed are based on a 6 ft length.

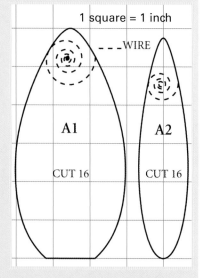

1 square = 1 inch

WIRE

A1 A2

CUT 16 CUT 16

Instructions

This project is constructed using similar methods to the TIGER LILY TRIO Candelabra (p107 & 108). Instructions specific to the DAISY BOUQUET project are explained below.

1 Follow steps 1 to 6 of LAZYBUG Garden Stake (p85) to prepare glass pieces.

2 Use needlenose pliers to shape 32 wire spiral overlays for glass petals. Refer to pattern and accompanying photos.

3 Flux and tack solder (p26) a wire spiral to each glass petal using needlenose pliers or a wood stick to hold the wire in place. No two flowers are exactly alike so have some fun and alternate the side of the glass that the wire overlays are attached to.

Preparing the Base

4 Follow steps 7 to 14 as given for the TIGER LILY TRIO Candelabra (p107) to prepare the various components necessary to make the base for this project.

- Measure, mark, and cut ¹/₂ in rigid copper pipe into 36 in length and 3 pieces 2 in long.
- Measure, mark, and cut 3 armature pieces (10 in, 11 in, and 13 in) from the ¹/₂ in malleable copper pipe.
- Solder tinned 4 in vase cap to each of 3 armature pieces and to 1 of the 2 in pieces of copper pipe.

Components of candelabra base

Attaching the Petals

This project has 4 flowers. Each flower has 4 large petals alternating with 4 small petals. Arrange petals so that spirals randomly face outside or center of flower.

5 Place a copper armature in the vise and clamp it securely beneath the attached vase cap.

6 Flux and tack solder 4 large petals (**A1**) to the base. Angle slightly outward and attach to vase cap in 3, 6, 9, and 12 o'clock positions. Tack solder petals to cap, at the base and on each side where lead came rests against rim of cap.

7 Center a small petal (**A2**) over opening between 2 large petals. Small petals face inside of flower, overlapping outer edge of large petals on either side. Tack solder bottom of petal to vase cap and at juncture where lead cames contact large petals on either side.

8 Follow steps 5 to 7, assemble and attach a daisy flower to vase caps on remaining 2 armatures and 1 length of 2 in copper pipe.

9 Remove residual flux from flowers with a neutralizing solution and water.

Assembling the Candelabra

Assemble components and attach in order to complete the candelabra.

10 Starting from bottom and working up, assemble candelabra parts: 36 in length of copper pipe, copper T-joint, 2 in copper pipe, copper T-joint, 2 in copper pipe, copper T-joint, 2 in copper pipe with attached daisy. Fit end of 10 in copper armature into top T-joint and 11 in armature into middle T-joint, and 13 in armature into lower T-joint. Gently bend copper armatures to level daisies, if needed.

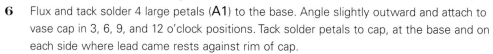

Placement of petals

11 Follow steps 22 to 28 for TIGER LILY TRIO Candelabra (p108) to complete this project.

MAJESTIC WATER BIRDS
Garden Sprinklers

These unique garden sprinklers are beautiful complements to any garden or outdoor setting. Imagine a sprinkler set amongst tall Siberian irises or reedy grasses growing beside a garden pond brimming with goldfish and water lilies. The sculptural nature of these magnificent birds is pleasing to the eye whether the water sprinkler function is utilized or not. But who can resist the sight of glistening sprays and flying droplets of water against a backdrop of colorful rainbows, sparkling pieces of stained glass, and lush, verdant foliage?

Making the Garden Sprinkler Apparatus

The stately 3-dimensional stained glass birds are soldered to a sprinkler apparatus made with a combination of copper pipe pieces and plumbing fittings that can be found at the local hardware or plumbing supply store. A circle of copper pipe fixed atop a post, comprised of straight lengths of pipe and fittings, form the framework of the apparatus. A spiral of copper pipe is attached to the front of the apparatus and another spiral to the opposite side, providing visual interest, more outlets for water spray, and additional support for the glass bird. The **Blue Heron** and the **Snowy Egret** are shown mounted on a sprinkler apparatus with a curved rotating sprinkler armature attached to the top. As the armature spins, sprays of water and droplets whirl through the air. Due to the position and height of its outstretched wings, the **Pelican** has been affixed to a sprinkler apparatus that was assembled without the rotating armature. This simpler version of the garden sprinkler apparatus is appropriate for use with any of the bird designs.

Instructions

1. The various sizes and types of copper pipe must be cut into pieces of specific lengths in order to assemble the garden sprinkler apparatus. Malleable copper pipes are purchased wound in loose coils. Do not attempt to straighten these coils but take advantage of the natural curves that are present in the pipe. Measure and mark the following lengths to be cut: $1/8$ in copper pipe – 1 piece 1 in
 $1/2$ in rigid copper pipe – 1 piece 12 in & 1 piece 36 in
 $1/4$ in malleable copper pipe – piece 7 in, 1 piece 65 in, & 1 piece 72 in
 $1/2$ malleable copper pipe – 1 piece 42 in

2. Cut each length of copper pipe, 1 piece at a time. To cut a piece, fasten the pipe cutter to the copper pipe with the cutting blade on top of the mark. Score and cut the pipe by continually rotating and tightening the cutter until the desired length separates from the main piece of copper pipe. Refer to photo on p48. Use caution when cutting the thinner malleable pipe as it may crimp if too much pressure is applied when tightening pipe cutter.

3. Prepare the pieces of copper pipe, the $1/2$ in copper T-joints, and the $1/2$ in copper end cap. Use medium weight emery cloth or sandpaper to remove any burrs and steel wool to rub off any oxidization from the copper surfaces.

4. Using the accompanying photos for reference begin assembling the sprinkler apparatus. Starting from the top and working downward, the parts are fitted together in the order listed on p112.

Additional Materials & Tools Required

Materials
- $1/8$ in rigid copper pipe (1 in)
- $1/4$ in malleable copper pipe (144 in)
- $1/2$ in rigid copper pipe (48 in)
- $1/2$ in malleable copper pipe (42 in)
- 2 – $1/2$ in copper T-joints
- 1 – $1/2$ in copper end cap
- 1 brass female hose coupling with barbed end to fit $5/8$ in diameter garden hose
- 1 – $1/4$ in X $1/8$ in MIP brass compression fitting with inserts

Tools
- Pipe cutter
- Med. grade emery cloth or sandpaper
- Propane torch
- Mallet or hammer
- Center punch
- Power drill with $3/32$ in, $1/4$ in, & $3/8$ in drill bits

 Note
- In colder climates, store the garden sprinkler indoors during winter and freezing temperatures.

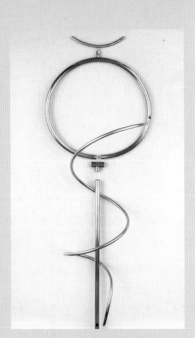

Components of sprinkler apparatus & rotating armature

Ring formed from the 42 in length of $\frac{1}{2}$ in malleable copper pipe
Copper T-joint
36 in length of copper pipe
Copper T-joint (rotate so remaining opening is perpendicular to top ring)
12 in length of $\frac{1}{2}$ in rigid copper pipe
Copper end cap

Following the instructions described in Soldering Copper Pipe Joints (p82), solder each joint where a copper pipe or fitting connects with another.

5 Use a mallet or hammer to gently tap the barbed end of the hose coupling into the remaining opening on the lower copper T-joint. Apply flux and solder the joined fittings together using the propane torch.

Making and Attaching the Rotating Armature

The rotating armature is a feature of the garden sprinkler apparatus that can be omitted if you choose. The Pelican's position on the sprinkler prohibits the use of this mechanism. To complete the assembly of a sprinkler version that excludes the rotating armature skip steps 6 to 20 and continue with step 21.

Detail of hose couplings & bottom T-joint

6 The armature is created using the 7 in curved piece of $\frac{1}{4}$ in malleable copper pipe. Holes are drilled on the opposite sides of each half of the armature to produce a swirl of water spray. Lay the curved copper pipe on its side. Starting $\frac{1}{2}$ in from 1 end, measure and mark for 3 holes that are 1 in apart. Turn the pipe over and measure and mark for 3 holes to be drilled on the opposite side of the other half of the armature.

7 Use a center punch to make a depression where the holes are to be drilled. If the center punch does not have a mechanism to make the depression, gently tap the punch handle with a mallet or hammer.

8 Use the power drill fitted with a $\frac{3}{32}$ in bit to drill the 6 holes. Place the tip of the drill bit into a depression made by the center punch and drill through the copper. Exercise caution as copper is a soft metal and has a tendency to "grab" at the drill bit.

9 Measure and mark the center point ($3\frac{1}{2}$ in) on the underside of the curved pipe.

10 Make a depression with the center punch at the mark.

11 Use a $\frac{1}{4}$ in bit to drill the hole through the underside of the armature.

12 Insert an end of the 1 in length of $\frac{1}{8}$ in copper pipe into the hole but not far enough to restrict the water flow. Flux and solder the copper joint creating a watertight seal.

13 Seal the ends of the armature shut. Flux the ends of the pipe and use a soldering iron to apply solder to each end until completely soldered over.

14 Refer to the accompanying photos for assistance in attaching the brass compression fitting to the armature and the main sprinkler apparatus. Unscrew the compression fitting so that there are 3 parts: nut with attached sleeve, insert, and threaded fitting.

Note There are thousands of plumbing parts and endless variations depending on local availability and preference. If you are not familiar with the parts listed for a project, take this book with you and ask for assistance from the knowledgeable staff at the local supply store. If parts are not available as described in the instructions then suitable substitutions can be found for you.

Detail of rotating armature components

15. Fit the nut and sleeve (attached inside the nut) on the end of the 1 in length of ⅛ in pipe. Use a cotton swab to apply a meager amount of flux to the copper pipe and the end of the sleeve that sticks out from the nut. Use the soldering iron tip to apply a small amount of solder to tack the sleeve and pipe together. Do not apply solder to the nut as this will interfere with the rotating action of the armature.

16. Mark the center point on the top of the copper ring. Make a depression with the center punch and then drill a hole into the copper ring using a ⅜ in drill bit.

17. Screw the end of the threaded fitting (that does not fit the nut) into center hole on the copper ring.

18. Apply flux and solder the fitting in place using the propane torch.

19. Place the insert into the end of the ⅛ in pipe attached to the armature. Join the armature and the main sprinkler apparatus together by screwing the nut onto the threaded fitting. Tighten the nut as much as possible until the armature is secure but still able to rotate freely.

20. Apply flux and tack solder the bolt and fitting together to permanently fasten the armature to the main sprinkler apparatus while leaving it free to spin once connected to a pressurized water supply.

Attaching the Copper Spirals

21. Holes must be drilled into the sprinkler post and the copper ring before the 2 copper pipe spirals can be attached. Measuring from the base of the ring, place a mark on the front of the post at 20 in and a mark on the back at 19 in. Mark the front of the ring at the 3 o'clock position. Turn the ring over and mark the 3 o'clock position on the back. The holes will be on opposite halves of the ring.

22. Use a center punch to make a depression where each hole is to be drilled.

23. Use a power drill with a ⅜ in diameter metal drill bit to make the 4 holes.

24. Remove any burrs present around the rim of the drilled holes.

25. For guidance in arranging the copper spirals examine the photos of the finished sprinklers. Each sprinkler has its own distinctive look and no other sprinkler will ever look exactly alike. Being careful to prevent crimps in the pipe, thread the 72 in copper spiral around and through the main post and copper ring while bending and manipulating the pipe into a favorable shape. Insert the upper end of the pipe into the hole on the front of the ring and the other end in a hole on the post. Repeat the procedure with the 65 in copper spiral inserting an end in the hole at the back of the ring and the opposite end into the remaining hole on the post.

26. Verify that the ends of the spirals fit snugly into the drilled holes and are not pushed in far enough to constrict the water flow. Flux and solder each copper joint to create a watertight seal.

Attaching the Stained Glass Bird to Garden Sprinkler Apparatus

27. Refer to the photos to assist in the placement of the glass bird on the copper pipe ring. Find a position that allows for the most contact points with the ring and the 2 copper pipe spirals, while still visibly appealing. Mark these contact points on the copper ring. The copper spirals can be carefully adjusted to accommodate a better fit when necessary. Remove the bird from the sprinkler.

28. Pre-tin marked locations on copper ring and spirals. Apply flux and a thin layer of solder at each contact point using propane torch or hot soldering iron tip to heat copper thoroughly. Apply enough heat so solder is molten and flows smoothly onto copper.

Helpful Hints
- Glass, metal, and lead cames become hot to the touch during the soldering stage. Wear work gloves or use a cloth when handling projects, to prevent burns (from hot metal, glass, and molten solder) while soldering or when holding the ends of lead came together to solder the joints.
- Use a wood stick to hold wire and metal overlays in place while soldering. Some metal implements may adhere to the solder while plastic tools may melt as overlays and wires heat up. Wooden chopsticks or pieces of small wood dowel are excellent, inexpensive tools for this task.

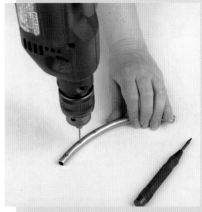

Drilling holes in the armature

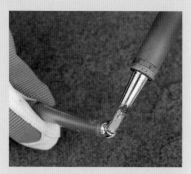

Solder ends of armature closed

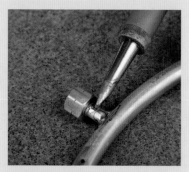

Step 15 - tack solder sleeve & copper pipe together

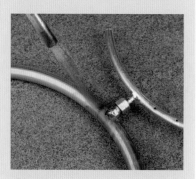

Step 18 - use propane torch to solder fitting to copper ring

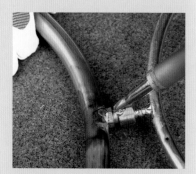

Step 20 - tack bolt to fitting, fastening armature to sprinkler apparatus

29 Place the bird back onto the copper ring. Flux and solder the bird to the copper ring at each contact point. Use the hot soldering iron tip to heat the pre-tinned copper pipe first. Be patient as this may take several minutes of constant contact for the pipe to heat. Apply fresh flux and solder to create a solid solder joint fusing the lead came and the copper pipe together.

Note Do not use a propane torch for this stage due to the potential for melting the lead came or causing heat cracks in adjacent glass pieces.

30 Each bird pattern has accompanying stained glass shapes that are attached to the copper pipe spirals. The Blue Heron is resting in the cattails, the Pelican has spotted a school of fish, and the Snowy Egret is wading through lily pads. Flux and solder the appropriate shapes to the copper pipe spirals in the same manner described in steps 27 to 29.

31 Once the completed bird and sprinkler apparatus has cooled, remove all traces of residual flux with neutralizing solution and water. Rub the copper with fine steel wool (000) to remove heat discoloration, oxidation, and manufacturer's labeling.

32 The solder at each copper pipe joint can be left to acquire a natural and weathered finish or copper patina can be applied (pp22 & 23) to match the coloration of the pipe.

33 Apply a protective coat of finishing compound or wax (p23).

Drilling the Water Spray Holes

The sprays of water are released from the main sprinkler apparatus through holes drilled into the copper pipe ring and the cascading copper spirals.

34 Measure and mark the sites where the water spray holes are to be drilled. For the sprinkler projects demonstrated, holes were placed approximately 6 in apart on both the copper ring and the copper spirals. Avoid placing holes that may steer water towards the underside of the stained glass bird or any of the smaller glass shapes attached to the copper spirals. The direction of the spray pattern can be determined by the position of the holes on the copper pipe. Placed in the center of the pipe the spray will flow straight up but if the hole is drilled off-center the spray will be directed towards the stained glass bird or outwards from the sprinkler and into the surrounding garden. If the sprinkler has a rotating armature, do not situate holes along the copper ring directly beneath the armature. To do so will interfere with the movement of the armature and the spray pattern.

35 Use a center punch to make a depression where each hole is to be drilled.

36 Use a power drill with a $^{3}/_{32}$ in bit to drill the holes.

37 Add holes as needed to achieve the desired spray pattern. Unwanted holes can be soldered over to close the opening.

38 Position the completed garden sprinkler in a highly visible area for all to enjoy. Insert the bottom of the main post into the ground until the sprinkler stands firmly upright. Hook up a garden hose, turn on the water, and watch the neighbors drop by to run through the most beautiful sprinkler around. Let the fun begin!

39 To enjoy your MAJESTIC WATER BIRD during the winter months, bring the sprinkler indoors. Fill a large flowerpot with enough sand or pebbles to hold the sprinkler safely upright and place in a sunny corner of your favorite room.

Blue Heron
Garden Sprinkler

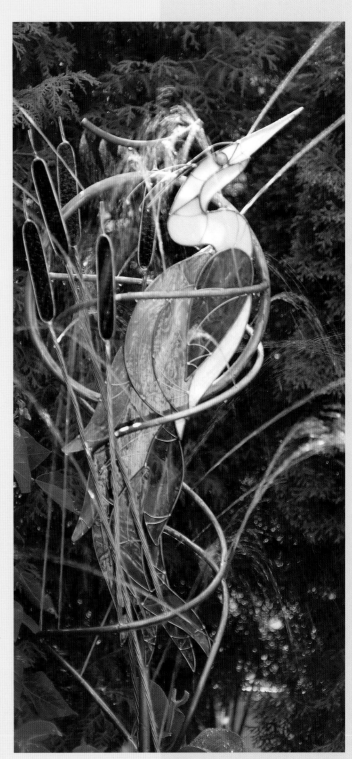

Dimensions 15 in wide X 67 in high X 10 in deep
No. Of Pieces 27
Glass Required

A 8 in X 16 in white wispy
B 14 in X 16 in light blue-gray wispy
C 2 in X 7 in yellow & white wispy
D 2 in X 7 in black
E 10 in X 18 in dark blue-gray wispy
F 10 in X 7 in root beer brown granite
G 6 in X 13 in clear texture
H 2 iridescent opaque yellow glass nuggets
 (medium)

Letters identify type of glass used on pattern (pp116 & 117). The
quantity of glass listed is a close approximation of the amount
needed for the pattern. You may wish to purchase more glass to
allow for matching textures and grain.

Additional Materials & Tools Required

Materials

- 8 lengths of ⅛ in lead U-channel came
- 16-gauge tinned copper wire
- 10 ft of 6-gauge copper ground cable (7 strands of copper wire

Note

Quantities of cames listed are based on a 6 ft length.

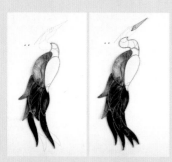

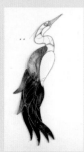

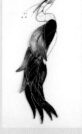

Instructions

Preparing the Glass Pieces

1. Make 1 copy (p14) of each pattern provided on p117. Use copy as a guide to cut the glass pieces to the required shape and size. If opalescent glass is used in this project, make a second copy and cut out the necessary pattern pieces for use as tracing templates. Enlarge (p14) a copy of the assembled view of the bird pattern (p117) to full scale to help put together the pieces to form the bird.

2. Use the marker to trace (p15) each pattern piece on the glass to be cut.

3. Cut (pp15-20) each piece of glass required, making sure to cut inside the marker line.

4. Grind or smooth any jagged edges (pp20 & 21) so each glass piece fits in pattern lines. Rinse glass under clean running water and dry with a clean cloth.

5. Wrap (p80) each glass piece with lead U-channel came and solder (pp81-82) together the juncture where the 2 ends of the lead came butt together.

6. Use wire cutters to cut a 24 in length from the spool of tinned copper wire. It is easier to manipulate a shorter length of wire than it is to handle an entire spool.

7. Cut lengths of wire as necessary to complete the attachment of the wire overlays.

8. Tack and bead solder (pp26 & 27) the wire overlays to front side of each wrapped glass piece shown on pattern. Many pieces have several wire overlays and these may be soldered to both the lead came and other wire overlays. Attach one wire overlay at a time. Begin by soldering one end of wire to lead came, then shape wire as shown on pattern (p117). Sever wire where it contacts lead came or another wire overlay at opposite end.

9. Hold wire in place with a wood stick. Solder the free end to lead came.

10. Repeat steps 6 to 9 to attach remaining wire overlays to surrounding lead cames and to adjacent wires (see pattern and photos). Use this procedure to attach wire overlays to glass pieces that shape the heron.

11. 2 wire overlays on the heron's black crest (**D**) extend past lead came wrapped around glass. Use needlenose pliers to form a small loop at end of each wire. Apply flux and solder loop closed.

12. Stalks and pointed tips of the 5 cattails are cut from 10 ft length of 6-gauge copper ground cable (made of 7 strands of copper wire wound together). Use heavy-gauge wire cutters to clip 5 different lengths to create cattail stalks: 13 in, 15 in, 20 in, 24 in, and 28 in. Each cattail tip is 1½ in long and 2 wires thick. Cut two – 1½ in long pieces of cable and separate 5 pairs of wires.

13. Tin (p27) first ½ in of both ends of each stalk and one end of cattail tips. Apply flux and heat copper wires with hot soldering iron tip to coat with a thin layer of solder.

14. Flux and bead solder a tip and a stalk to either end of each brown cattail spike (**F**). Solder the tinned tip end to center of lead came at one end of flower spike. A stalk is then soldered to center of came at opposite end.

15. Use warm water and neutralizing solution to wash away residual flux from the glass pieces before continuing.

Assembling the Bird

16. Position first layer of glass pieces over full scale copy of assembled view of the bird.

17. Flux and bead solder each point of lead came wrapped glass pieces contact.

18. Carefully turn the assemblage over to flux and solder the lead joints on the back side.

19. Turn the assemblage right side up and place over the pattern in the correct position.

20. Repeat steps 16 to 19 to set up and solder each layer of glass pieces to complete assembly.

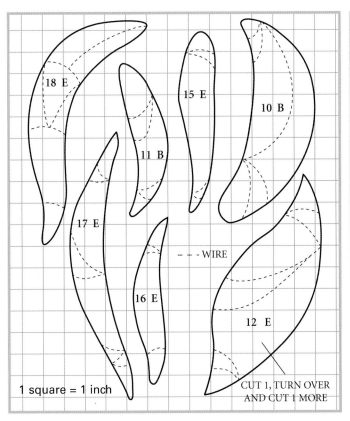

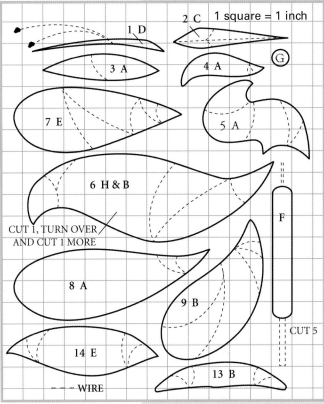

21　Make sure all lead joints are soldered and all glass pieces are in place. Apply additional solder to lead joints where needed or add wire overlays.

22　Wash any residual flux with warm water and neutralizing solution before attaching the heron to the sprinkler stand.

23　To attach heron to sprinkler stand follow the instructions on pp 113 to 114. Assemble version of garden sprinkler apparatus (pp111-114) you choose and attach heron and cattails to stand.

24　Clean all solder joints with warm water and neutralizing solution before applying a protective coat of finishing compound or wax (p23).

Detail of assembled blue heron

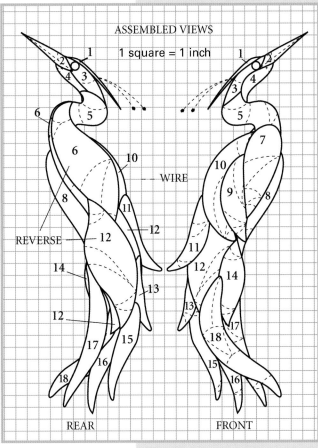

Pelican
Garden Sprinkler

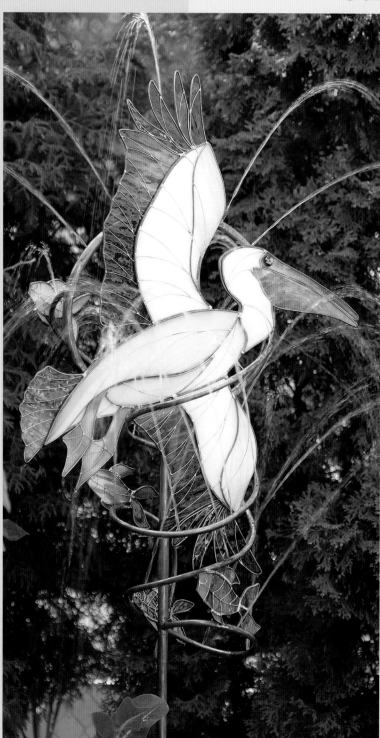

Dimensions 24 in wide X 72 in high X 10 in deep
No. Of Pieces 45
Glass Required

A	17 in X 24 in white wispy
B	12 in X 15 in clear with white swirl
C	9 in X 8 in orange-red & white ring mottle
D	12 in X 18 in translucent dark gray & white wispy
E	1 iridescent black glass nugget (medium)
Fish	Approximately 1½ sq ft of assorted art glass to make 4 fish.

Letters identify type of glass used on pattern (p120). The quantity of glass listed is a close approximation of the amount needed for the pattern. You may wish to purchase more glass to allow for matching textures and grain.

Instructions

This project is constructed using similar methods described for building the BLUE HERON Garden Sprinkler (pp116 & 117). Instructions specific to the PELICAN Garden Sprinkler are explained below.

1 Follow steps 1 to 10 as given for the BLUE HERON Garden Sprinkler (p116) to prepare the glass pieces for assembly.

- Patterns for individual glass pieces and assembled view of pelican pattern are on p120.
- Enlarge the fish pattern in several sizes and use a variety of colorful glasses to make at least 4 fish to be attached to the copper spirals on the garden sprinkler apparatus. This is a wonderful way to make use of smaller pieces of glass left over from other projects.
- Wrap all glass pieces cut from the white wispy glass (**A**) with the thicker ⅛ in lead U-channel came: the large wingspan and the 2 large wing overlay pieces, the 2 head and neck pieces, and the main body piece. Use the thinner ⁵⁄₆₄ in lead U-channel came to wrap all the other glass pieces that make up the pelican and the fish.
- The glass nugget eye can be attached to the pelican using 1 of 2 methods.

> **1** Use clear silicone to glue the eye to the assembled pelican as shown in the photo of the finished garden sprinkler (p118).
>
> <div align="center">Or</div>
>
> **2** Wrap the glass nugget with ⁵⁄₆₄ in lead U-channel came as in the accompanying photos illustrating the placement of glass pieces and the varying layers that form the pelican. The wrapped eye is then soldered in place.

- Attach wire overlays on both sides of the largest piece of glass (**A**) that represents the pelican's wingspan.
- Use needlenose pliers to form the small wire overlay loop that represents the eye on each fish. Apply flux and solder the loops closed.

First layer

2 Follow steps 16 to 21 as described on pp116 & 117 to assemble the pelican.

3 Place the glass pieces for each fish on the appropriate pattern. Apply a slightly rounded seam of solder along the abutting lead cames where the fins and tail pieces rest adjacent to the main body of each fish.

4 Tack solder the lead joint created where the tip of the dorsal fin and the upper tail come in contact with one another.

5 Turn each fish over and repeat steps 3 and 4 to finish the other side.

6 Wash away any residual flux with warm water and neutralizing solution before attaching the pelican and the fish to the sprinkler stand.

7 Following the instructions provided on pp111-114, assemble a garden sprinkler apparatus without the rotating armature and attach the pelican and the school of fish to the stand.

8 Clean all solder joints with warm water and neutralizing solution before applying a protective coat of finishing compound or wax (p23).

Additional Materials & Tools Required

Materials

- 3 lengths of ⅛ in lead U-channel came
- 7 lengths of ⁵⁄₆₄ in lead U-channel came
- 16-gauge tinned copper wire

 Note

Quantities of cames listed are based on a 6 ft length.

Second layer

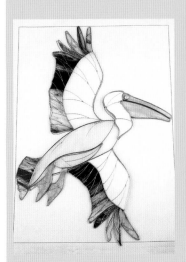

Third layer

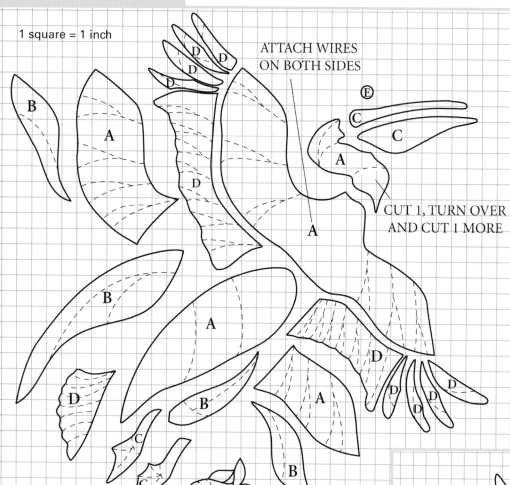

1 square = 1 inch

B

A

D D
D
D

ATTACH WIRES
ON BOTH SIDES

Ⓔ

C

C

A

CUT 1, TURN OVER
AND CUT 1 MORE

A

D

B

A

D

D D
D
D

D

B

A

C

C

B

CUT 4 IN VARYING SIZES
AND COLORS

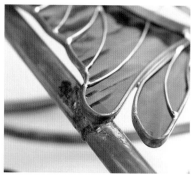

Close-up of wing tip soldered to
sprinkler

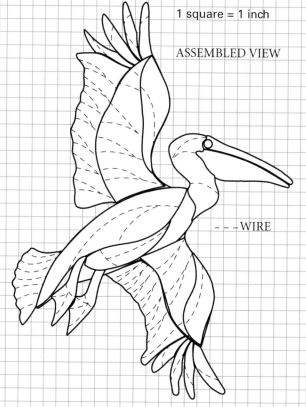

1 square = 1 inch

ASSEMBLED VIEW

- - - WIRE

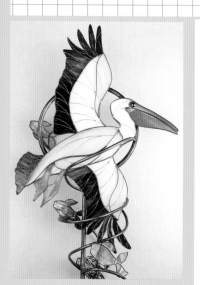

Assembled Pelican sprinkler

Snowy Egret
Garden Sprinkler

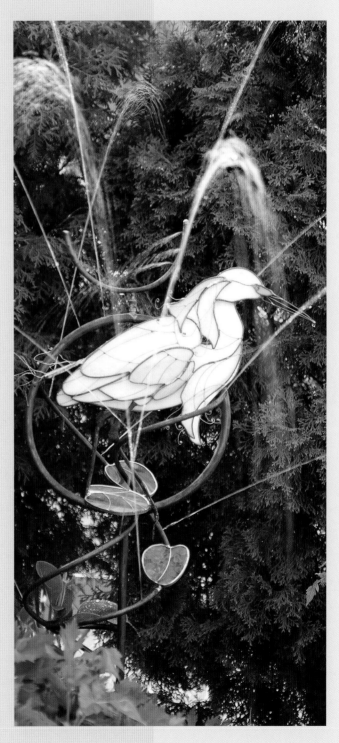

Dimensions 21 in wide X 60 in high X 10 in deep

No. Of Pieces 31

Glass Required

A	14 in X 16 in	white wispy
B	2 in X 2 in	opaque yellow
C	16 in X 16 in	iridescent translucent white glue chip
D	2 in X 6 in	black
E	12 in X 16 in	iridescent white wispy
F	8 in X 10 in	green & white ring mottle

Letters identify type of glass used on pattern (p124). The quantity of glass listed is a close approximation of the amount needed for the pattern. You may wish to purchase more glass to allow for matching textures and grain.

Materials

- 6 lengths of $^5/_{64}$ in lead U-channel came
- 1 length of $^1/_8$ in lead U-channel came
- 16-gauge tinned copper wire
- $^1/_8$ in malleable copper tube (20 in)
- 36-gauge medium weight tooling copper (2 in X 4 in)
- 14-gauge tinned copper wire
- Black patina

Tools

- Hammer

 Note

Quantities of cames listed are based on a 6 ft length.

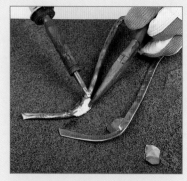

Soldering together copper components for egret legs

Instructions

This project is constructed using similar methods described for building the BLUE HERON Garden Sprinkler (pp116 & 117). Instructions specific to the SNOWY EGRET Garden Sprinkler are explained below.

1 Follow steps 1 to 10 as given for the BLUE HERON Garden Sprinkler (p116) to prepare the glass pieces for assembly.

- The large white glass piece (**A**) that forms the egret's body and neck has a deep inside curve that some hobbyists may find difficult to cut (pp15-20). Consider grinding (p21) the glass away to achieve the deepest portion of the curve or using a glass band saw (p20) to cut this difficult arc.

- The wire overlays are attached to the textured side of the iridescent translucent white glue chip glass (**C**) used for the tail and the pieces representing the trailing chest feathers and the head crest. Reverse the pattern and transfer the pattern outlines (p15) onto the iridescent side of the glass sheet before cutting these pieces of glass. When assembling the glass pieces, the iridescent side of these pieces will face the underside of the egret.

- Wrap all glass pieces used to create the egret with $^5/_{64}$ in lead U-channel came. Use the thicker $^1/_8$ in lead U-channel came to wrap the 3 lily pads (**F**).

- Do not attach the wire overlay to the 2 pieces of glass (**A**) that represent the egret's head, at this time. Use 16-gauge tinned copper wire for all other wire overlays. For aesthetics and additional support, attach wire overlays on both sides of the black beak (**D**) and the large piece of white wispy glass (**A**) that forms the egret's body and neck.

2 Use needlenose pliers to form the small inner loops that shape the eye and at the end of each wire overlay that extends past the lead came wrapped around the tail and the chest feather and head crest pieces. Apply flux and solder (pp26-29) the loops closed.

3 Once all glass pieces are wrapped with lead came and the joints have been soldered, wash away residual flux with warm water and neutralizing solution.

Making the Snowy Egret's Legs

4 Use wire cutters to cut two 10 in lengths of $^1/_8$ in malleable copper tube.

5 Bend 2 copper tube lengths to form egret's legs into shape indicated on pattern (p124).

6 Flatten the copper tubes with a hammer to give leg pieces a more realistic shape.

7 Trim the bottom end of each copper leg at a 45° angle. The top of the legs are cut at an angle that corresponds with the glass piece that it is to be butted against and soldered to as shown on the pattern. Use a metal file to smooth away any burrs and rub each leg with steel wool to remove oxidization from the surface.

8 Use pliers to gently bend and mold the bottom end of each leg into a slight curve.

9 Flux and tin solder the entire surface of both copper legs.

10 Place a pattern copy over the piece of medium weight tooling copper. Pressing firmly, use a pen to trace the outlines of 4 knee joints onto the copper sheet. Remove the pattern, revealing the outlined impressions on the copper surface. Cut the shapes from the copper sheet with a pair of scissors.

11 Use needlenose pliers to hold a copper knee joint centered over the bend of a tinned copper leg and tack solder in place. Turn the leg over and tack second knee joint in place.

12 Crimp opposing knee joints together, sandwiching tinned leg between them. Flux and bead solder 3 copper pieces together, adding solder as necessary to create a natural appearance.

13 Complete the second leg, repeating steps 11 and 12.

Assembling the Egret

Closely observe the accompanying photos and close-ups but feel free to use artistic license in the assembly of the egret. The snowy egret is more 3-dimensional than the birds featured in the previous garden sprinkler projects. It has been constructed taking both the front and back sides into consideration so that the egret can be viewed from any angle.

14 Lay the small tail and head glass pieces for the backside face down with the main body piece positioned overtop. The lead came at each end of the body lays over the adjacent cames of the tail and head. Solder (pp81 & 82) the lead came joints together on both sides of the pieces.

15 Place the matching front tail and head pieces on the main body, directly over the attached tail and head pieces on the back side. Solder each point where the lead cames come in contact with one another on both sides of the pieces.

16 Carefully slip the edge of the wide end of the beak between the 2 opposing head pieces. Apply a slightly rounded seam of solder along the abutting lead cames on either side of the beak.

17 Position a yellow eye piece (**B**) to the head on the front side and solder at each point where a lead came joint is formed. Solder the 14-gauge tinned copper wire overlay to the lead came at the tip of the eye and to the back of the head. Turn the assemblage over and attach the corresponding eye and wire overlay on the other side.

18 Begin assembling the wing on the front side. As shown in the photo, stack the 3 white (**A**) wing tip pieces from the bottom and upwards. Tilt the lower edges of each piece slightly forward so that the lead came on the uppermost point of the top piece contacts the lead came along the edge of the egret's lower back. The lead came along the top edge of the lower 2 pieces should not be visible. Solder each lead joint to fasten the pieces in position.

19 Slip the top edge of the upper leg piece under the bottom wing tip. Apply a slightly rounded seam of solder along the abutting lead cames.

20 Beginning with the largest, position and solder the 3 iridescent white (**E**) wing pieces to the assemblage, overlapping and angling the pieces as required. Tack solder all contact points where lead cames intersect to form a lead joint. Lower tip of large piece overlaps and rests flat against inside curve of white wing tip below while being slightly elevated over the body. The second iridescent white wing piece overlaps lower edge of the large piece and angles downward to rest on white wing tip below. Angle smallest iridescent white wing piece so that bottom edge rests against the main body piece and top edge rests against the lead came around the bottom of the second piece. Apply a slightly rounded seam of solder to abutting lead cames.

21 Solder the chest feather piece (**C**) to the small iridescent white wing piece and to the front of the neck. The 2 head crest pieces are attached to the 14-gauge tinned wire overlay on the head, to each other, and to the large wing piece.

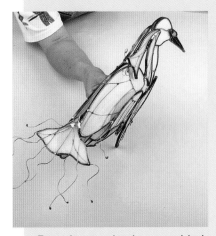

22 Referring to the pattern, position the front tinned copper leg so that it will be striding forward of the opposite leg and solder it to the upper leg piece above and the bottom edge of the body.

23 Turn assemblage over. Following steps 18 to 22, solder the glass pieces and remaining copper leg to the unfinished back side of the egret. For visual interest, slightly adjust the position of the chest feather piece, positioning it so that lower tip is slightly forward of its companion on the front side. There is only 1 head crest piece on the back side and it is placed so that it can be seen through the space between the 2 head crest pieces on the front.

Egret is completely assembled

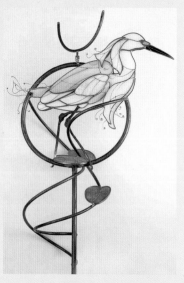

Detail of assembled egret

24 Place the large tail piece, with the textured side facing upwards, between the lower end of the large wing pieces and resting along the back of the egret. Solder all points where the lead cames of the tail and surrounding pieces come in contact with one another.

25 Examine the egret thoroughly to ensure all lead joints have been soldered and that the glass pieces and the copper legs are securely in place. Add wire overlays or apply additional solder to lead joints on any piece that requires additional support.

26 Wash away any residual flux with warm water and neutralizing solution before attaching the egret to the sprinkler stand.

27 Following instructions on pp111-114, assemble the version of the garden sprinkler that you would like to use and attach the egret and the lily pads to the stand.

28 Apply black patina (pp22 & 23) to the egret's tinned copper legs.

29 Clean (p22) the solder joints and the egret's legs before applying a protective coat of finishing compound or wax (p23).

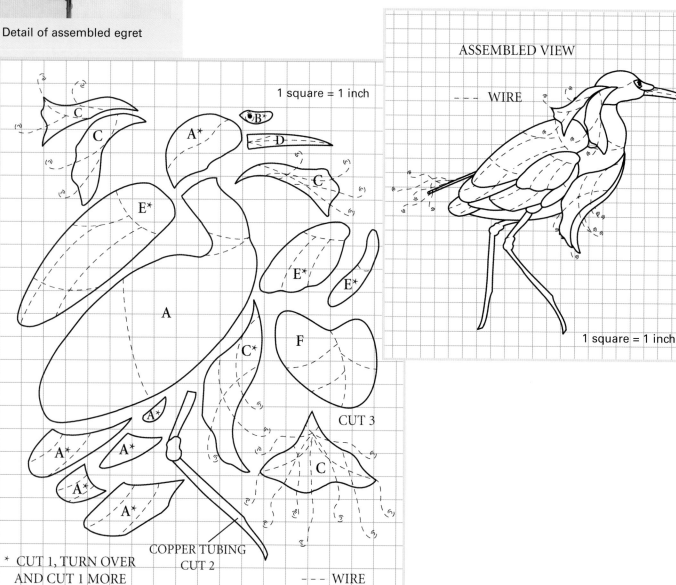

1 square = 1 inch

ASSEMBLED VIEW

--- WIRE

1 square = 1 inch

CUT 3

COPPER TUBING
CUT 2

* CUT 1, TURN OVER
AND CUT 1 MORE

--- WIRE

Spider Web
Obelisk

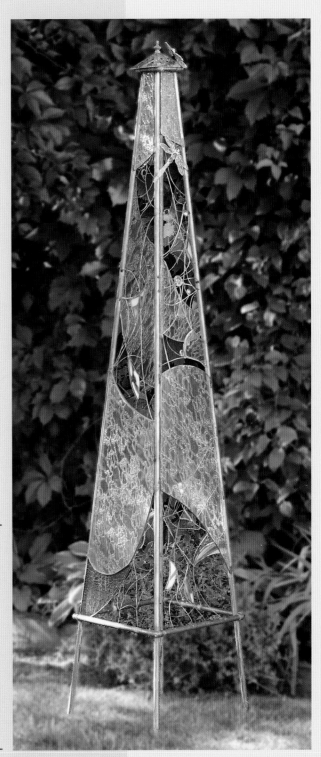

The classical stone obelisk has been given a contemporary update with this whimsical use of traditional copper plumbing parts and stained glass. A specific pattern has not been drawn up for this project but an array of ideas is presented for you to choose from. Have fun, get creative, and make a garden obelisk unique to your garden landscape!

Dimensions 15 in wide X 15 in deep X 74 in high
Glass Required Assortment of art glass, nuggets, jewels, & shapes

Helpful Hints
- A 6 in diameter brass vase cap can be used as a substitute for the copper roof. As explained in step 16 on page 68, the brass cap must be tinned before it is attached to the obelisk.
- Glass, metal, and lead cames become hot to the touch during the soldering stage. Wear work gloves or use a cloth when handling projects, to prevent burns (from hot metal, glass, and molten solder) while soldering or when holding the ends of lead came together to solder the joints

Additional Materials & Tools Required

Materials
- ½ in rigid copper pipe (30 ft 4 in)
- 8 – ½ in copper elbow fittings
- 8 – #8 stainless steel screws (1 in long)
- Cardstock or lightweight cardboard
- 8 in X 8 in copper sheet (22-gauge)
- Lamp finial
- 14-gauge tinned copper wire
- 18-gauge tinned copper wire
- ⅛ in and/or 5/64 in lead U-channel came
- Copper and/or black-back copper foil
- Copper patina

Tools
- Pipe cutter
- Propane torch
- Center punch
- Power drill with 5/64 in & 5/32 in bits
- Med. grade emery cloth or sandpaper
- Screwdriver to fit #8 screws
- Metal snips
- 4 in wood block

Fit end of wires into holes in frame

Instructions

1 The ½ in rigid copper pipe must be cut into 12 pieces in order to assemble the obelisk frame. Measure and mark 4 pieces of each length: 3 in, 16 in, and 72 in.

2 Cut each length of copper pipe, 1 piece at a time. To cut a piece, fasten the pipe cutter to the copper pipe with the cutting blade on top of the mark. Score and cut the pipe by continually rotating and tightening the cutter until the piece separates from the main length of copper pipe. See photo on p48.

3 Prepare the 12 pieces of copper pipe and the 8 copper elbow joints for soldering. Use medium weight emery cloth or sandpaper to remove any burrs and steel wool to rub off any oxidization from the copper surfaces.

4 Form 2 support squares. Connect the 3 in copper pipe lengths with 4 copper elbow joints to form the upper square and the 16 in lengths with the remaining 4 elbows to make the lower square.

5 Following the instructions described in Soldering Copper Pipe Joints (p82), solder each joint where a copper pipe or fitting connects with another.

6 The 4 lengths of 72 in copper pipe are the corner posts and are screwed to the inside corners of the upper and lower copper pipe squares. Holes are predrilled through the elbow joints and at 2 locations on the posts. Use the center punch to make a depression at the center of the inside corner of each elbow joint. If the center punch does not have a mechanism to make the depression, gently tap the punch handle with a mallet or hammer.

7 Use the power drill fitted with a 5/32 in bit to drill the 8 holes. Place the tip of the drill bit into the depression made by the center punch. Drill a hole straight through the bend of the elbow joint and out to the opposite side. Exercise caution as copper is a soft metal and has a tendency to "grab" at the drill bit.

8 Place the end of a 72 in length of copper pipe against the inside corner of an elbow joint on the upper square. Line up the end of the pipe flush with the top edge of the elbow joint. Make a mark on the pipe end that corresponds with the center of the hole drilled through the elbow joint. Mark the other 3 pipes in the same location.

9 Measure 12 in from the opposite end of each pipe and make a mark straight down from the one already made directly above.

10 Make a depression with the center punch at each of the marks.

11 Drill each hole into the side of the pipe that is marked. Do not drill straight through the pipe to the other side.

12 Use a screwdriver to fasten the four corner post pipes to the upper square first. Starting at the outer bend of an elbow joint, insert a #8 stainless steel screw into the hole and tighten until the screw is fastened right through the elbow joint and into the hole drilled at the top end of a corner post.

13 Slide the lower square over the corner posts and fasten with screws as described above.

14 Make a copper roof to complete the obelisk frame. To make the roof, follow steps 10 to 13 as described on pp57 & 58. The pattern of the copper shape required to make the roof is on p59.

15 Center the lamp finial over the center hole of the roof and bead solder (p27) in place on both the top and undersides.

16 As a decorative element holes can be drilled into the copper roof. Drill from the top and in towards the underside, making several holes in each side of the copper roof. Remove any sharpness along the cut edges with a round edged metal file.

17 Tin (p27) the top surface of the elbow joints on the upper support square and along the bottom inside edge of the 4 corners of the roof. Use the propane torch or a very hot soldering iron to heat the copper enough so that the solder will flow freely.

18 Apply flux to the 4 corners of the copper roof and the elbow joints. Center the roof over the obelisk frame and tack in place by heating the underside of the 4 corners with the torch. The solder on the roof and the elbow joints will heat enough to fuse together.

19 Lay the obelisk on its side and proceed to bead solder the inside joints of the upper and lower support squares at each point contact is made with the corner posts and the copper roof.

20 Use warm water and neutralizing solution to wash away residual flux before continuing with the next stage.

21 The wirework within the obelisk is a design element as well as a trellis for vines to twine about. Refer to the accompanying photos and sketch of the obelisk for ideas in laying out your own individual design. Use the 14-gauge tinned copper wire to shape the main threads of the spider webs and the 18-gauge wire for the finer, gossamer threads that radiate outward from the web center.

Make variation of dragonfly from p45

22 The wires must be anchored to the obelisk frame. Use a power drill with a ⁵⁄₆₄ in bit to bore holes wherever a wire should be fastened to the copper pipe.

23 Insert the wire ends into the holes. Secure the wires in place by applying a bead of solder at each of these points.

24 Decide which openings in the webs will be filled with glass. Make templates by placing cardstock or lightweight cardboard behind the openings and tracing around the inside perimeter of the wire outlines. Transfer (p15) the patterns onto the chosen selection of art glasses.

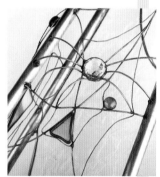

25 Cut (pp15-20) and smooth any rough edges (pp20 & 21) before wrapping (p80) the glass with the preferred size of lead U-channel came. Tack and bead solder the wrapped glass pieces in the wire openings.

Create spiders & other fun creatures

26 Make an assortment of insects to decorate the spider webs. Spiders can be made by soldering legs, shaped from tinned copper wire, to bodies made from glass jewels and nuggets that have been wrapped in copper foil or lead came. Construct variations of the dragonfly from the garden spinner project (p45) and use your imagination to create other fun creatures. Bead solder the finished insects to the spider webs to add the finishing touches to your obelisk.

27 Once the completed obelisk has cooled, remove all traces of residual flux with neutralizing solution and water. Rub the copper with fine steel wool (000) to remove heat discoloration, oxidation, and manufacturer's labeling.

28 The solder at each copper pipe joint can be left to acquire a natural and weathered finish or copper patina can be applied (pp22 & 23) to match the coloration of the pipe.

29 Apply a protective coat of finishing compound or wax (p23).

30 Position the obelisk in a location that has the natural light exposure to grow your favorite climbing plants. Leave some walking space around the obelisk so fellow gardeners and stained glass enthusiasts can get up close to observe this creative mix of Mother Nature and glass artisan.

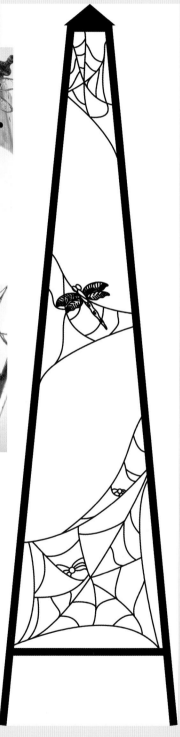

Index

Metric Equivalents					
inches	mm	cm	inches	mm	cm
1/8	3	0.3	1¾	44	4.4
¼	6	0.6	2	51	5.1
⅜	10	1.0	2½	64	6.4
½	13	1.3	3	76	7.6
⅝	16	1.6	3½	89	8.9
¾	19	1.9	4	102	10.2
⅞	22	2.2	4½	114	11.4
1	25	2.5	5	127	12.7
1¼	32	3.2	6	152	15.2
1½	38	3.8			